Clive Nichols

Paradise Found

Gardens of Enchantment

teNeues

Table of Contents

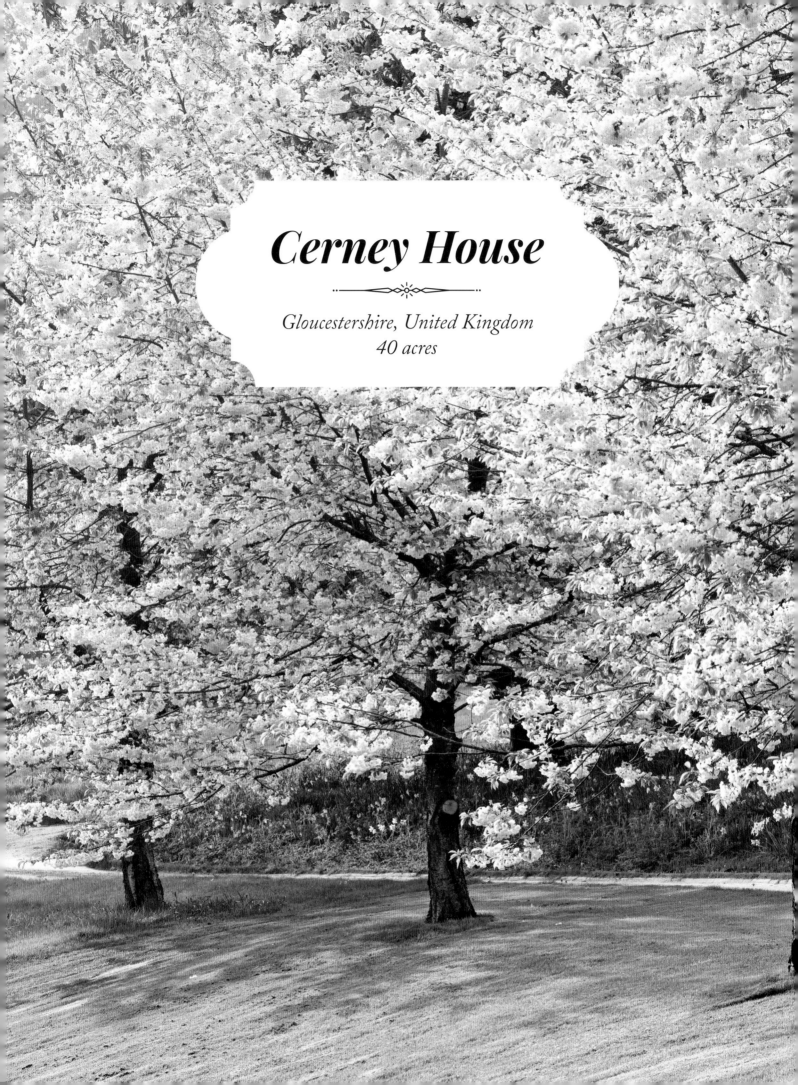

Cerney House

Gloucestershire, United Kingdom
40 acres

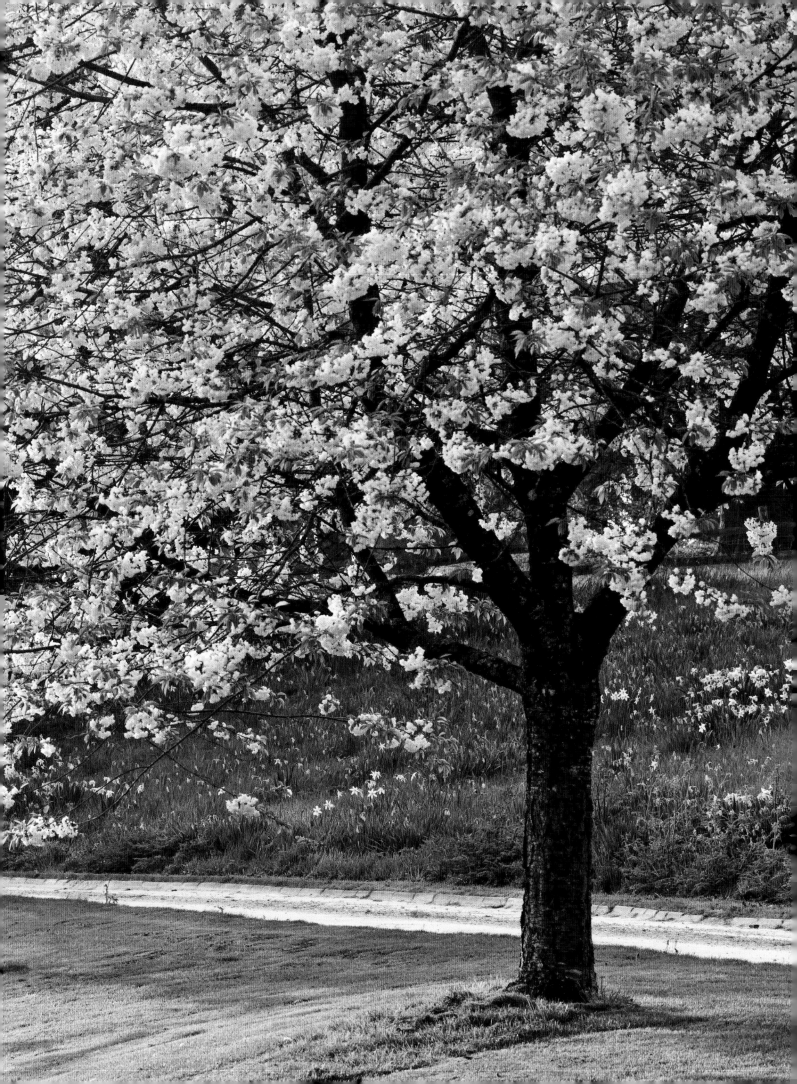

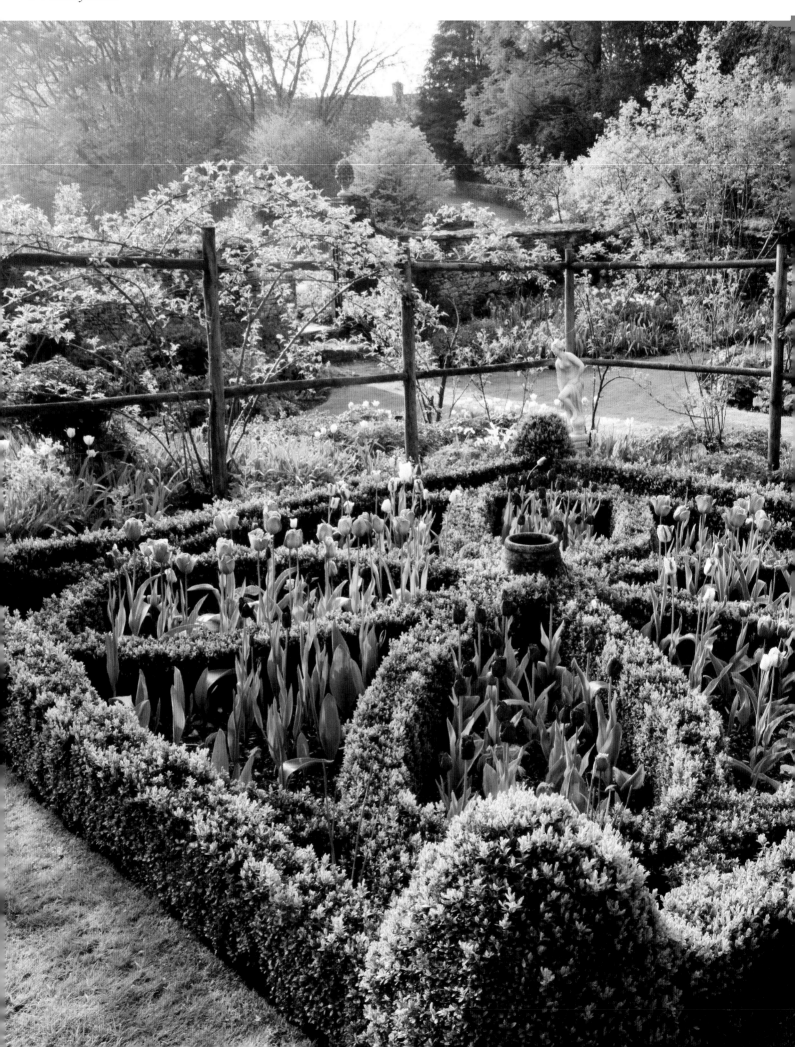

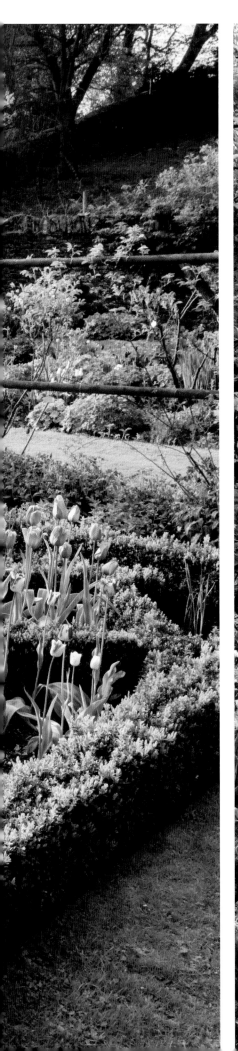
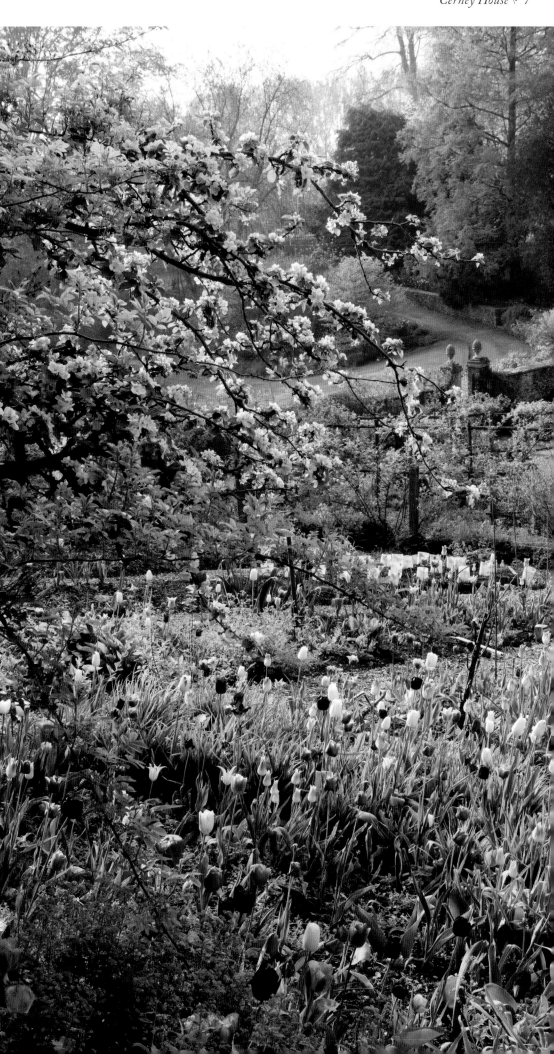

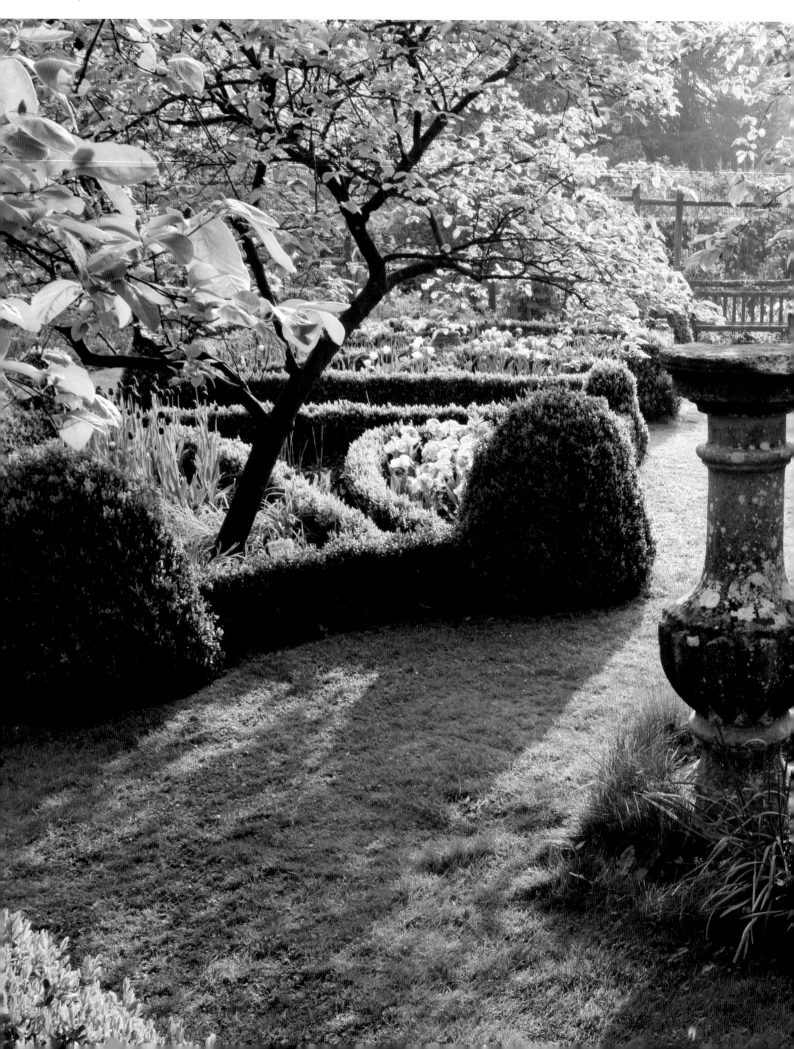

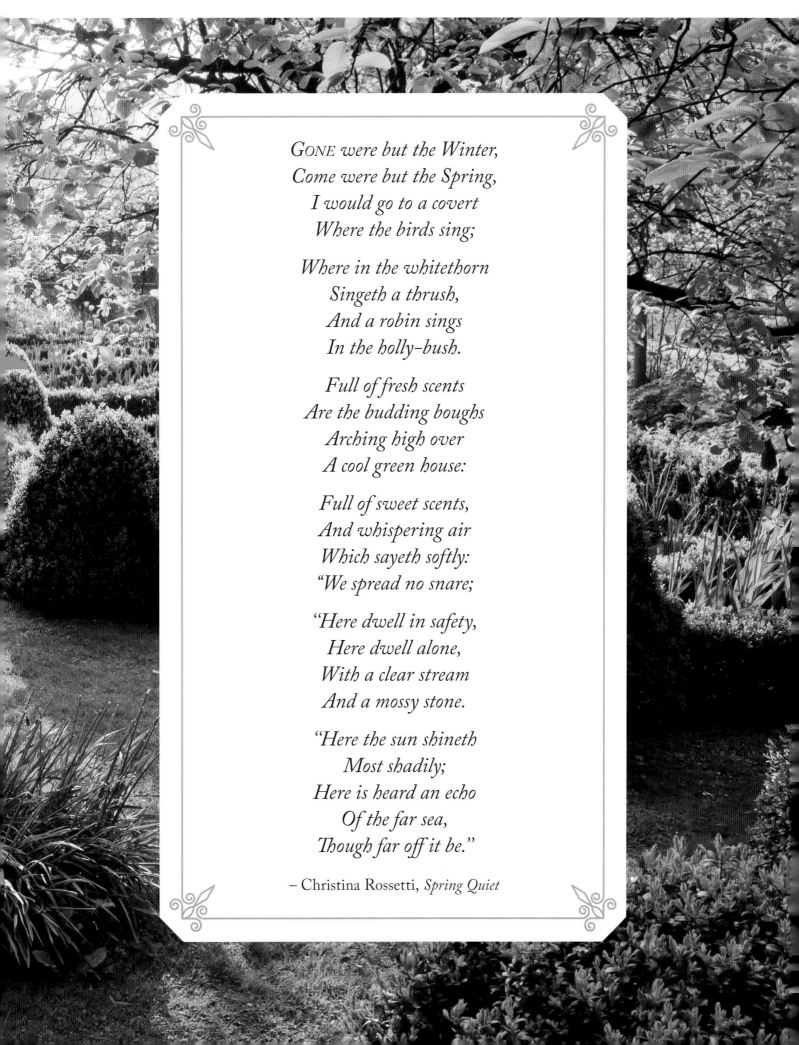

GONE were but the Winter,
Come were but the Spring,
I would go to a covert
Where the birds sing;

Where in the whitethorn
Singeth a thrush,
And a robin sings
In the holly-bush.

Full of fresh scents
Are the budding boughs
Arching high over
A cool green house:

Full of sweet scents,
And whispering air
Which sayeth softly:
"We spread no snare;

"Here dwell in safety,
Here dwell alone,
With a clear stream
And a mossy stone.

"Here the sun shineth
Most shadily;
Here is heard an echo
Of the far sea,
Though far off it be."

– Christina Rossetti, *Spring Quiet*

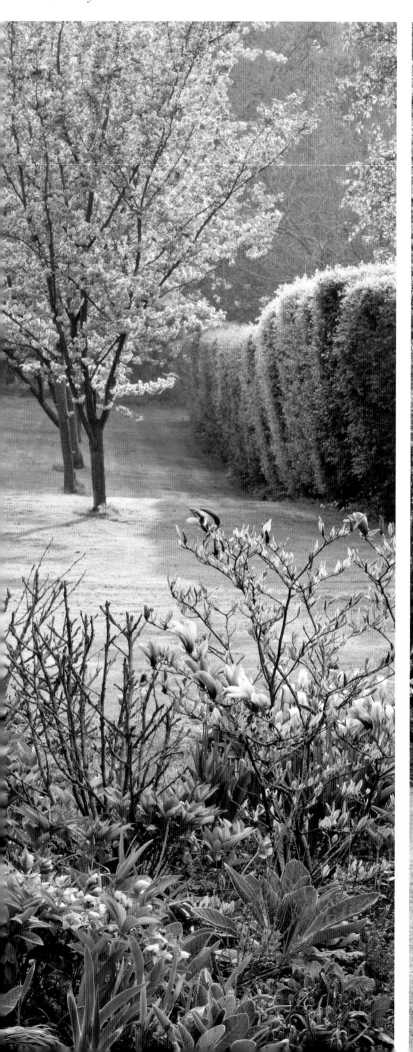
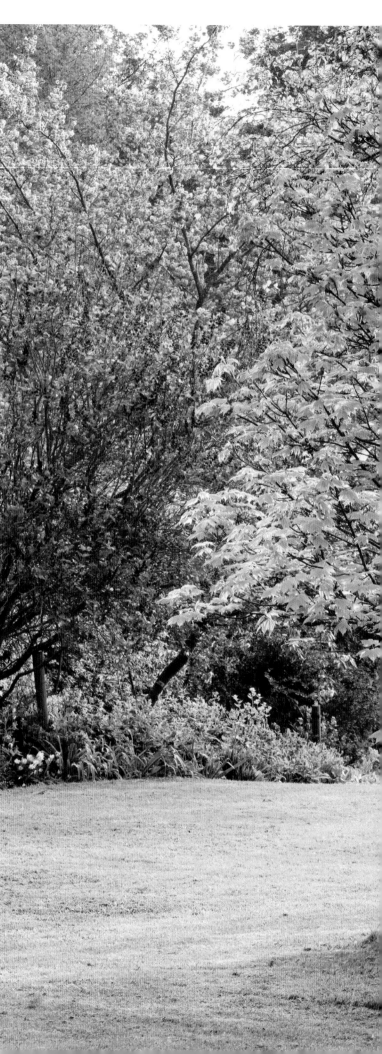

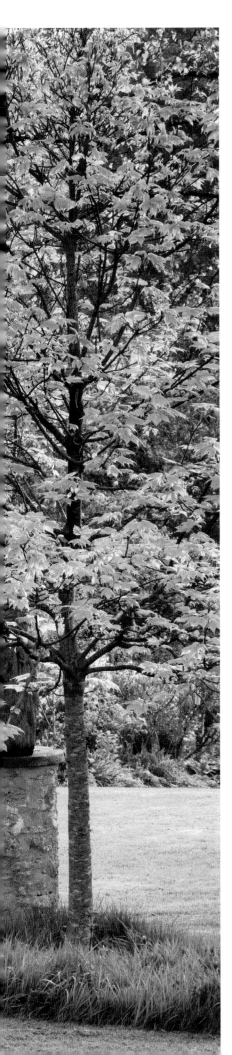
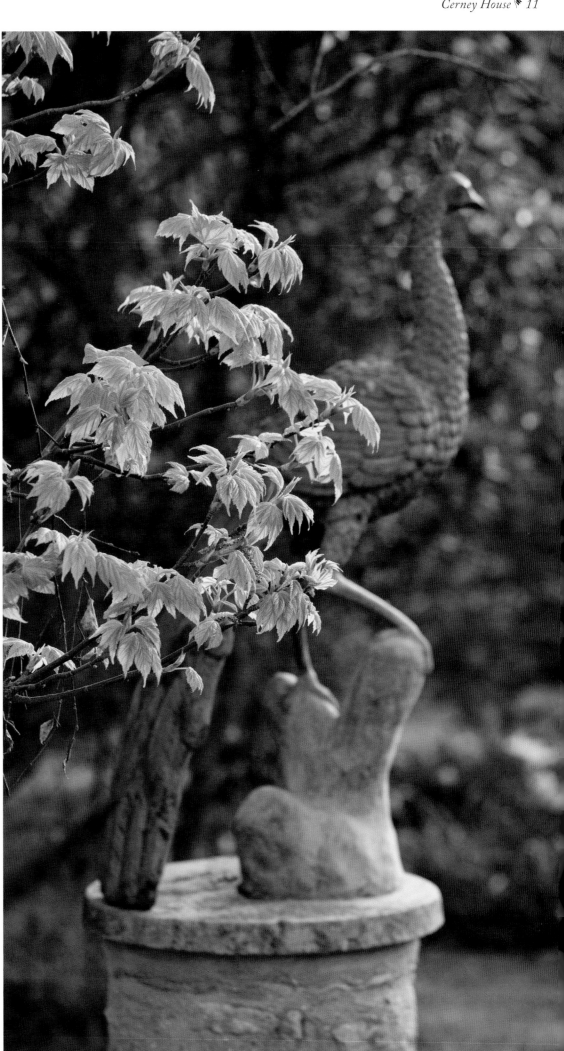

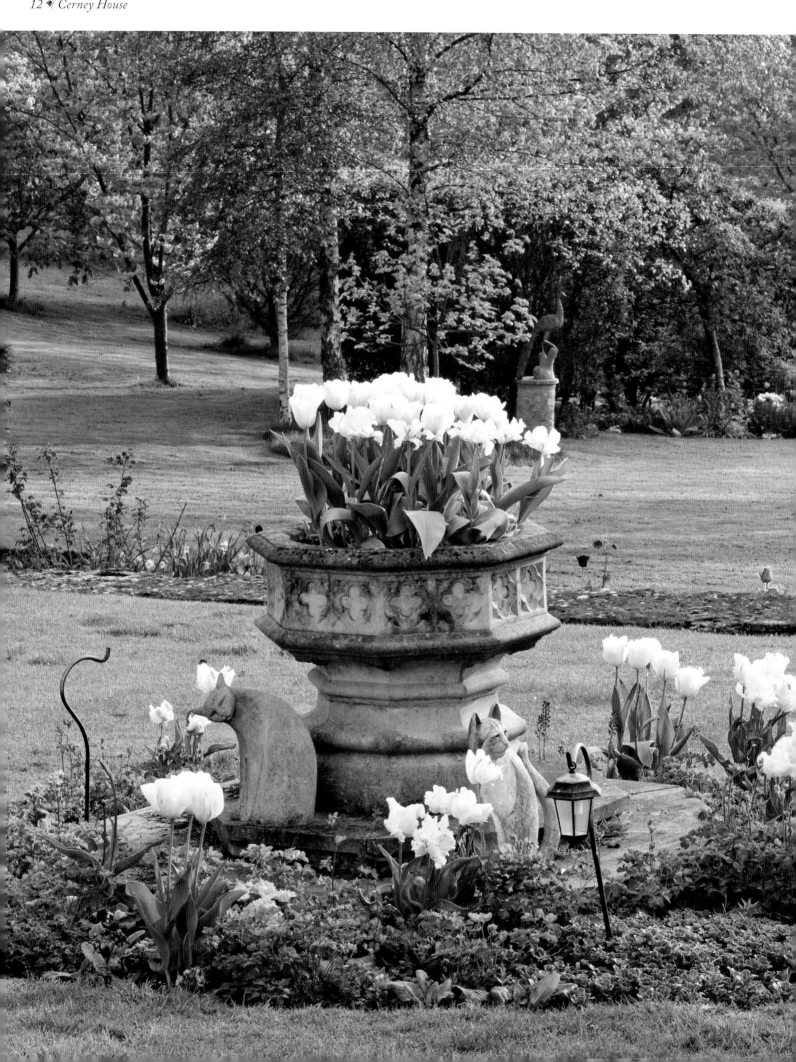

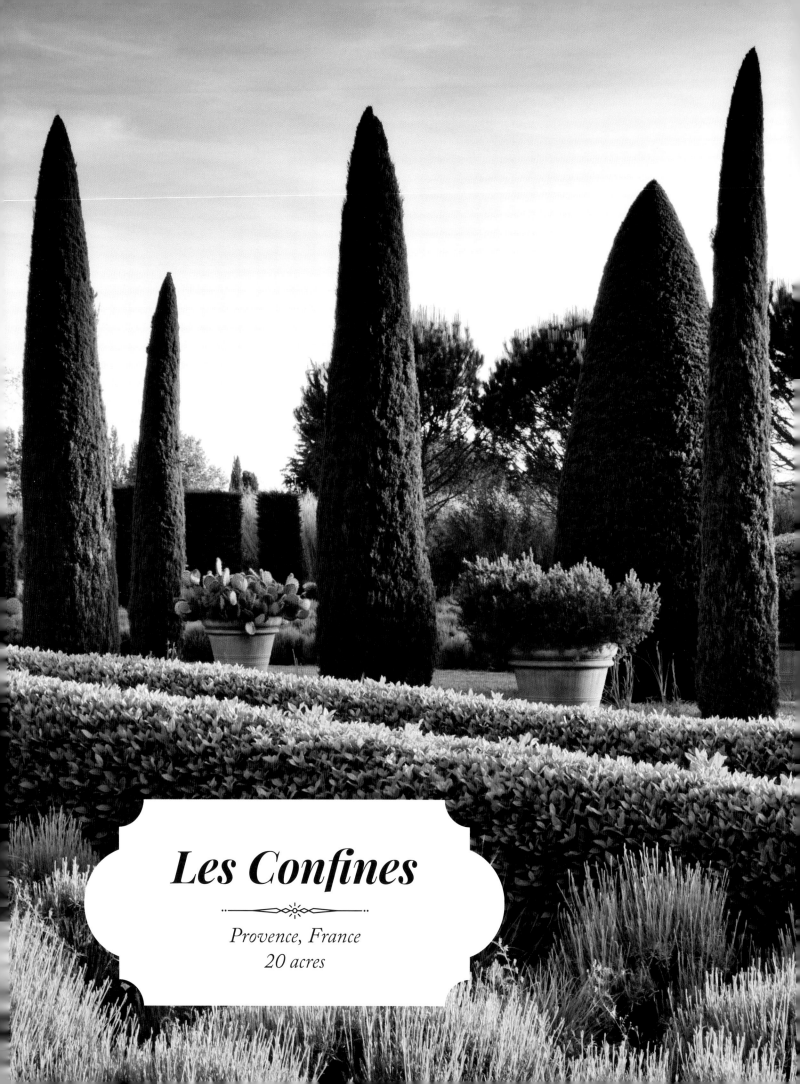

Les Confines

·······—◦—❋—◦—·······

Provence, France
20 acres

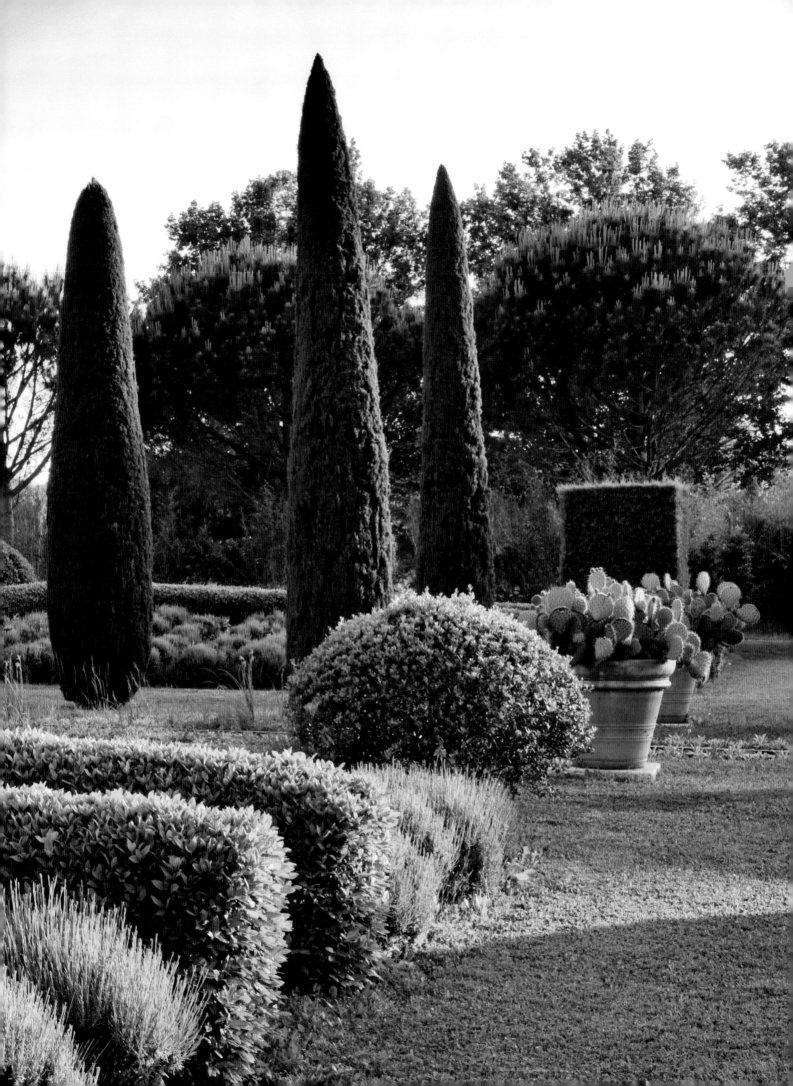

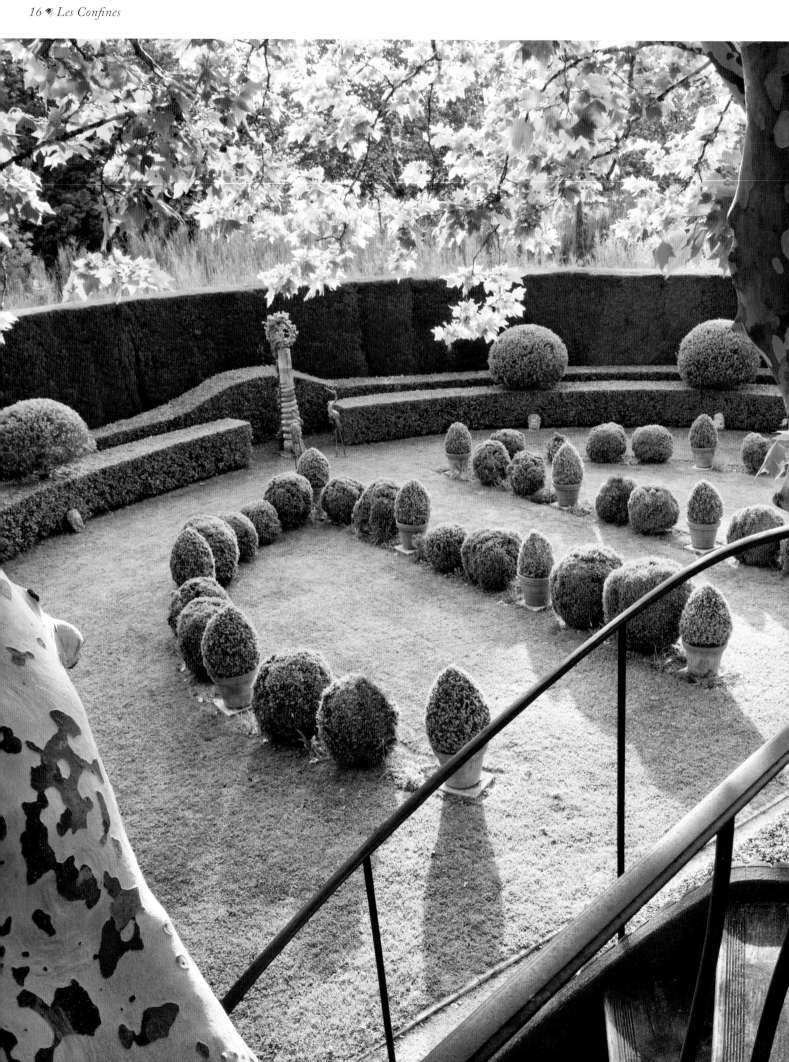

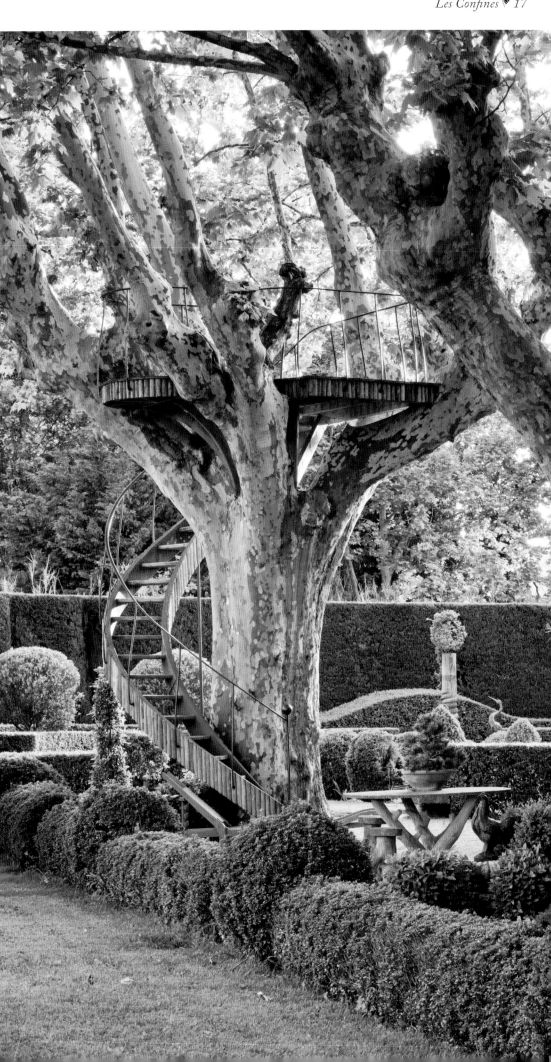

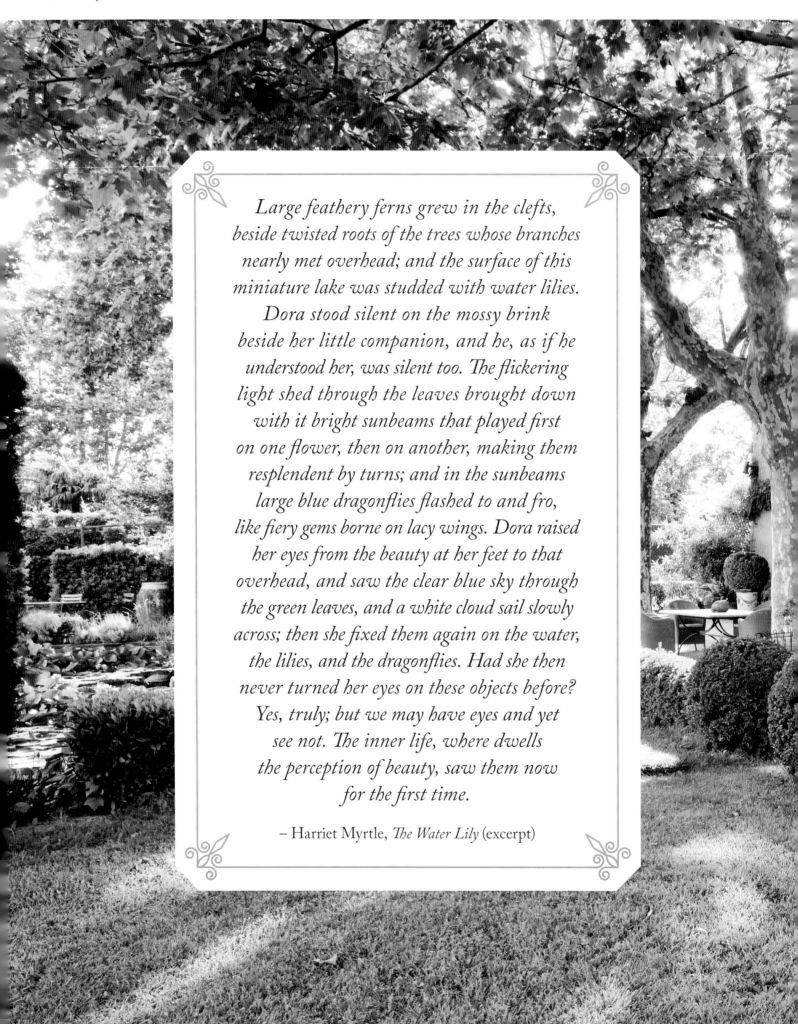

Large feathery ferns grew in the clefts, beside twisted roots of the trees whose branches nearly met overhead; and the surface of this miniature lake was studded with water lilies. Dora stood silent on the mossy brink beside her little companion, and he, as if he understood her, was silent too. The flickering light shed through the leaves brought down with it bright sunbeams that played first on one flower, then on another, making them resplendent by turns; and in the sunbeams large blue dragonflies flashed to and fro, like fiery gems borne on lacy wings. Dora raised her eyes from the beauty at her feet to that overhead, and saw the clear blue sky through the green leaves, and a white cloud sail slowly across; then she fixed them again on the water, the lilies, and the dragonflies. Had she then never turned her eyes on these objects before? Yes, truly; but we may have eyes and yet see not. The inner life, where dwells the perception of beauty, saw them now for the first time.

– Harriet Myrtle, *The Water Lily* (excerpt)

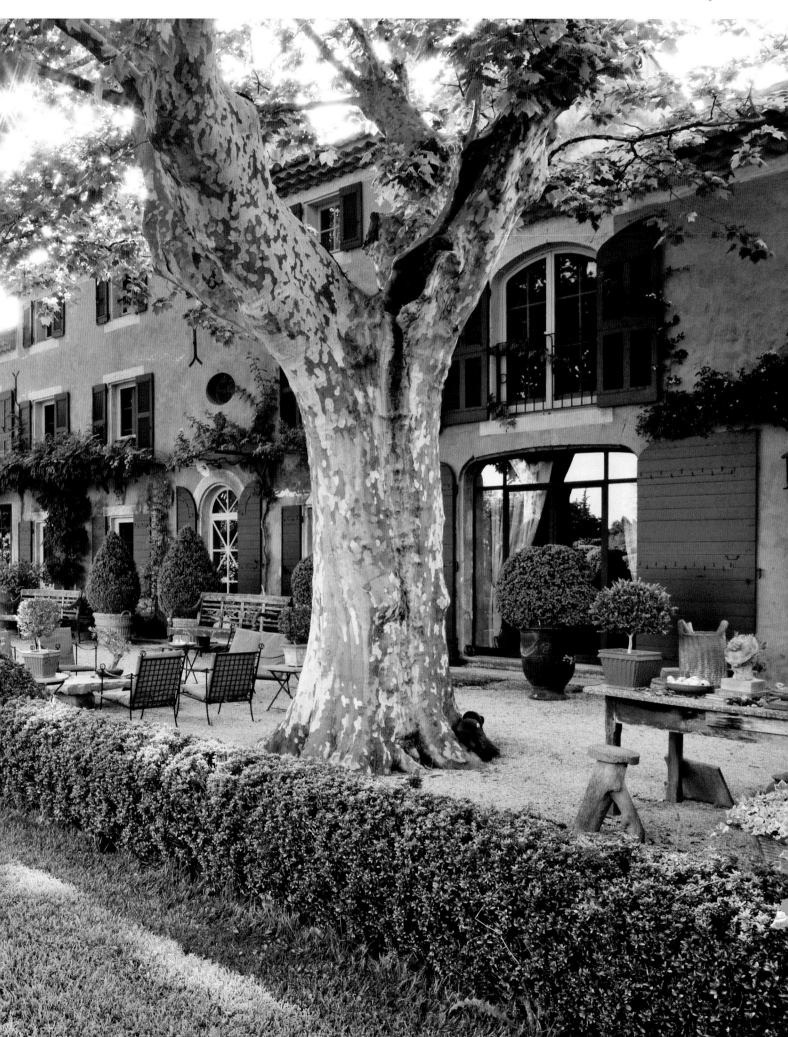

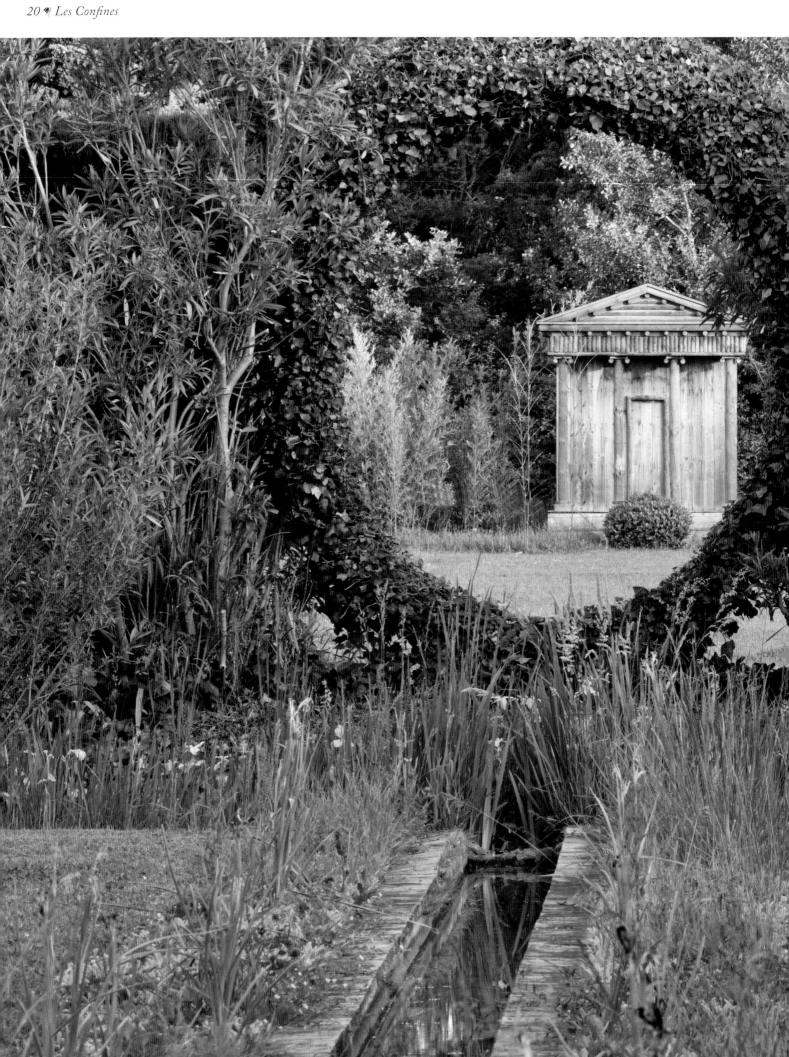

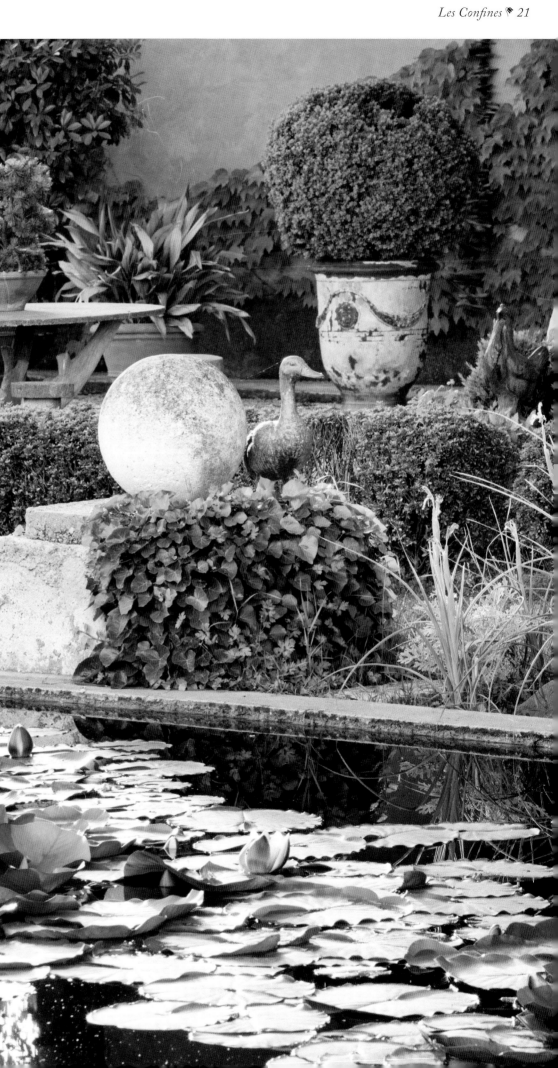

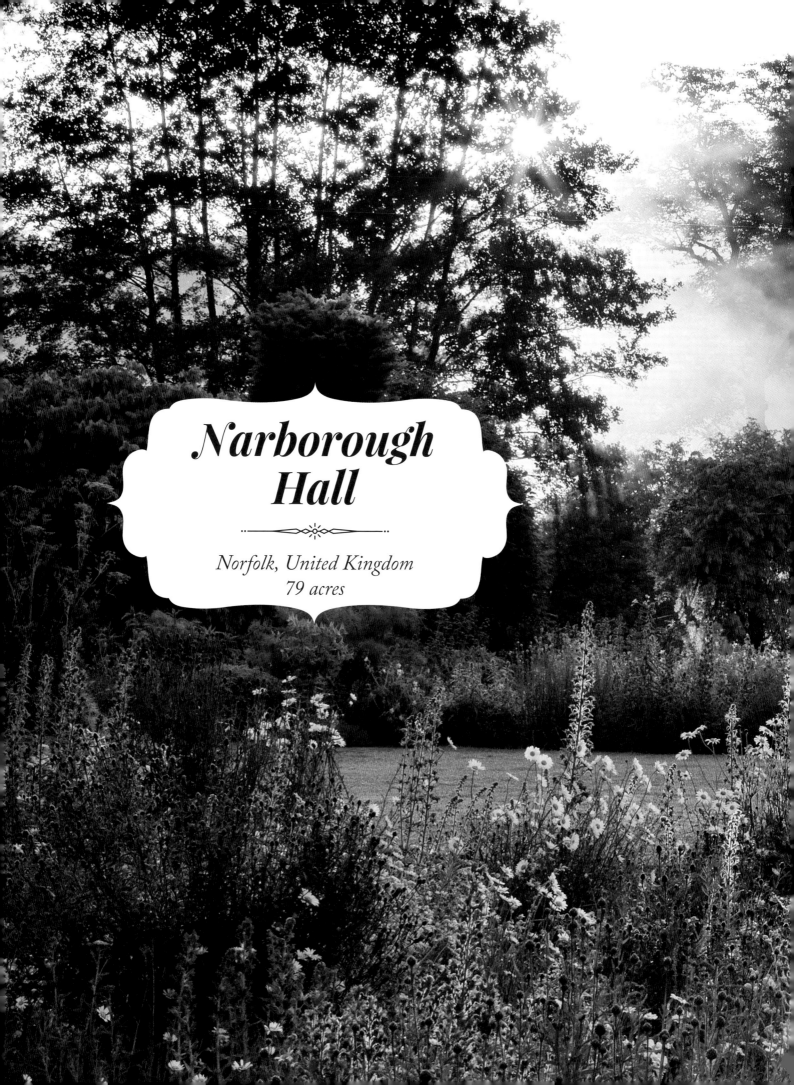

Narborough Hall

Norfolk, United Kingdom
79 acres

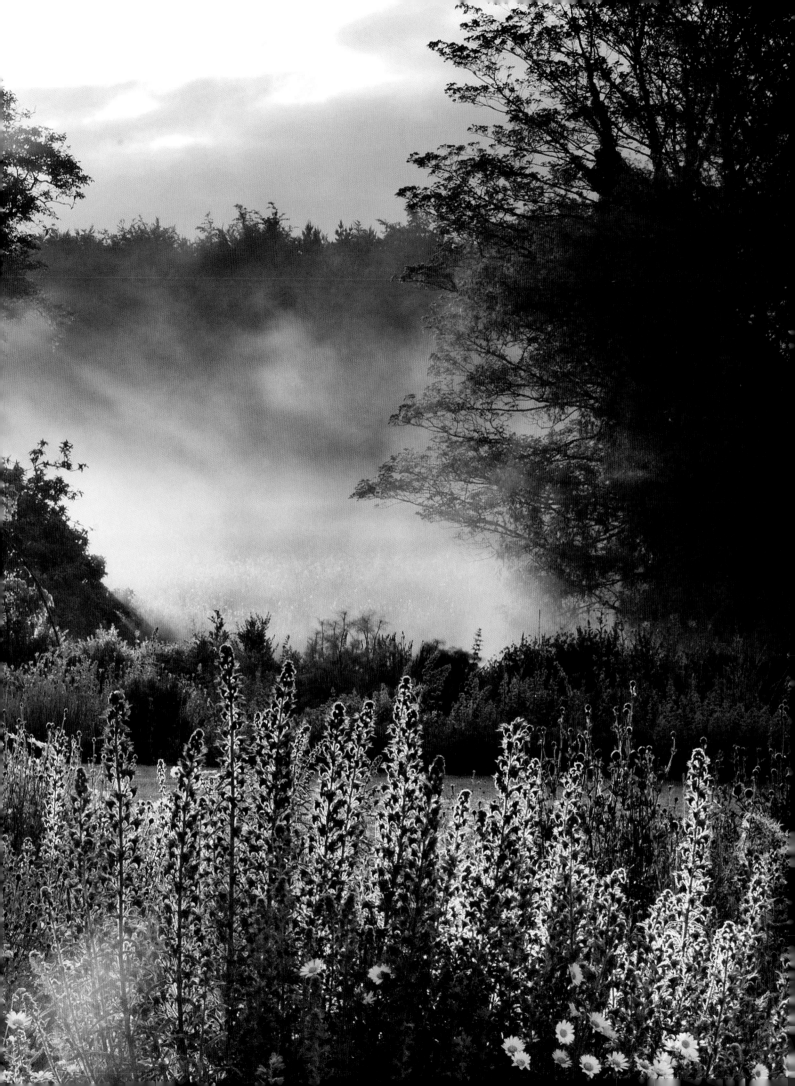

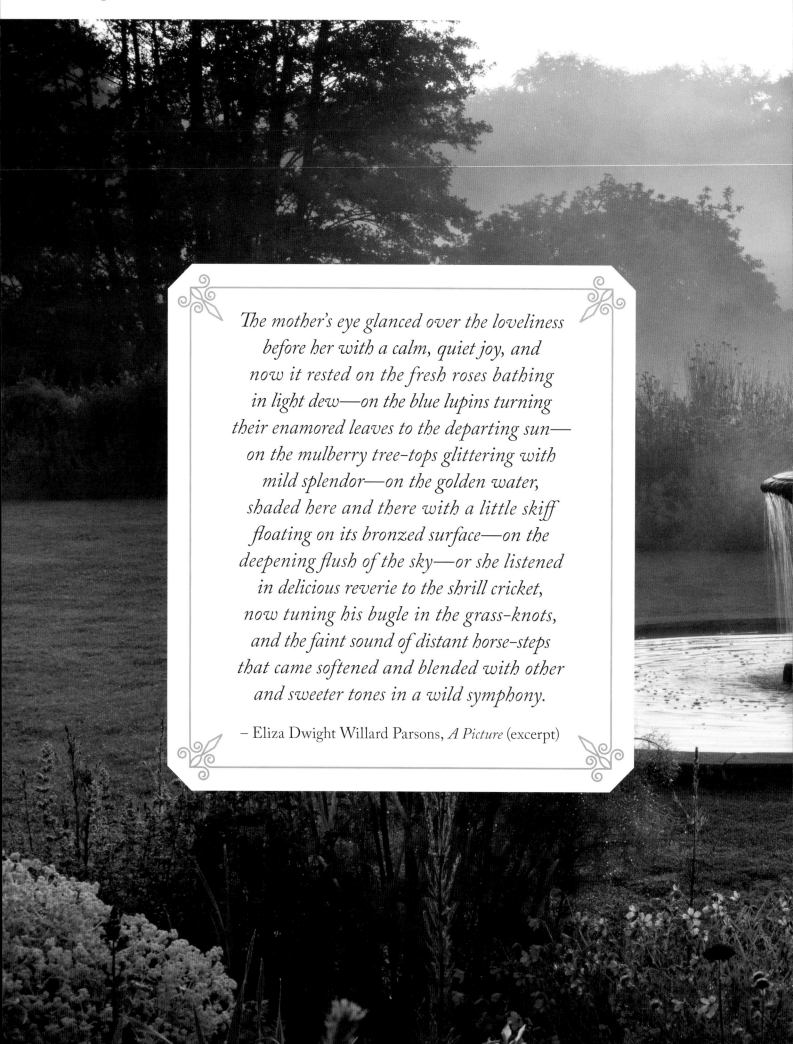

The mother's eye glanced over the loveliness
before her with a calm, quiet joy, and
now it rested on the fresh roses bathing
in light dew—on the blue lupins turning
their enamored leaves to the departing sun—
on the mulberry tree-tops glittering with
mild splendor—on the golden water,
shaded here and there with a little skiff
floating on its bronzed surface—on the
deepening flush of the sky—or she listened
in delicious reverie to the shrill cricket,
now tuning his bugle in the grass-knots,
and the faint sound of distant horse-steps
that came softened and blended with other
and sweeter tones in a wild symphony.

– Eliza Dwight Willard Parsons, *A Picture* (excerpt)

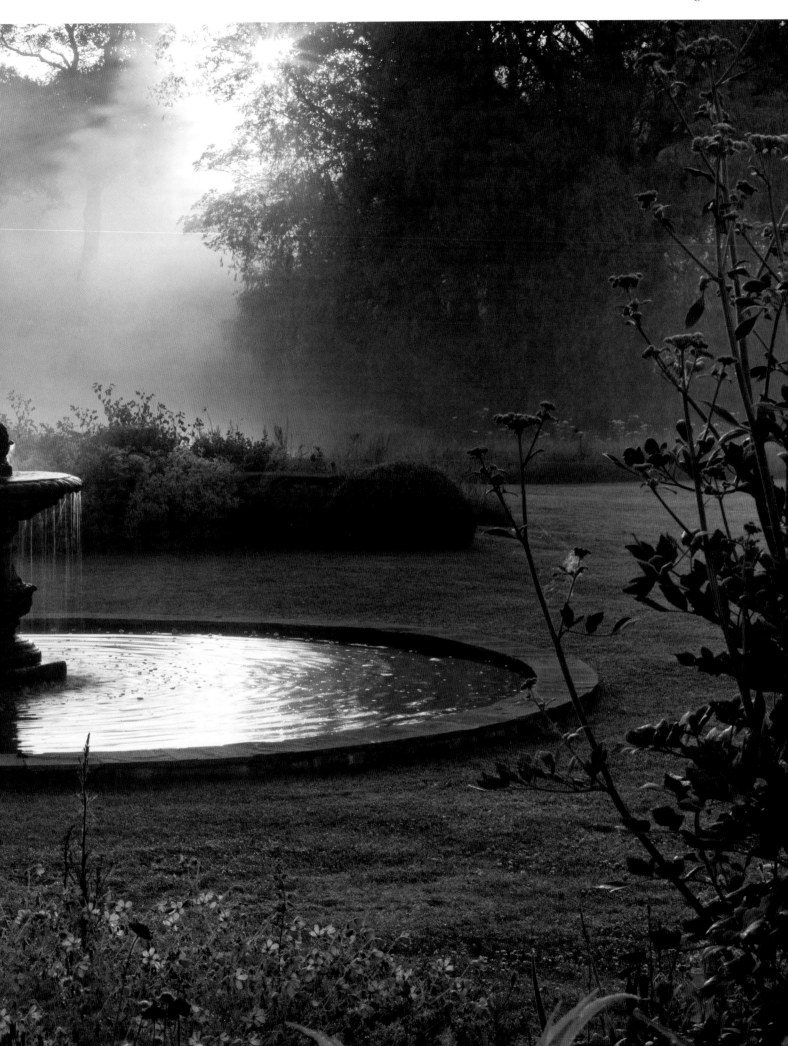

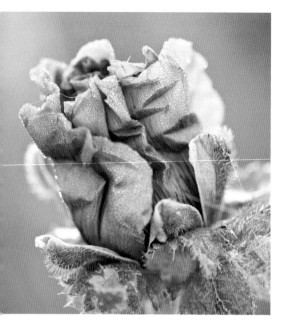

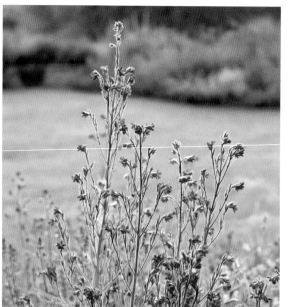

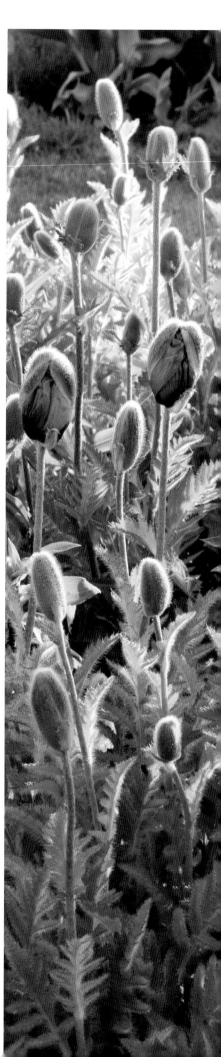

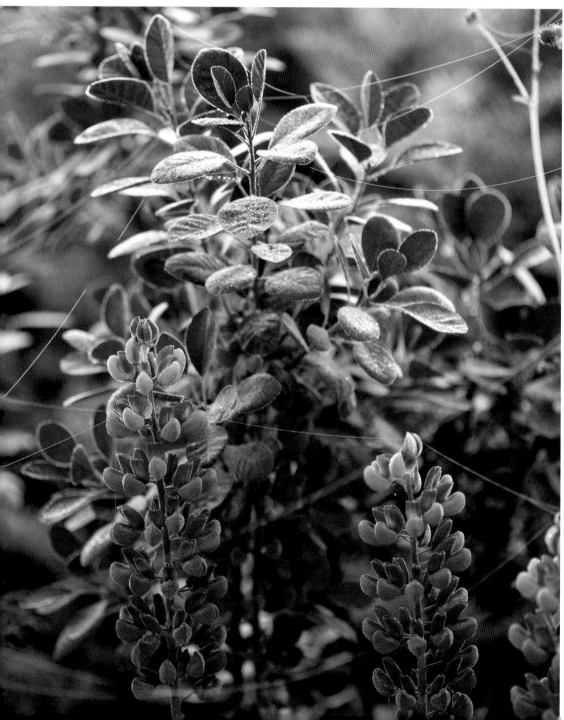

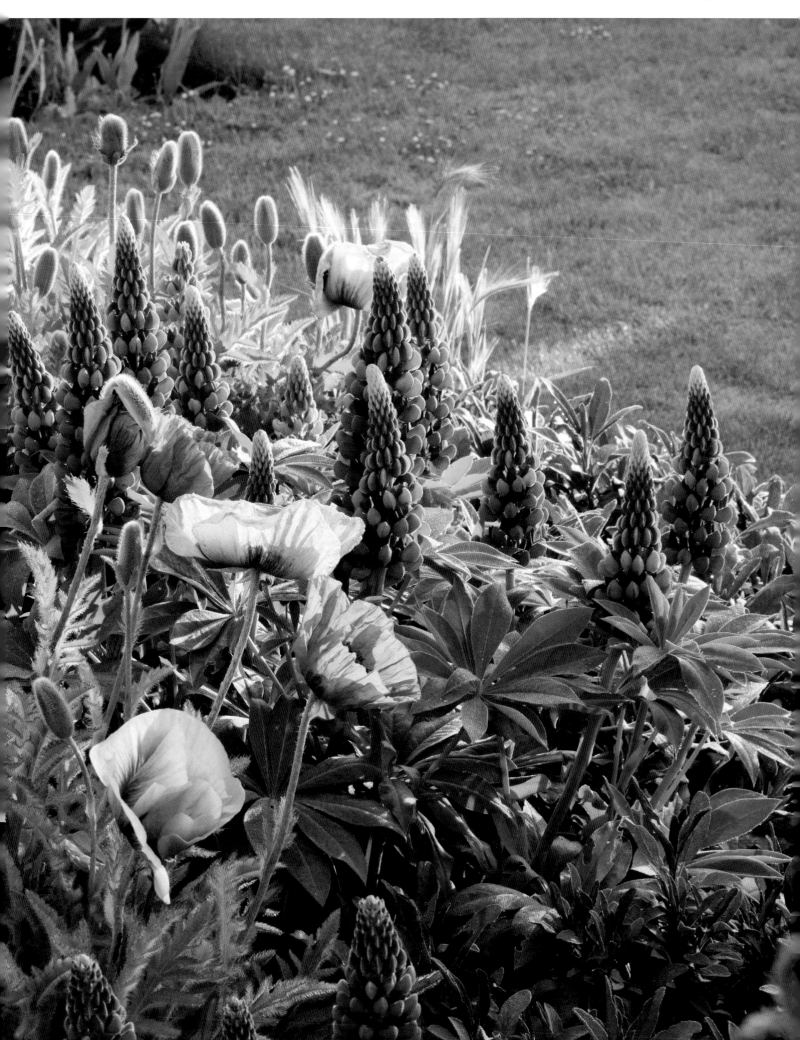

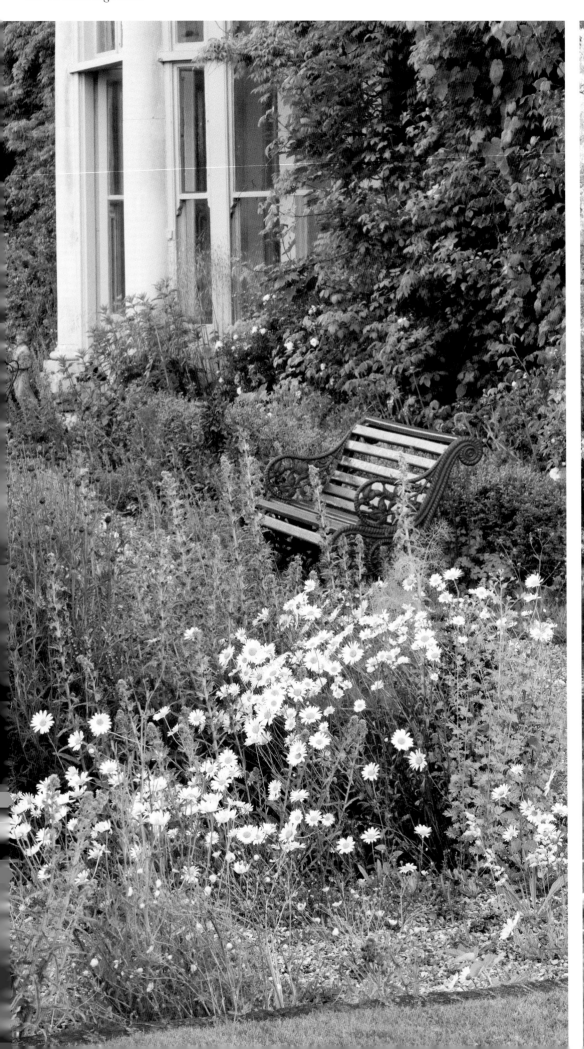
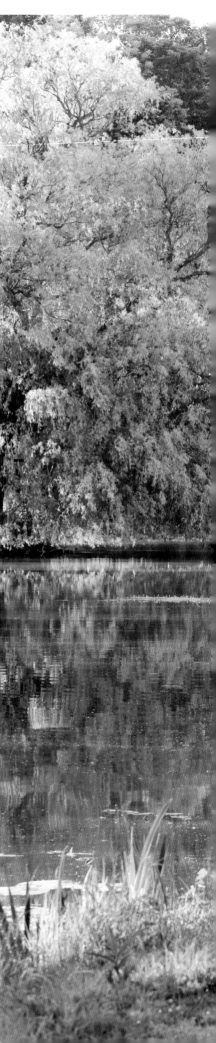

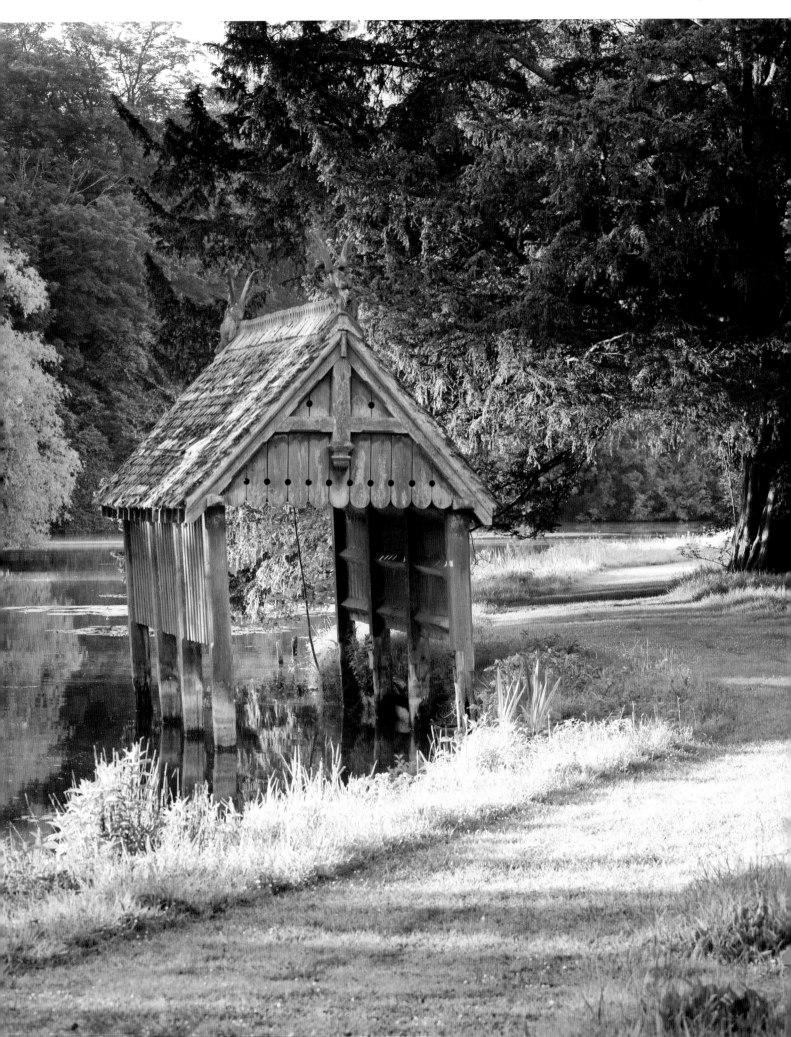

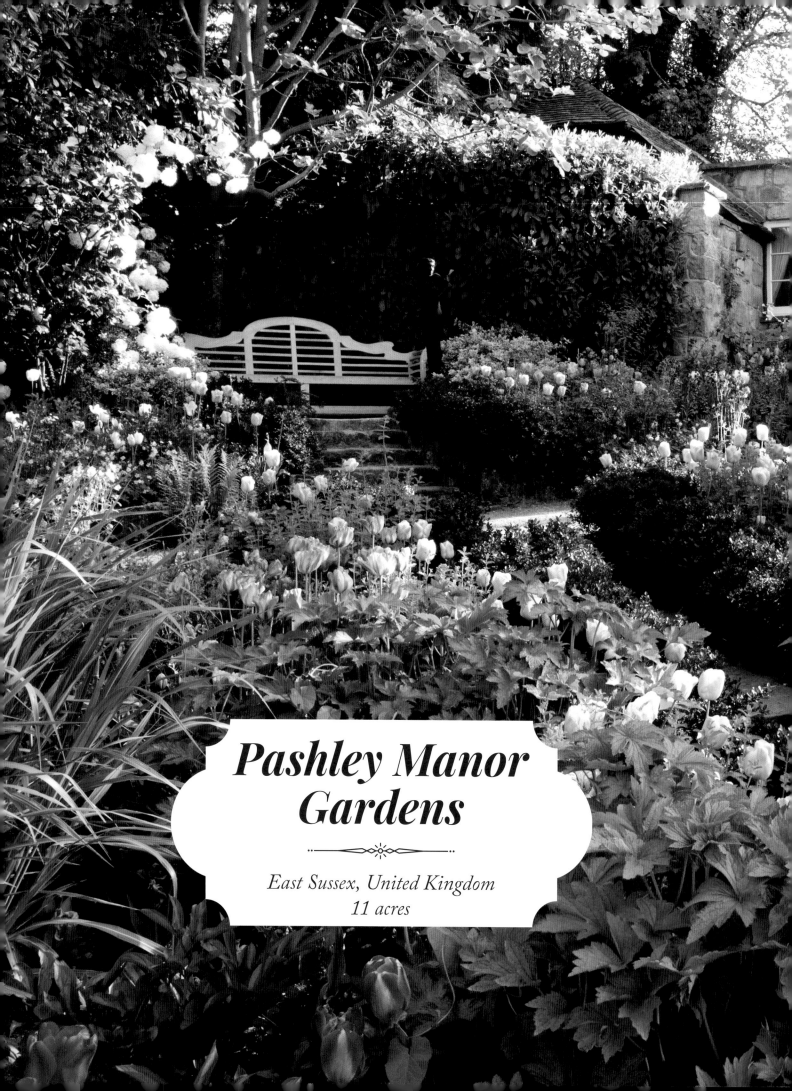

Pashley Manor Gardens

East Sussex, United Kingdom
11 acres

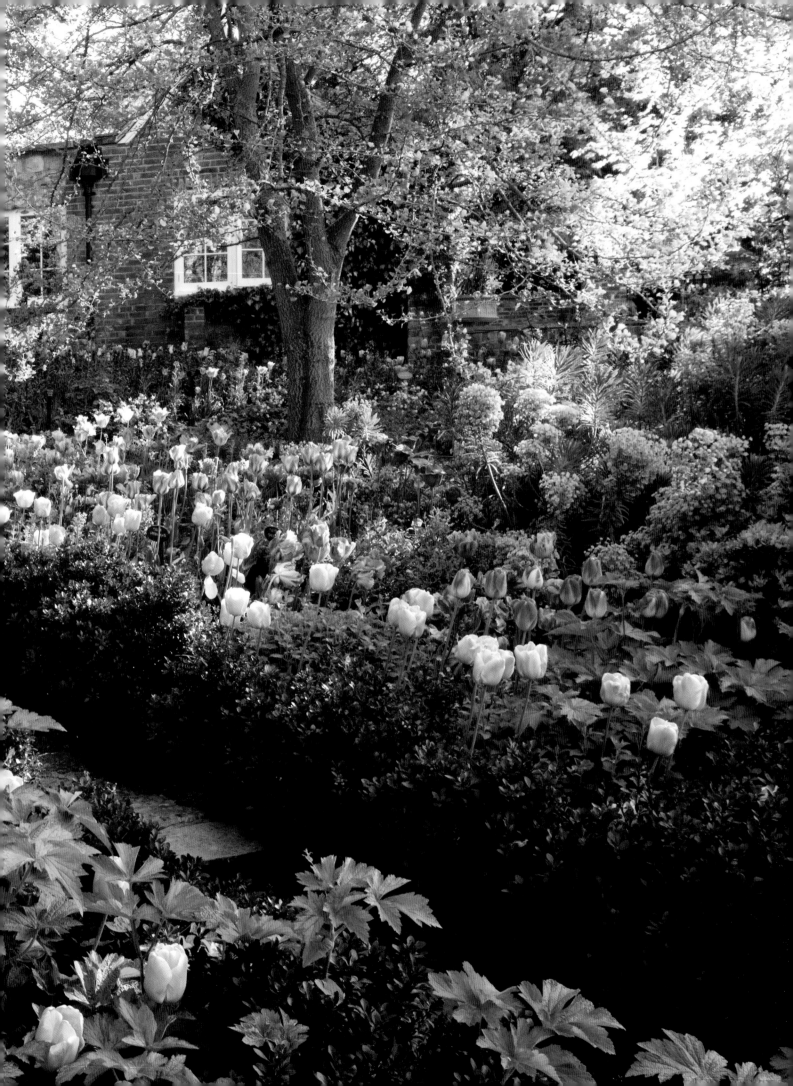

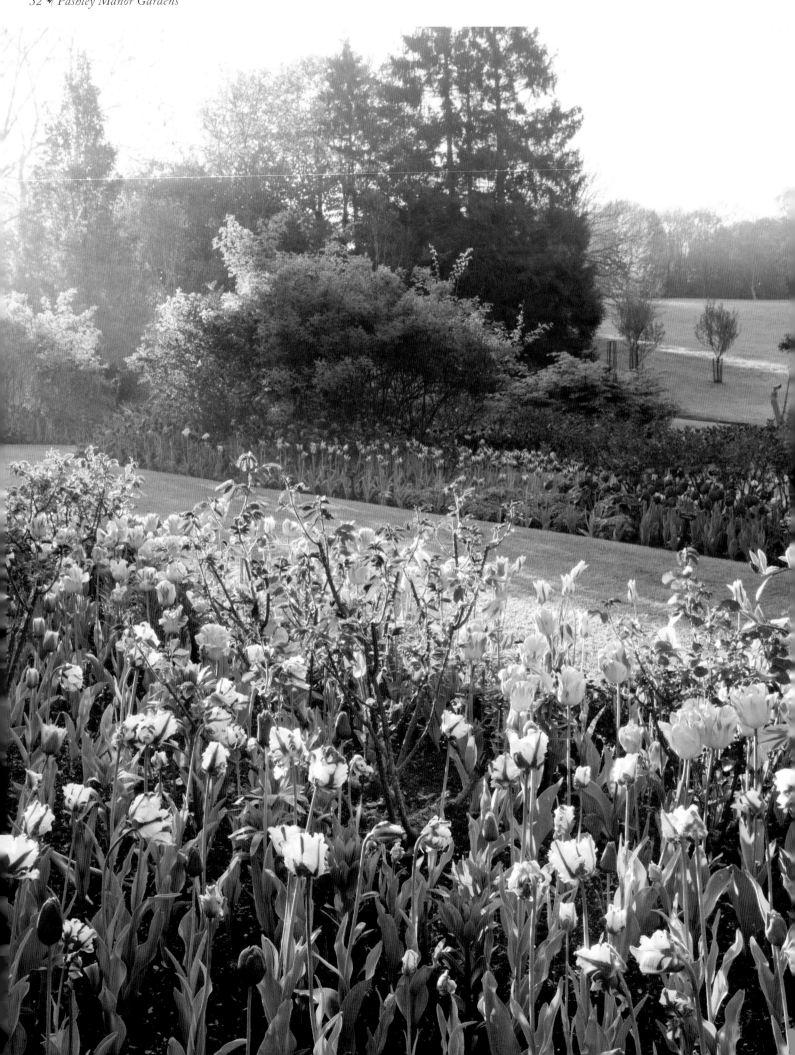

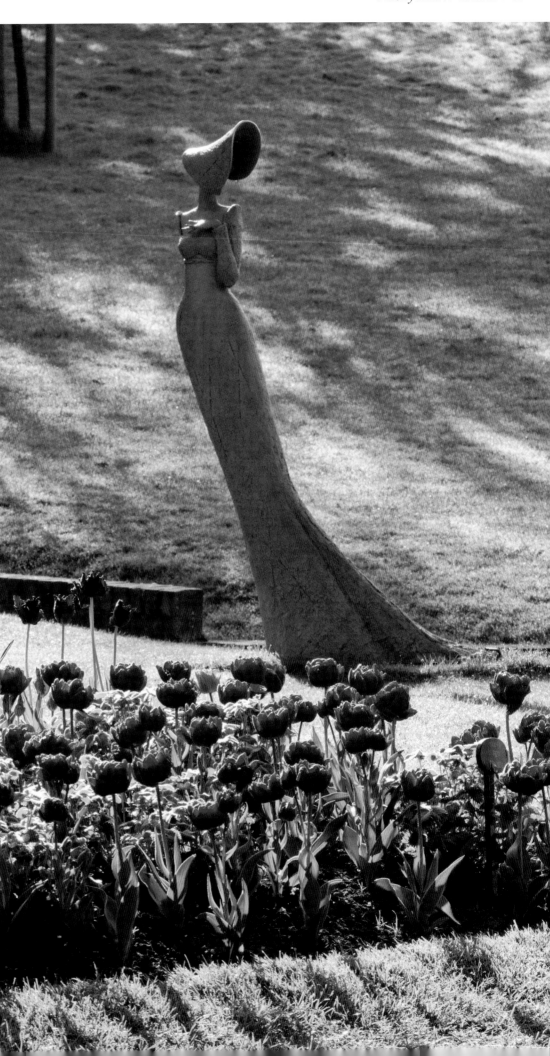

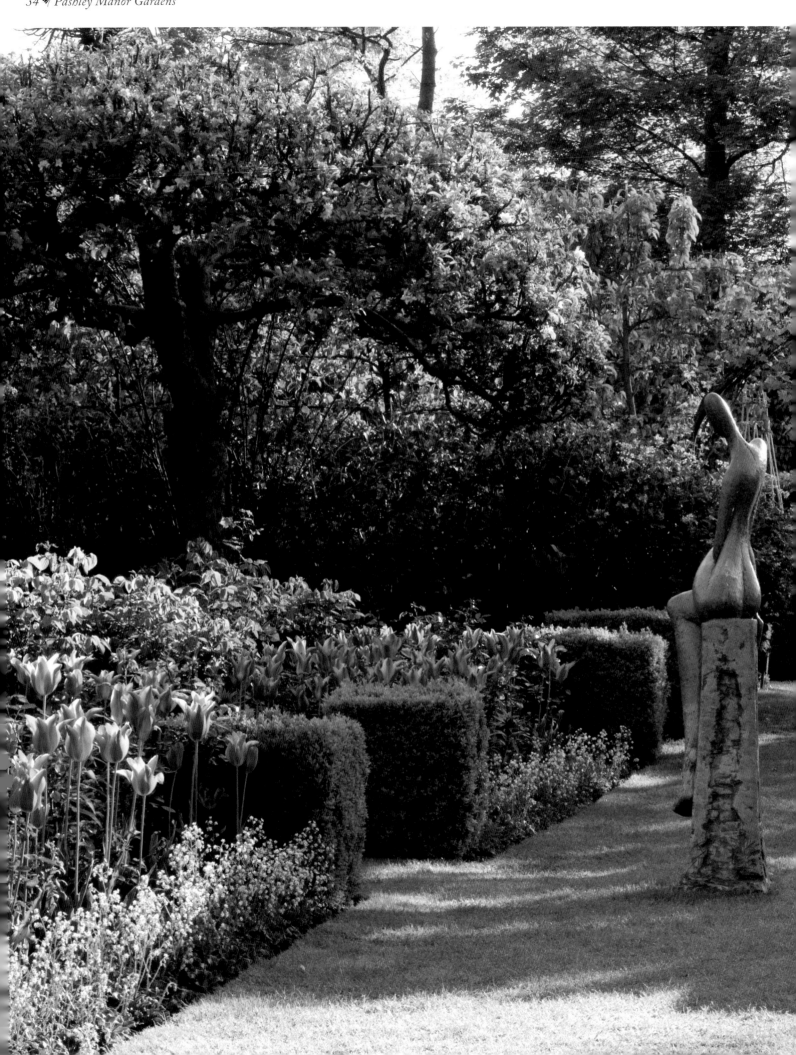

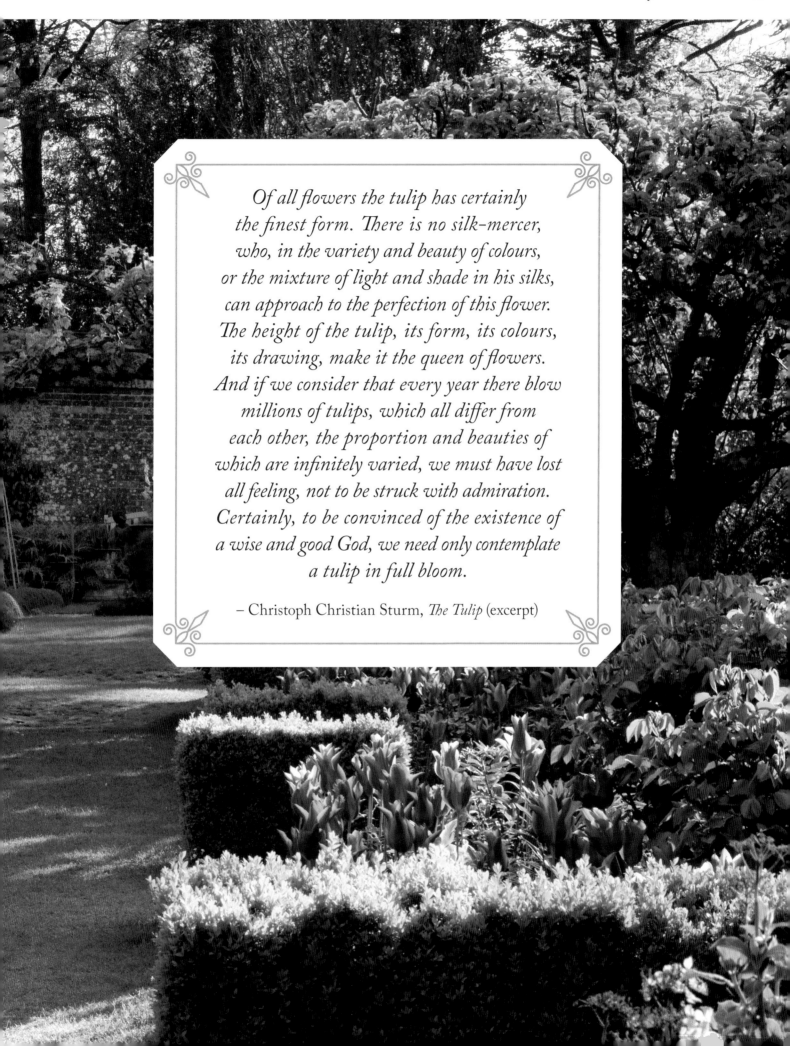

*Of all flowers the tulip has certainly
the finest form. There is no silk-mercer,
who, in the variety and beauty of colours,
or the mixture of light and shade in his silks,
can approach to the perfection of this flower.
The height of the tulip, its form, its colours,
its drawing, make it the queen of flowers.
And if we consider that every year there blow
millions of tulips, which all differ from
each other, the proportion and beauties of
which are infinitely varied, we must have lost
all feeling, not to be struck with admiration.
Certainly, to be convinced of the existence of
a wise and good God, we need only contemplate
a tulip in full bloom.*

– Christoph Christian Sturm, *The Tulip* (excerpt)

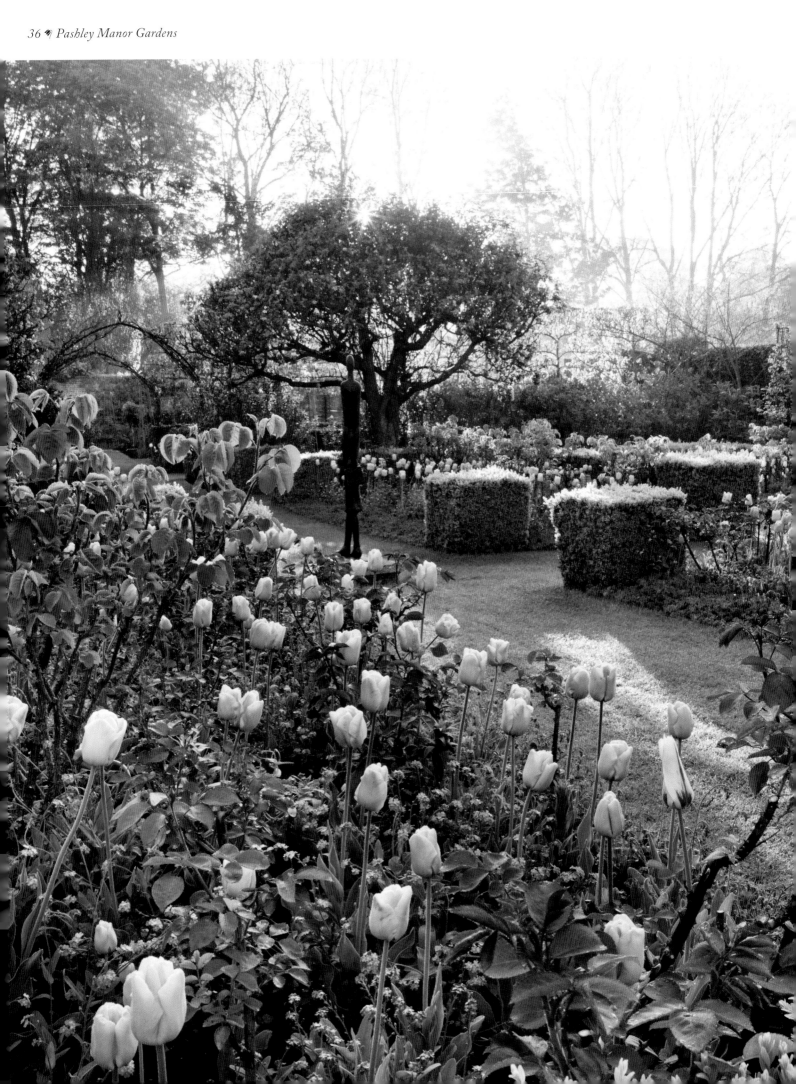

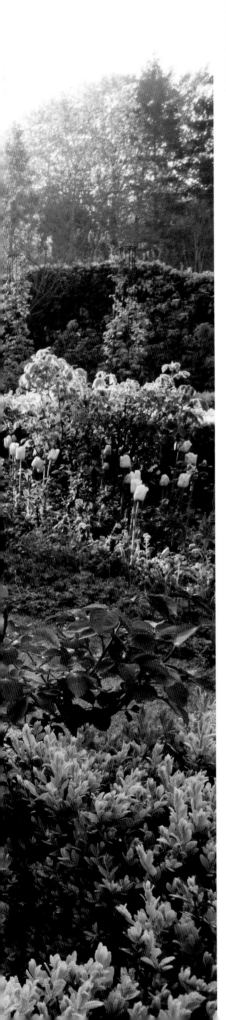

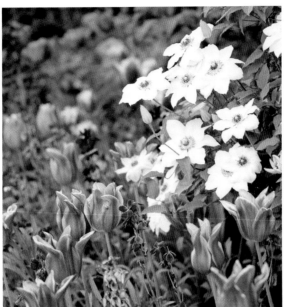

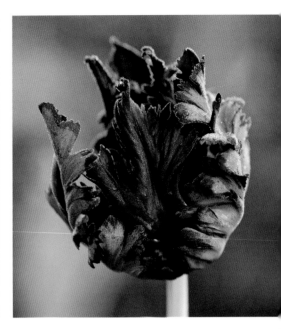

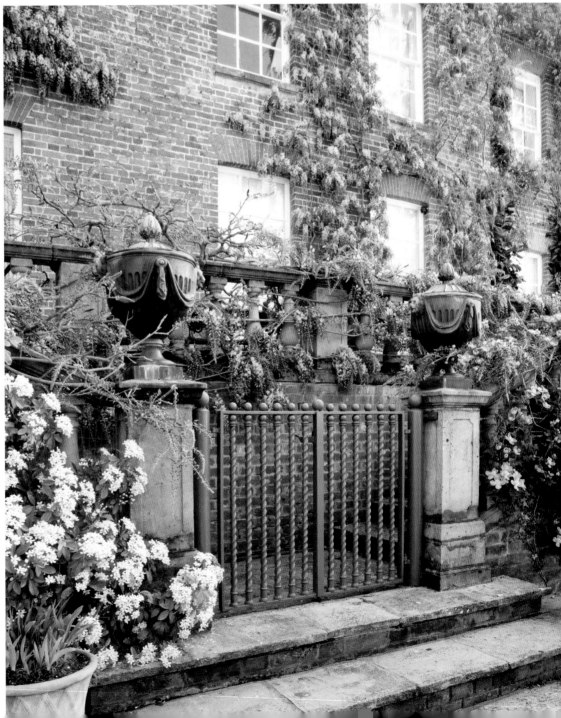

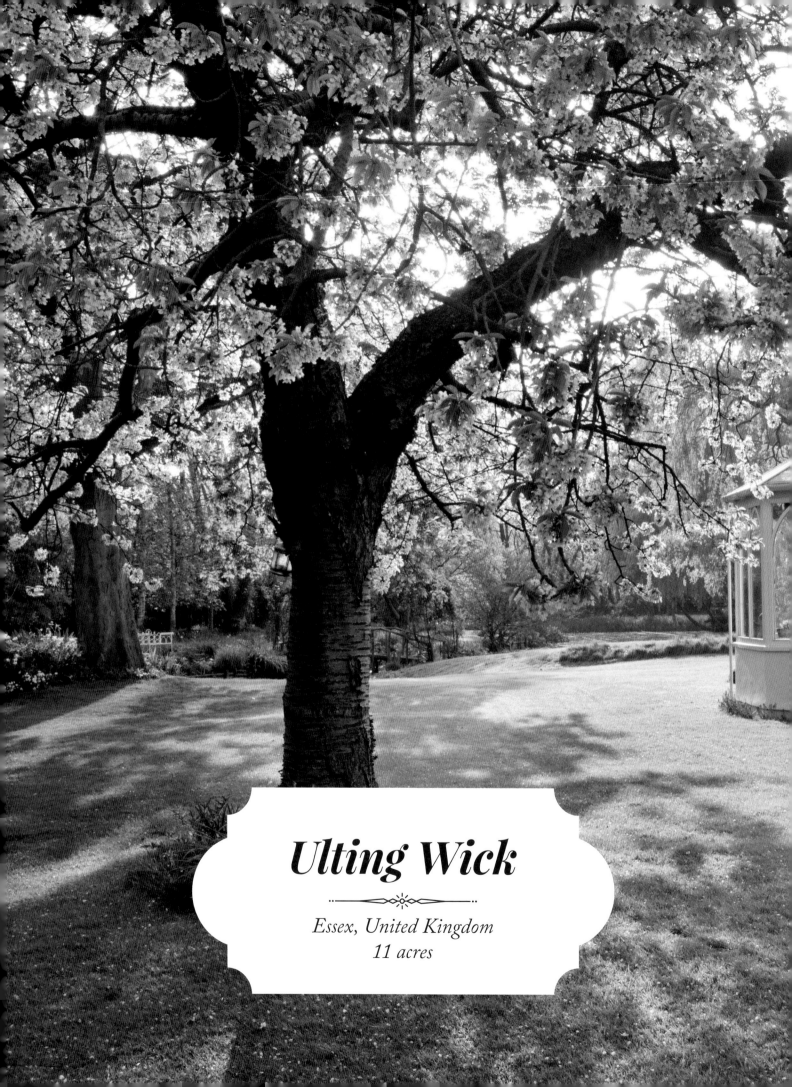

Ulting Wick

·····◆·····

Essex, United Kingdom
11 acres

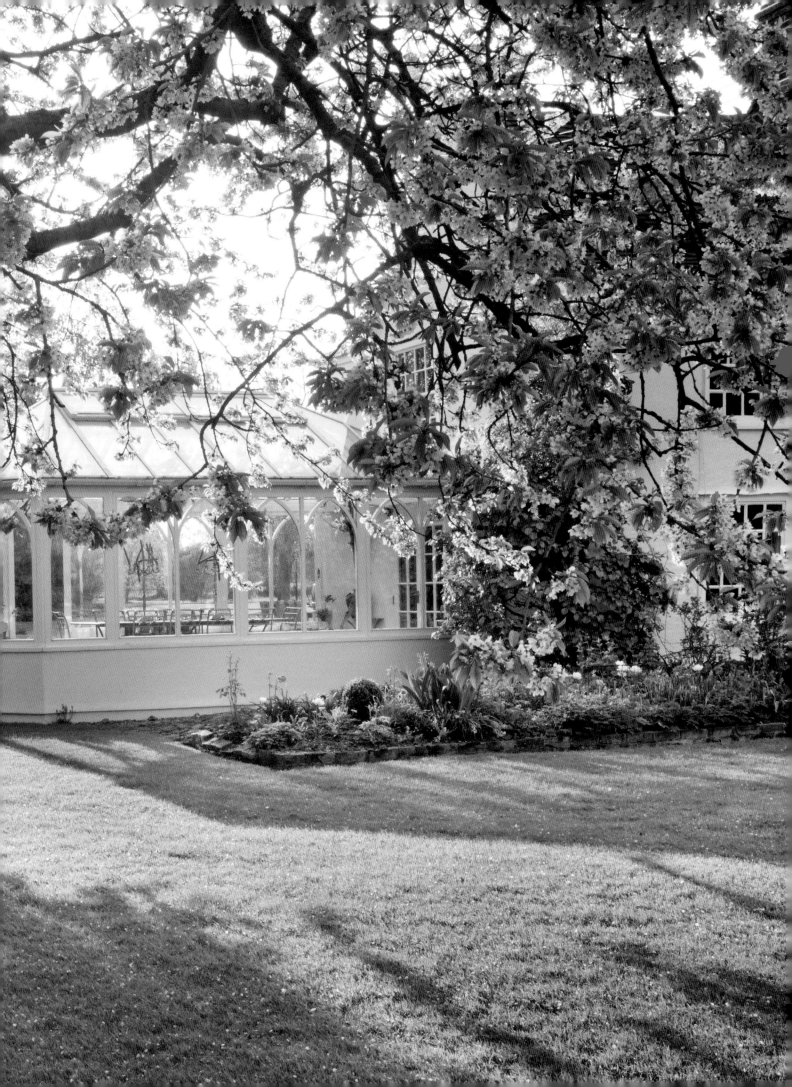

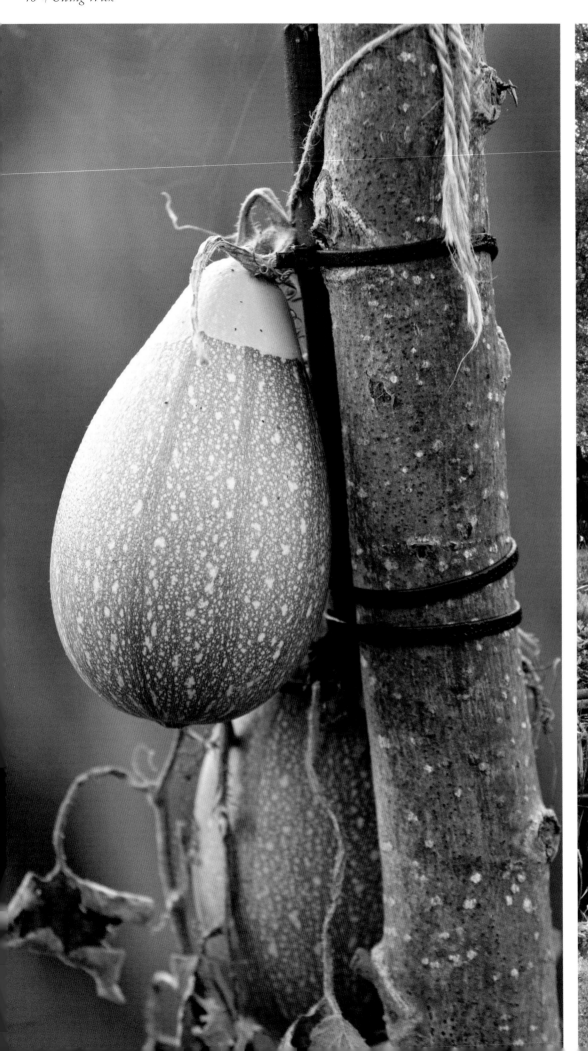

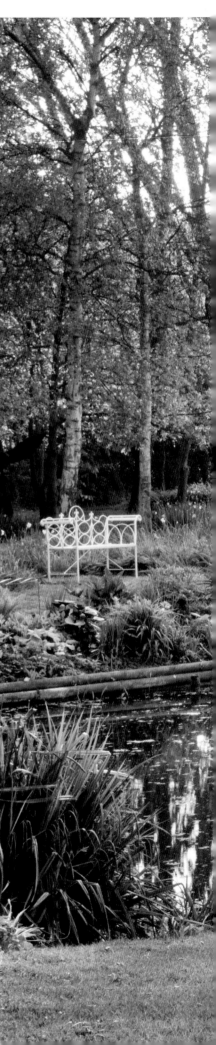

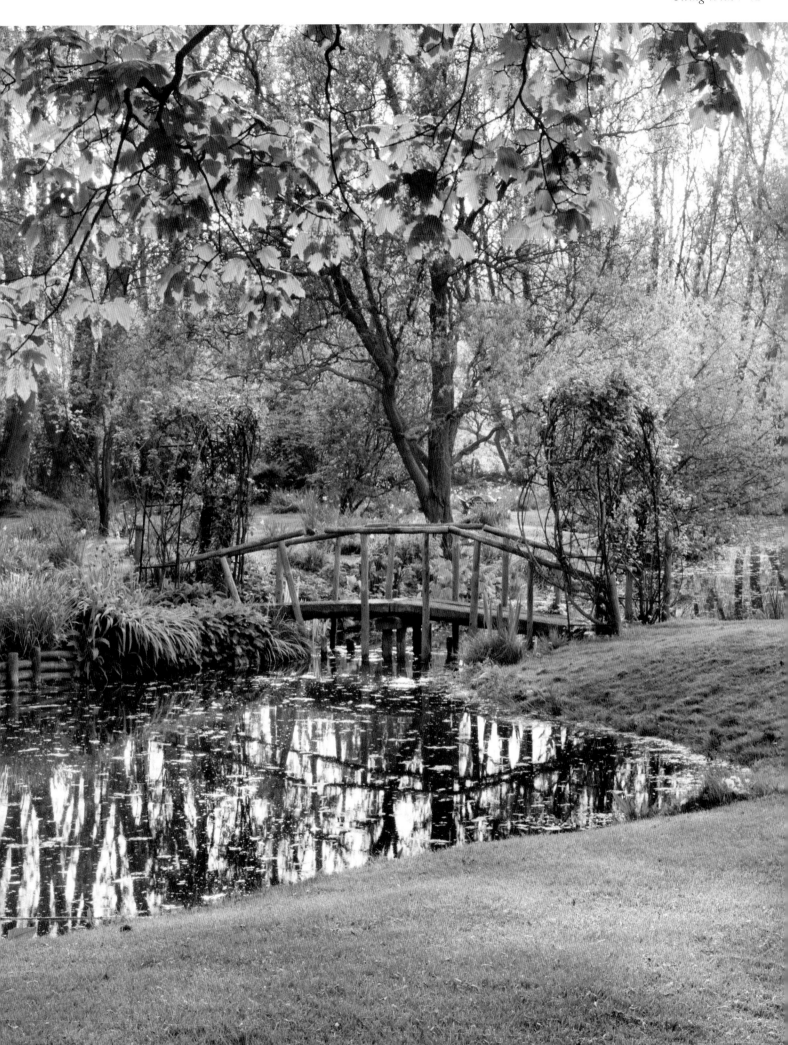

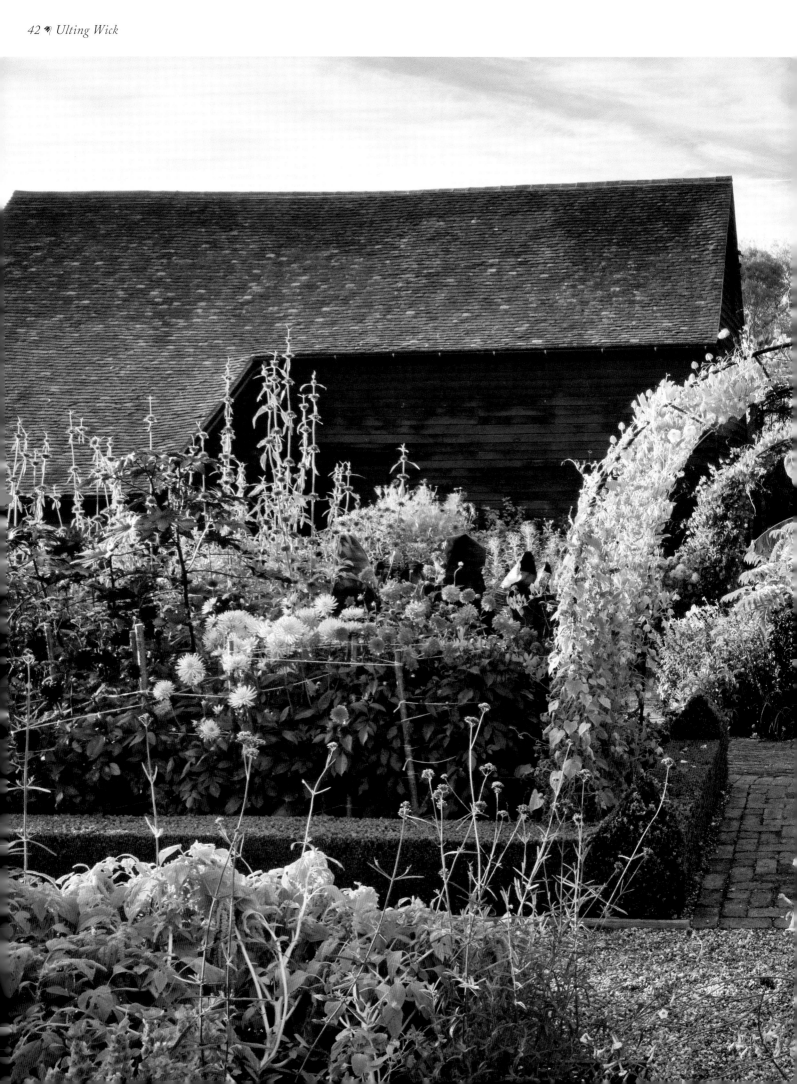

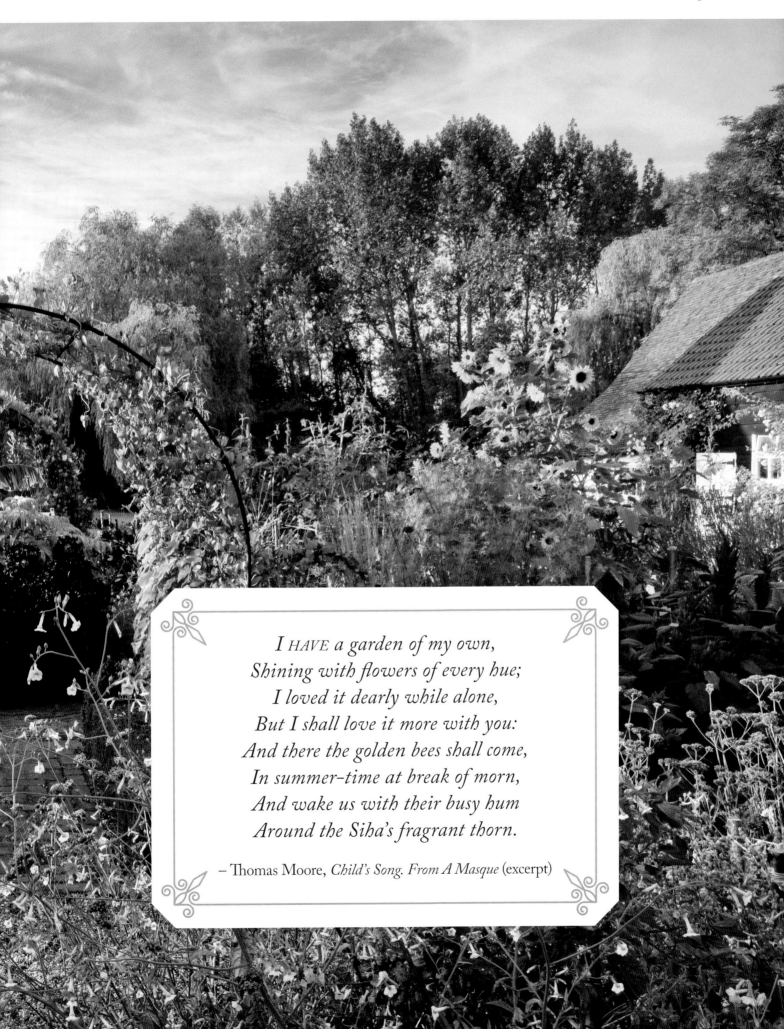

I HAVE *a garden of my own,*
Shining with flowers of every hue;
I loved it dearly while alone,
But I shall love it more with you:
And there the golden bees shall come,
In summer-time at break of morn,
And wake us with their busy hum
Around the Siha's fragrant thorn.

– Thomas Moore, *Child's Song. From A Masque* (excerpt)

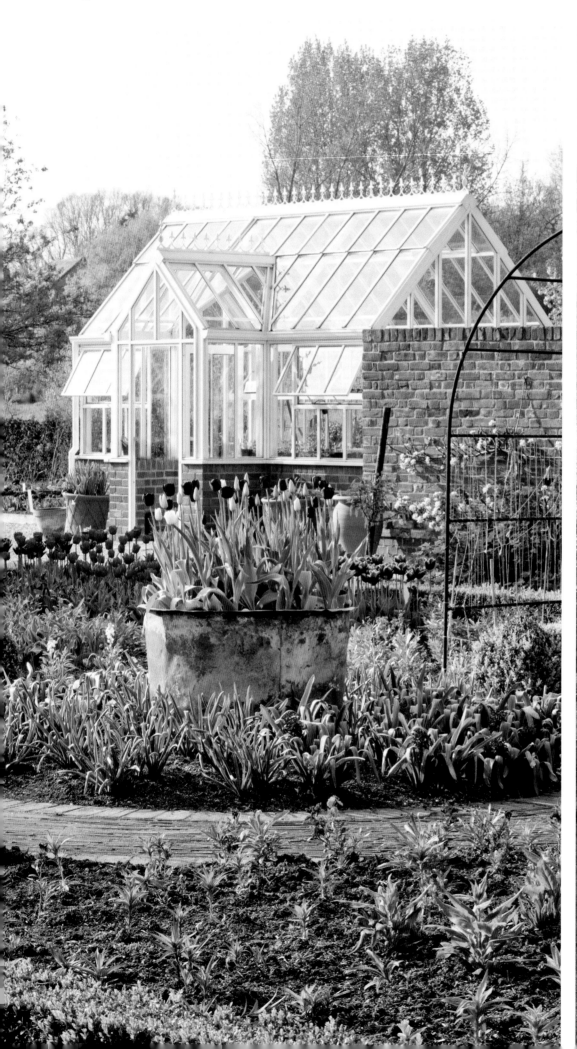
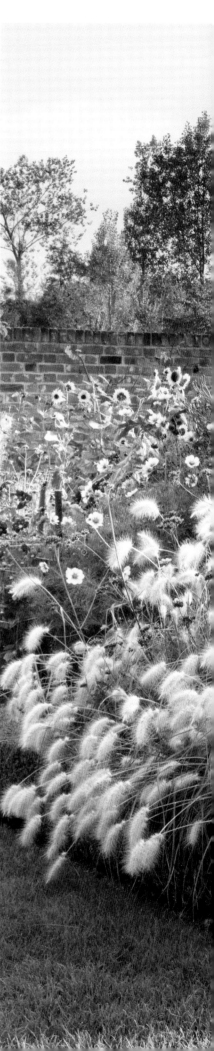

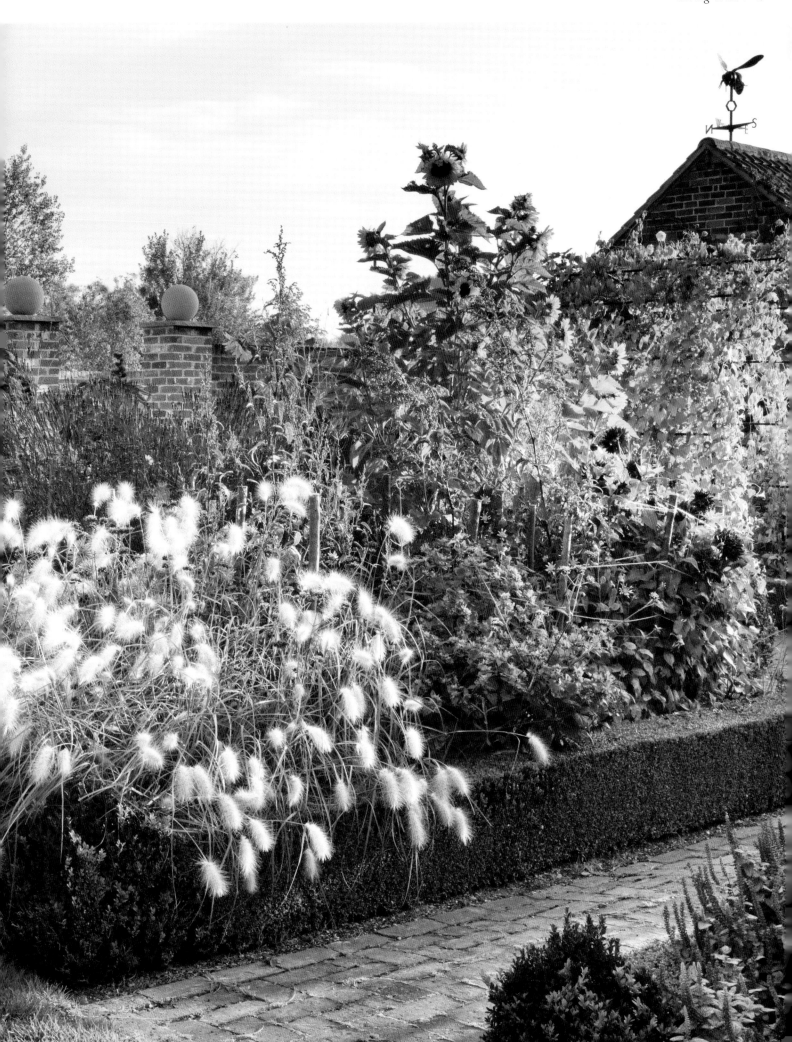

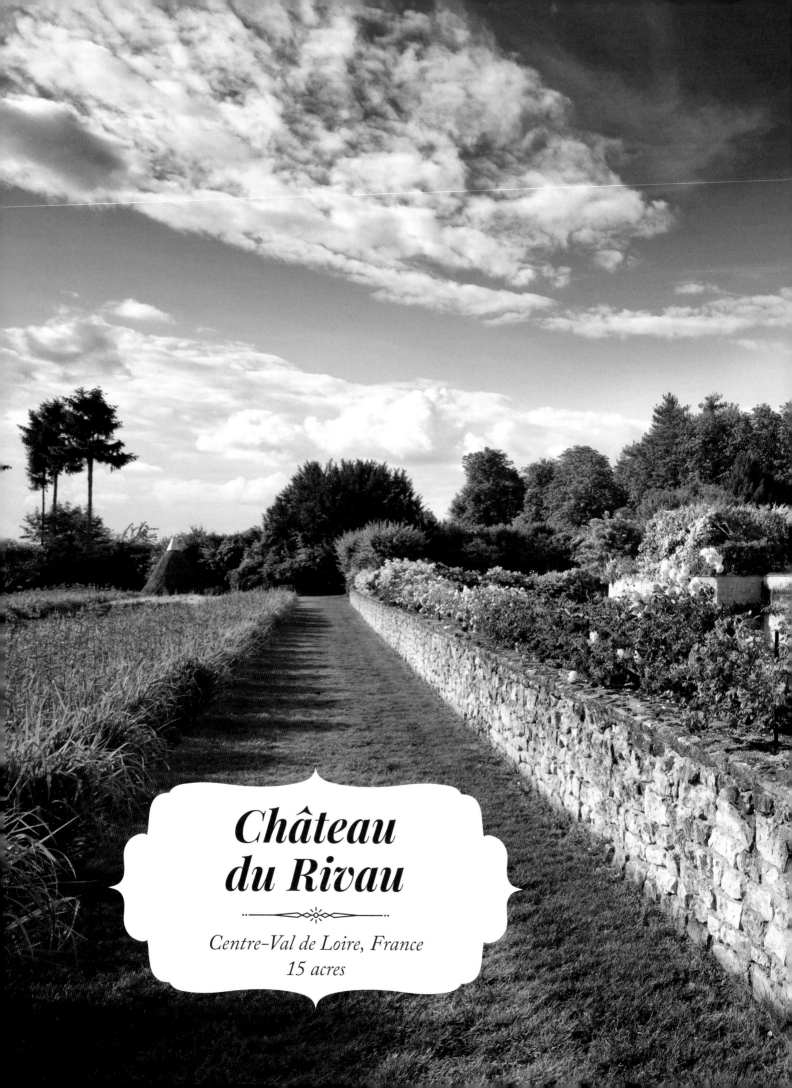

Château du Rivau

Centre–Val de Loire, France
15 acres

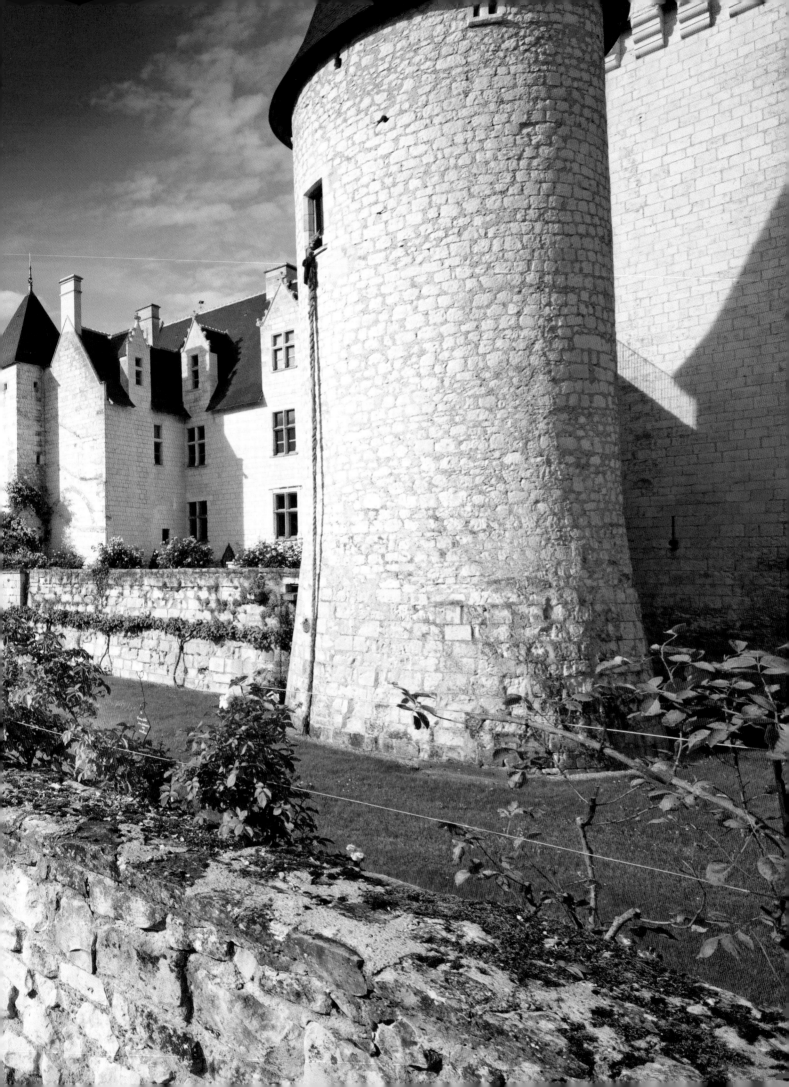

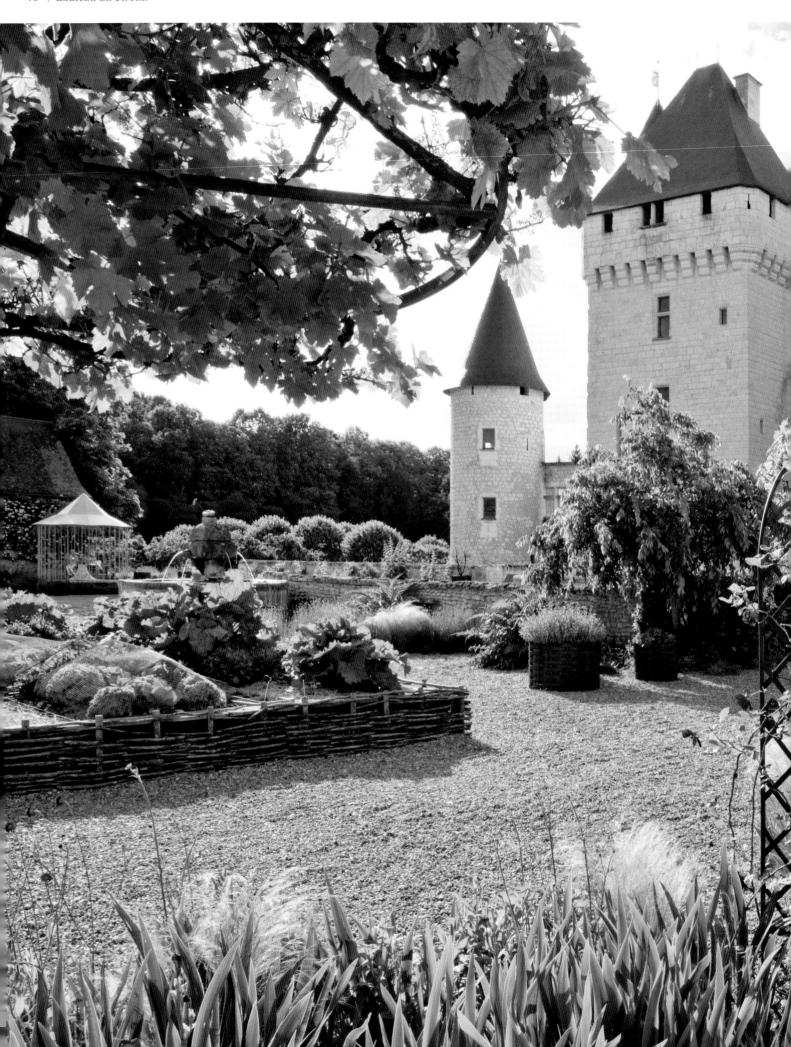

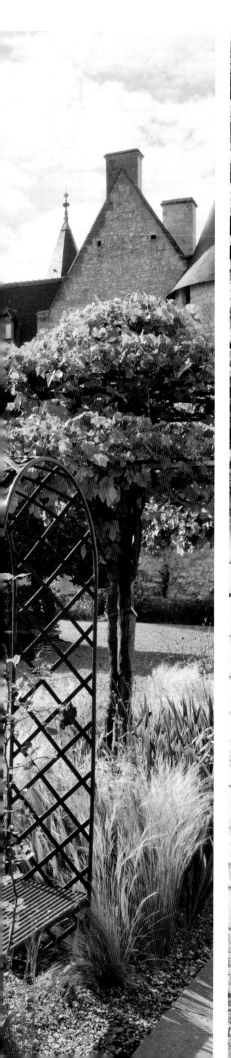

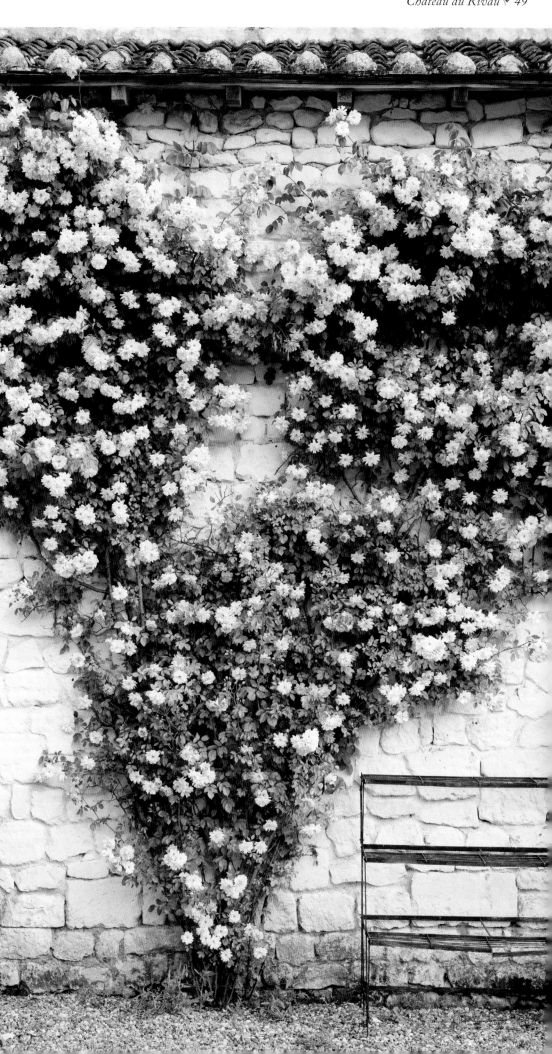

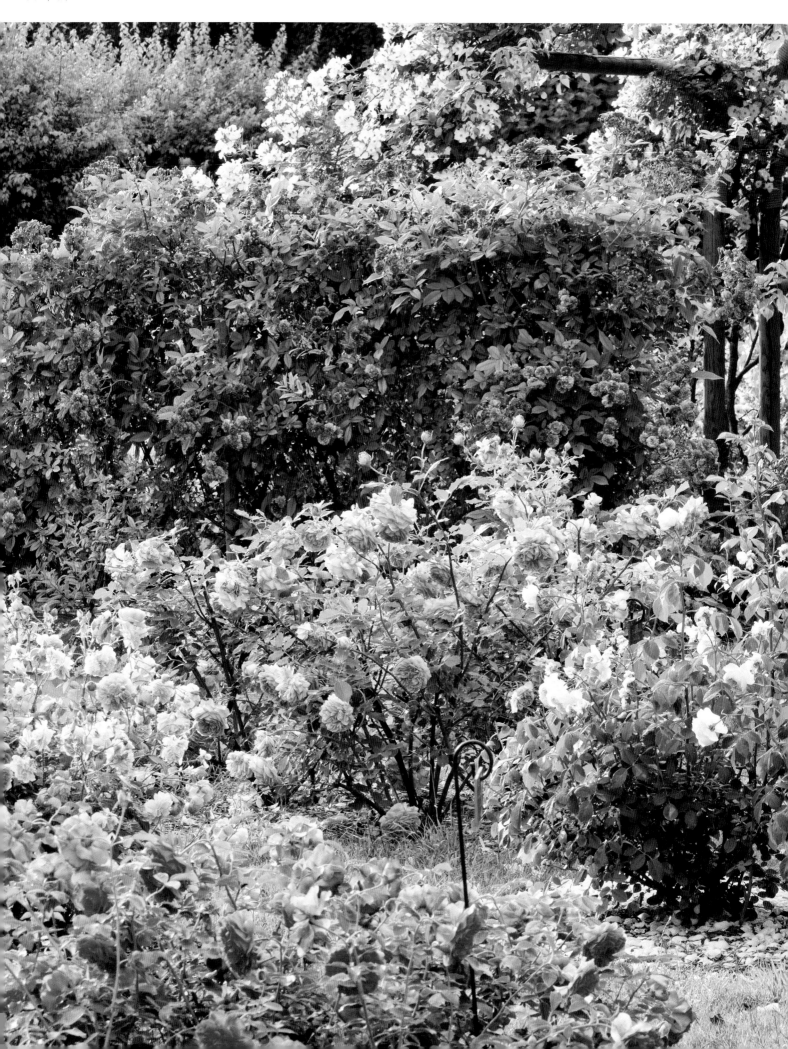

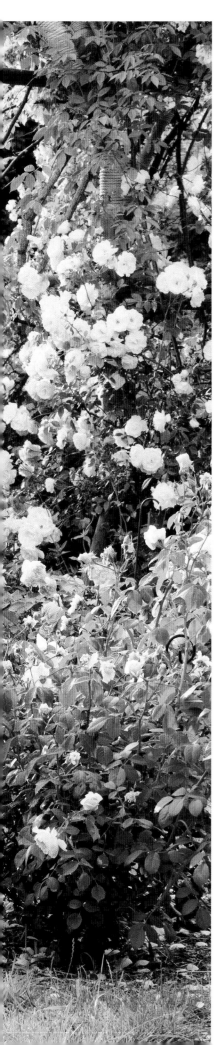

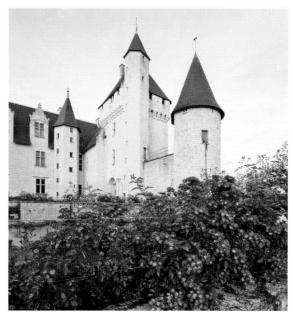

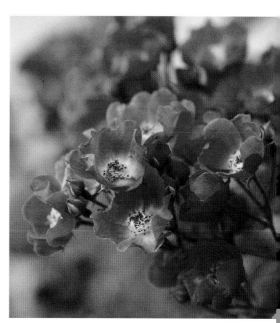

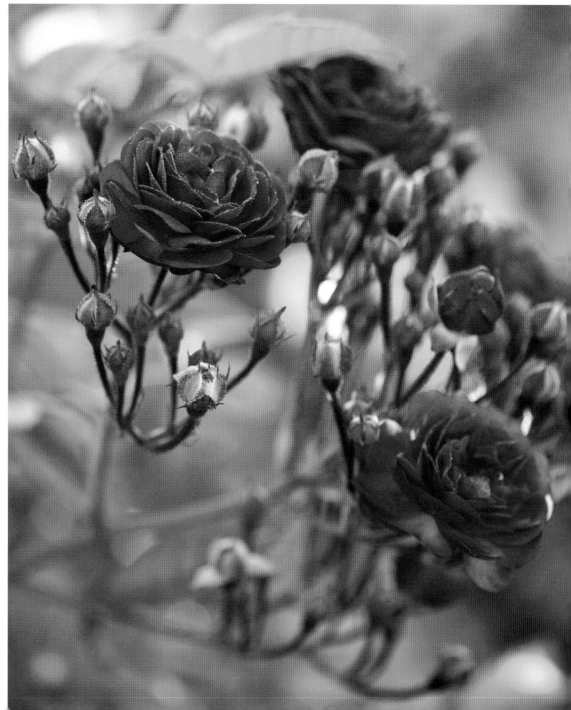

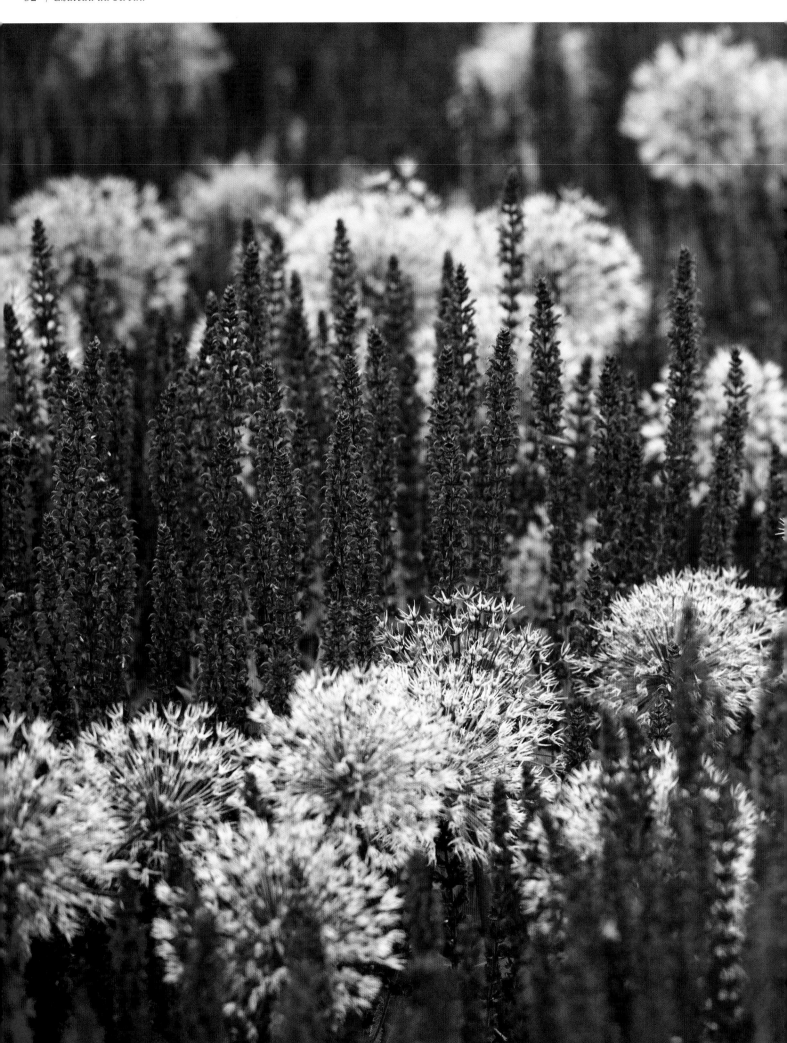

This time she came upon a large flowerbed, with a border of daisies, and a willow-tree growing in the middle.

"O Tiger-lily," said Alice, addressing herself to one that was waving gracefully about in the wind, "I wish you could talk!"

"We *can* talk," said the Tiger-lily, "when there's anybody worth talking to."

Alice was so astonished that she couldn't speak for a minute: it quite seemed to take her breath away. At length, as the Tiger-lily only went on waving about, she spoke again, in a timid voice—almost in a whisper.

"And can *all* the flowers talk?"

"As well as *you* can," said the Tiger-lily. "And a great deal louder."

"It isn't manners for us to begin, you know," said the Rose, "and I really was wondering when you'd speak! Said I to myself, 'Her face has got *some* sense in it, though it's not a clever one!' Still, you're the right colour, and that goes a long way."

"I don't care about the colour," the Tiger-lily remarked. "If only her petals curled up a little more, she'd be all right."

Alice didn't like being criticised, so she began asking questions. "Aren't you sometimes frightened at being planted out here, with nobody to take care of you?"

"There's the tree in the middle," said the Rose. "What else is it good for?"

"But what could it do, if any danger came?" Alice asked.

"It could bark," said the Rose.

"It says 'Bough-wough!'" cried a Daisy. "That's why its branches are called boughs!"

"Didn't you know *that?*" cried another Daisy, and here they all began shouting together, till the air seemed quite full of little shrill voices.

"Silence, every one of you!" cried the Tiger-lily, waving itself passionately from side to side, and trembling with excitement. "They know I can't get at them!" it panted, bending its quivering head towards Alice, "or they wouldn't dare to do it!"

"Never mind!" Alice said in a soothing tone, and stooping down to the daisies, who were just beginning again, she whispered, "If you don't hold your tongues, I'll pick you!" There was silence in a moment, and several of the pink daisies turned white.

"That's right!" said the Tiger-lily. "The daisies are worst of all. When one speaks, they all begin together, and it's enough to make one wither to hear the way they go on!"

"How is it you can all talk so nicely?" Alice said, hoping to get it into a better temper by a compliment. "I've been in many gardens before, but none of the flowers could talk."

"Put your hand down, and feel the ground," said the Tiger-lily. "Then you'll know why."

Alice did so. "It's very hard," she said, "but I don't see what that has to do with it."

"In most gardens," the Tiger-lily said, "they make the beds too soft—so that the flowers are always asleep."

This sounded a very good reason, and Alice was quite pleased to know it. "I never thought of that before!" she said.

"It's *my* opinion that you never think *at all*," the Rose said in a rather severe tone.

– Lewis Carroll, *The Garden of Live Flowers* (excerpt)

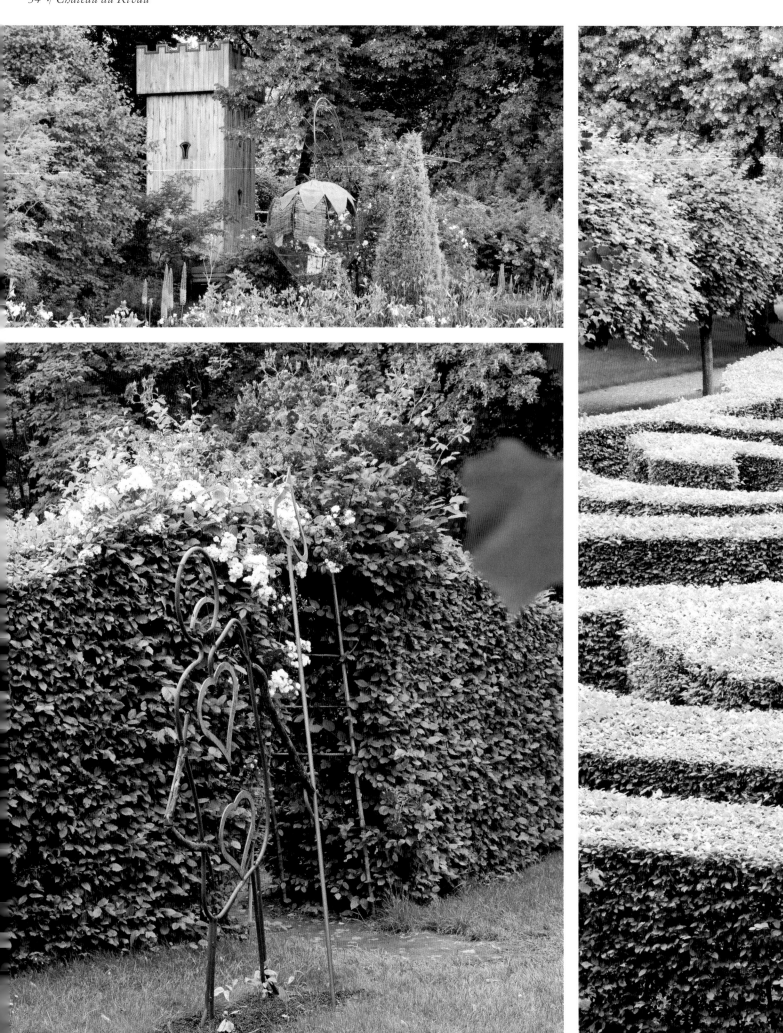

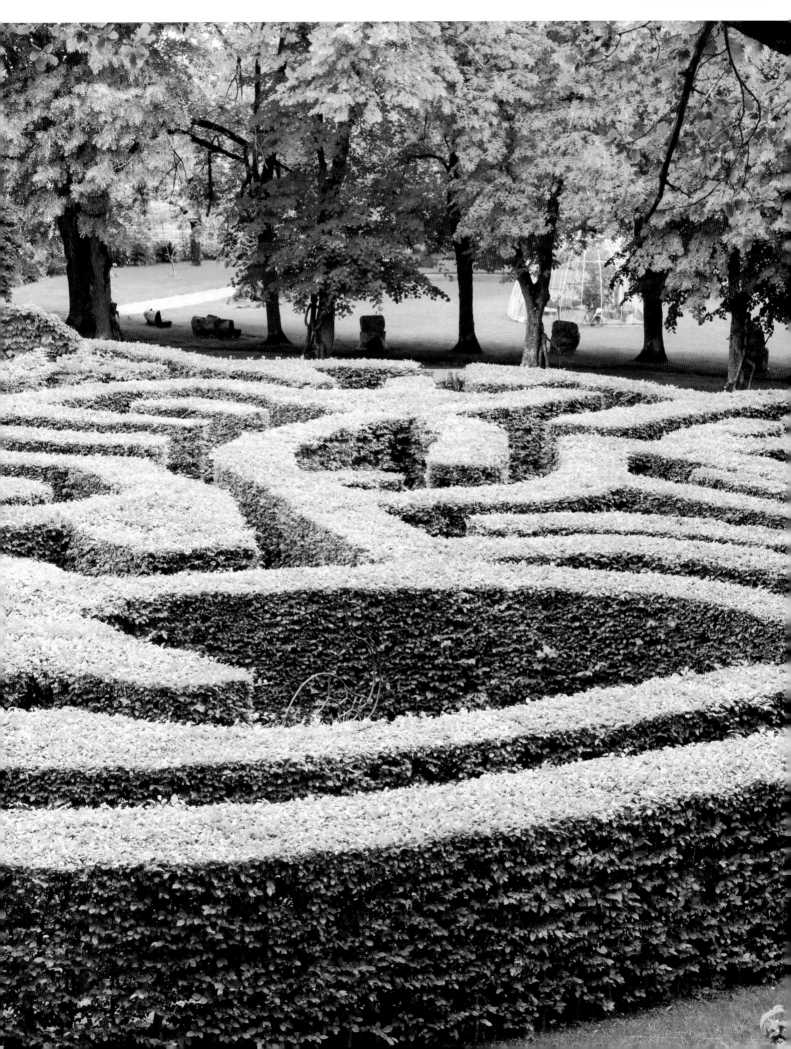

Grange Court

· · ·◦───◆───◦· · ·

Guernsey, United Kingdom
2 acres

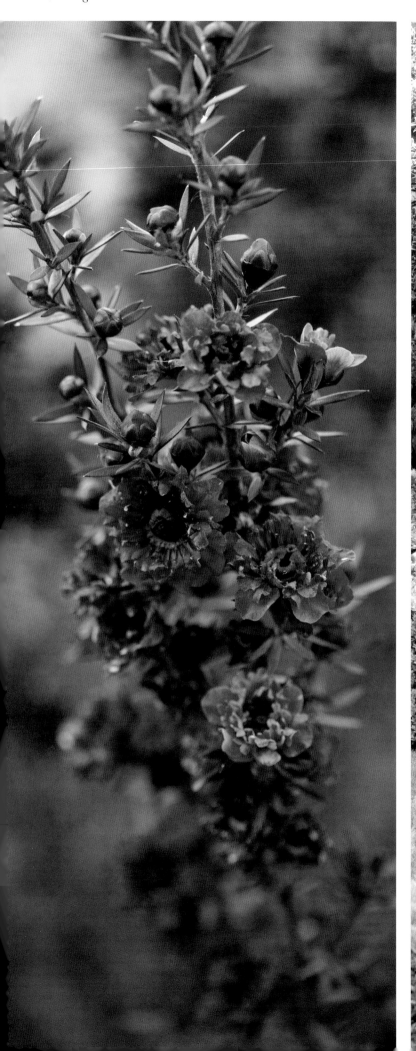

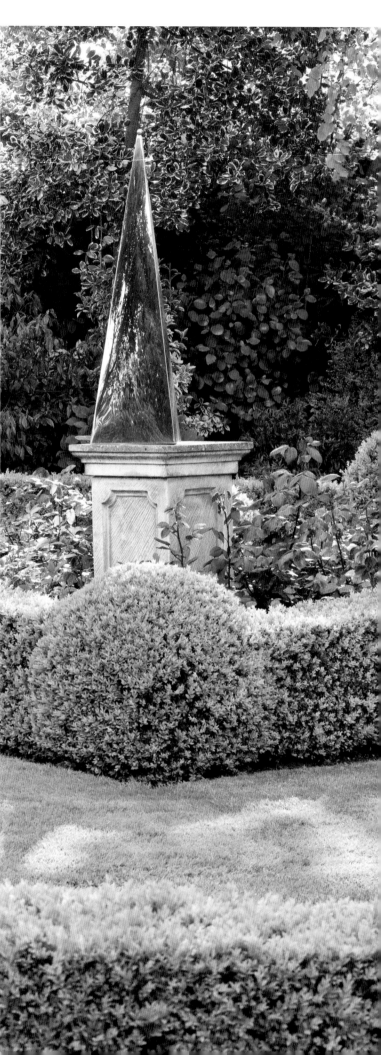

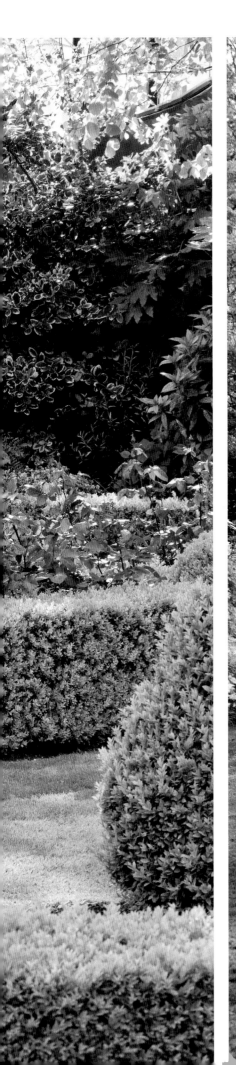

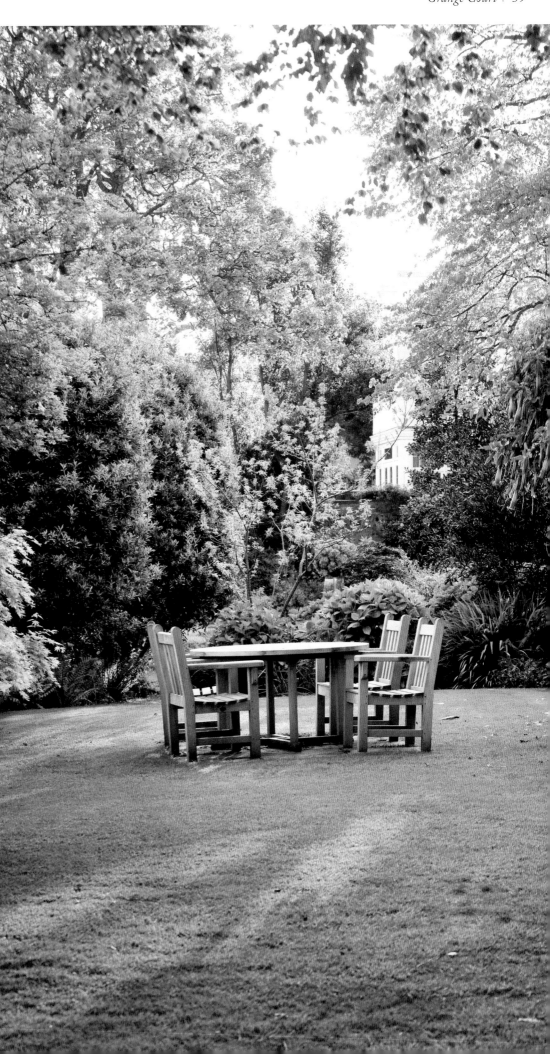

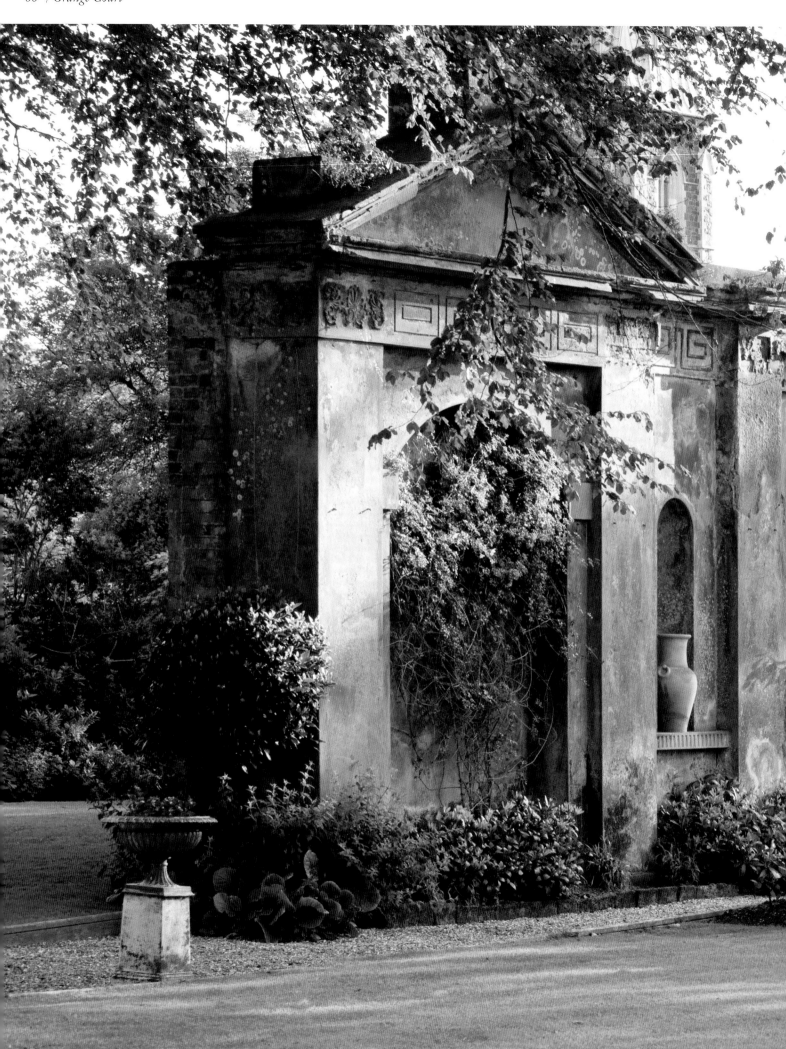

That was picturesque and nice, for several
handsome beech trees grew in the garden,
and the church showed over their tops;
the contrast between the old stones, and
the fresh green leaves, being lovely.
There were three trees there that I
especially remember. A tall elegant beech,
and close beside it a copper beech.
"Do you mean the tree I mean?"
"Yes, grandmamma," replied Caroline,
"it is a kind of brownish-purple colour,
with the same shaped leaves as a green beech."
"Yes, and in front of this copper beech was
a laburnum, so in spring the long golden
blossoms of the laburnum seemed to lay over
the dark purple tree; then behind that
the delicate green of the other beech, and
behind that again the hoary old church (…)."

– Emma Anne G. Davenport, *Grandmamma* (excerpt)

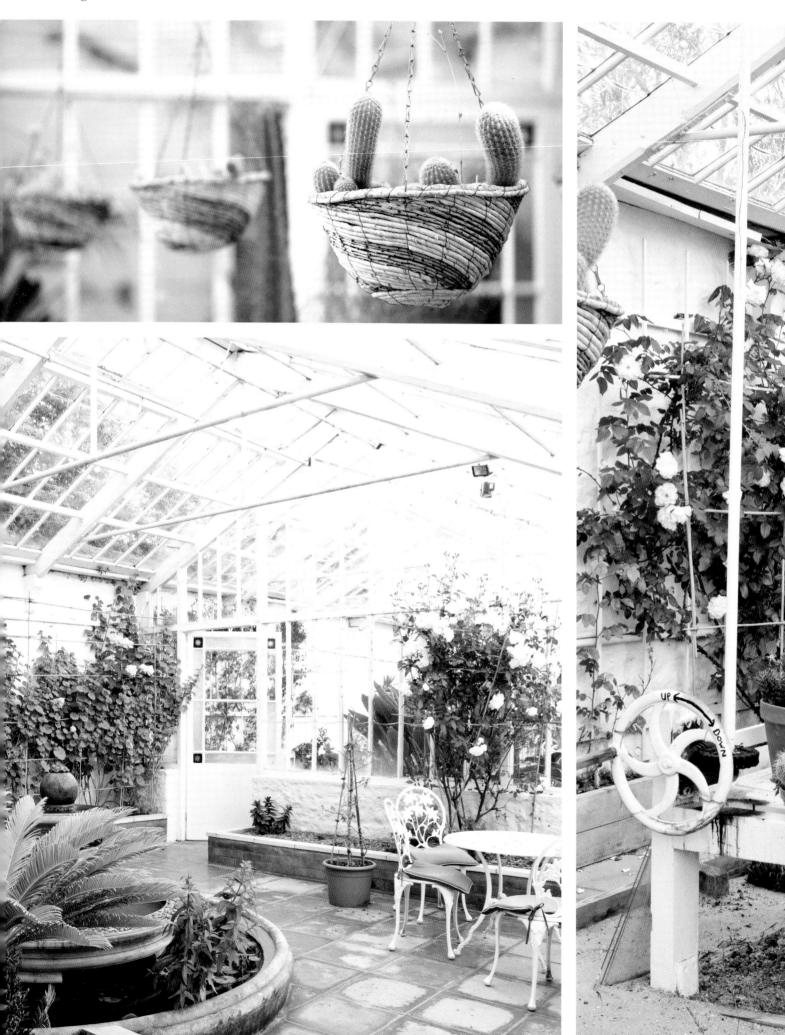

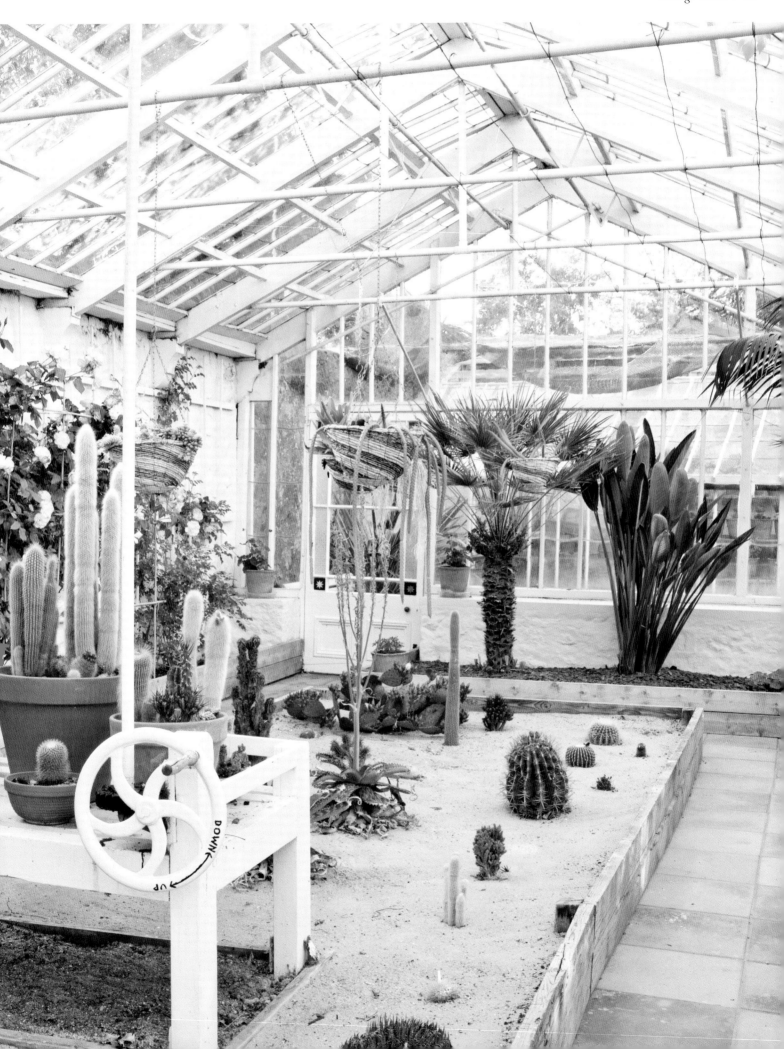

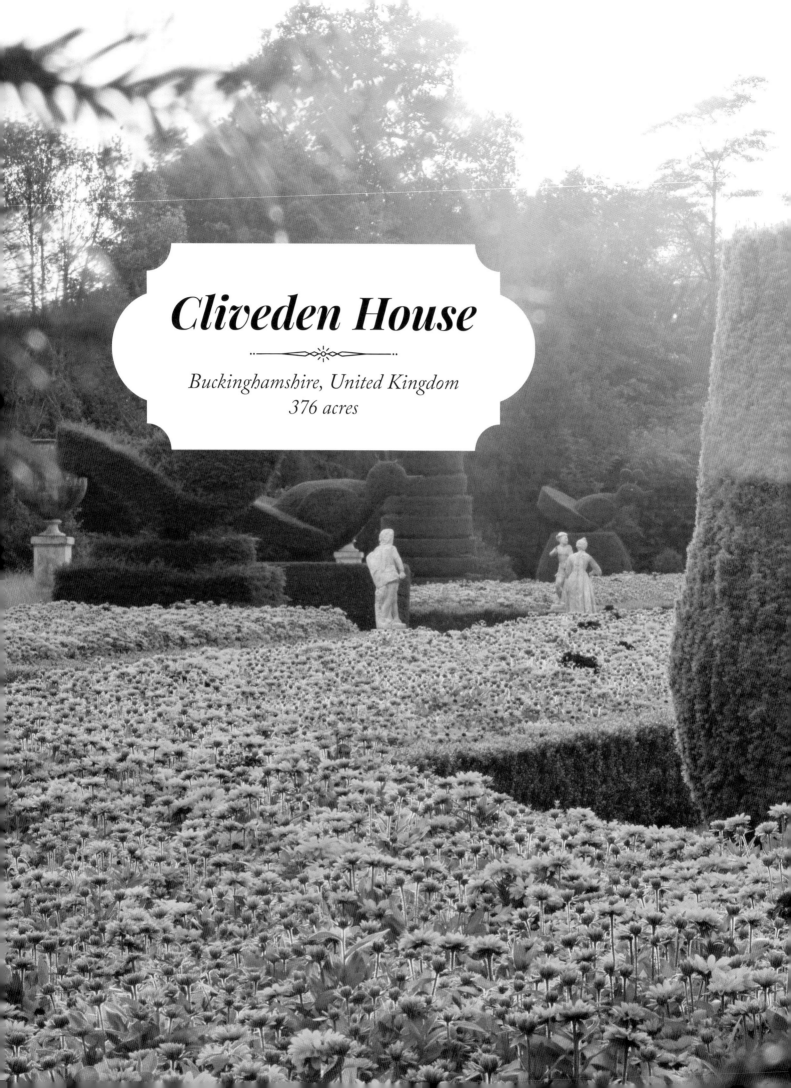

Cliveden House

Buckinghamshire, United Kingdom
376 acres

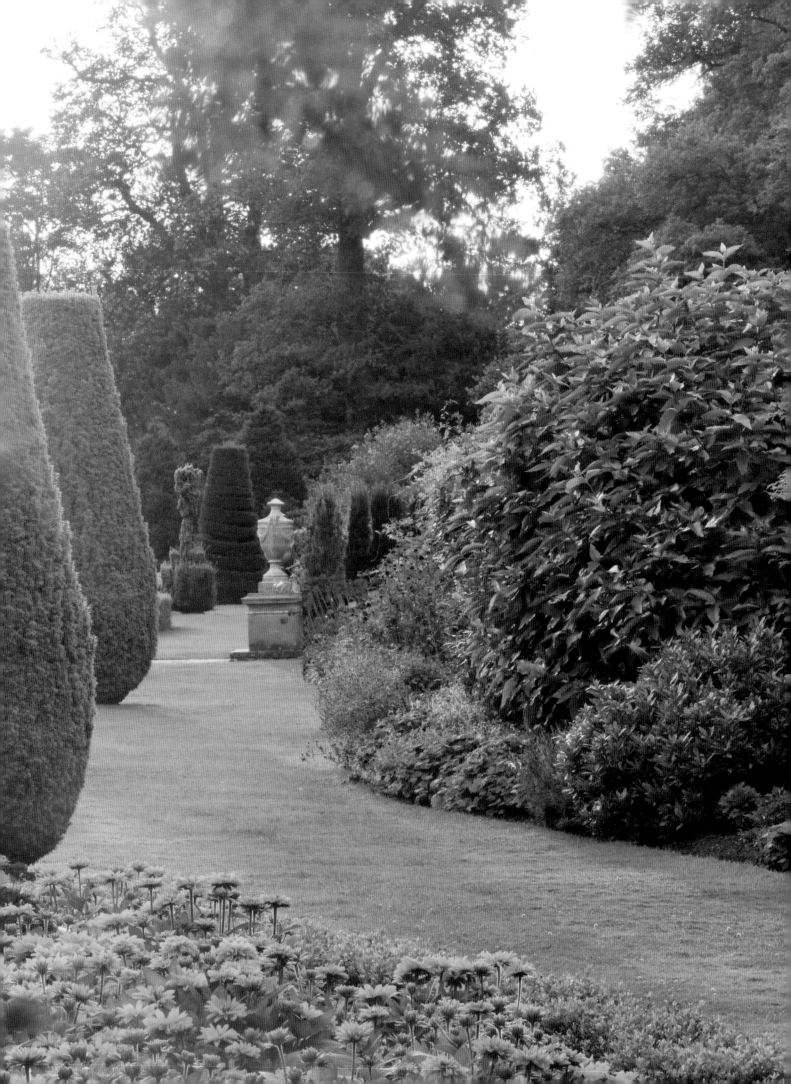

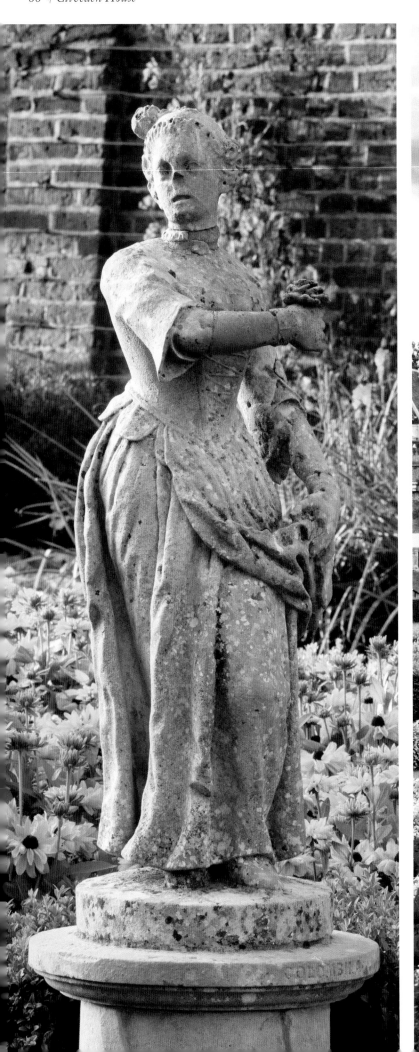

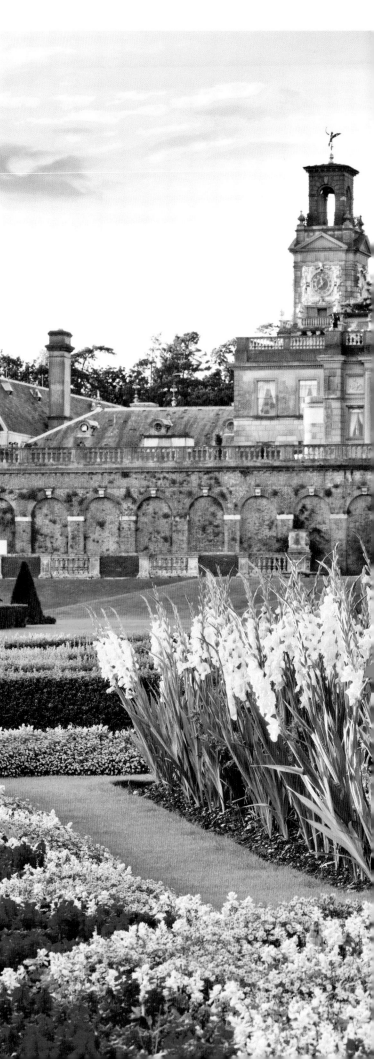

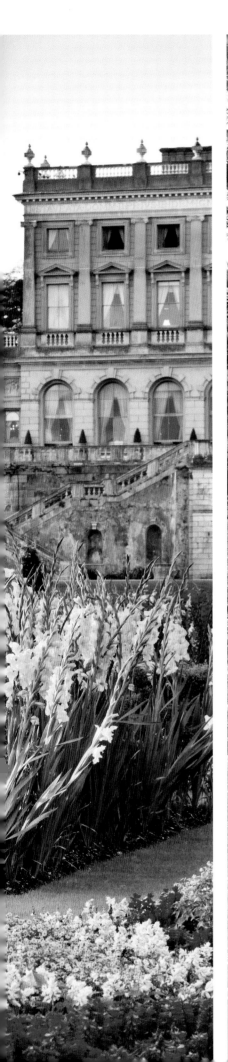

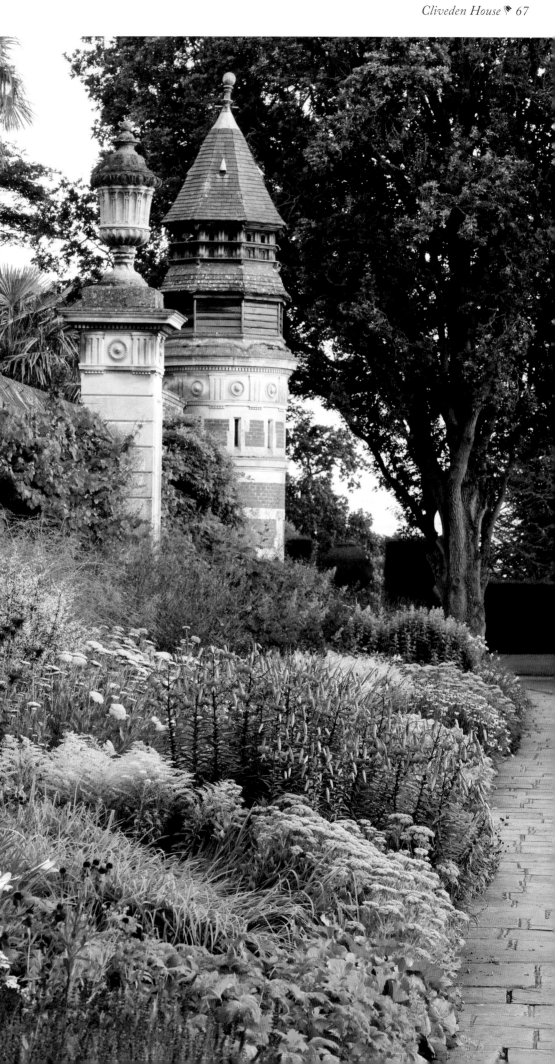

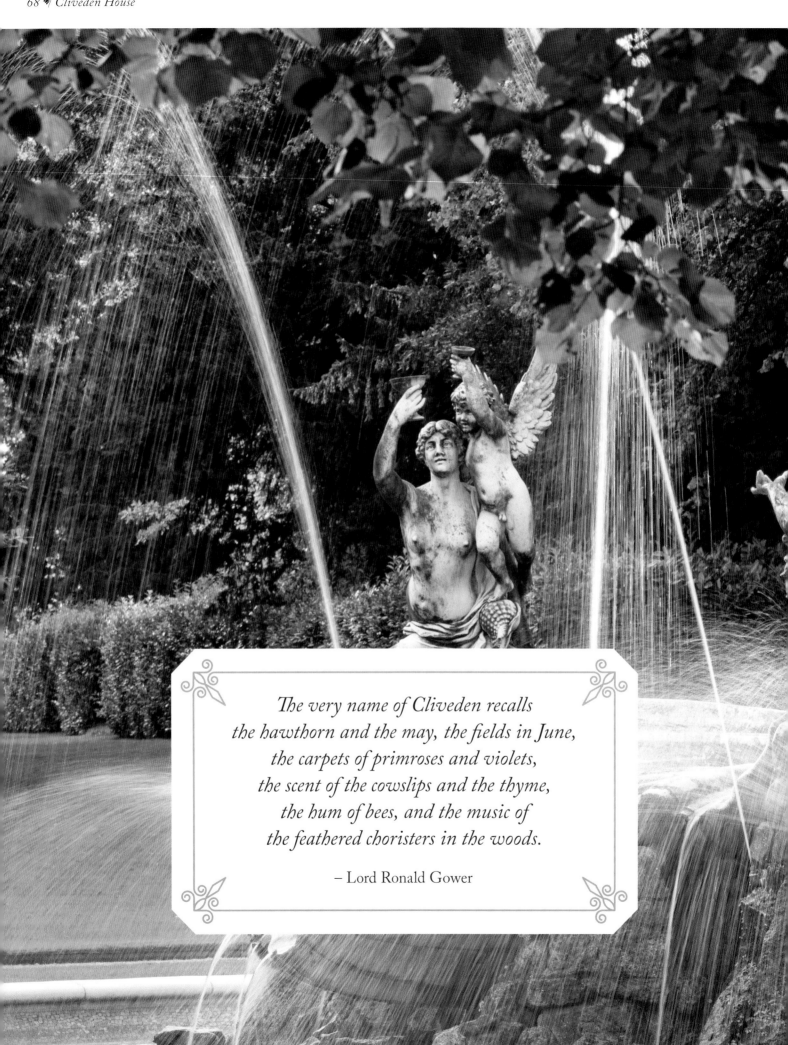

The very name of Cliveden recalls
the hawthorn and the may, the fields in June,
the carpets of primroses and violets,
the scent of the cowslips and the thyme,
the hum of bees, and the music of
the feathered choristers in the woods.

– Lord Ronald Gower

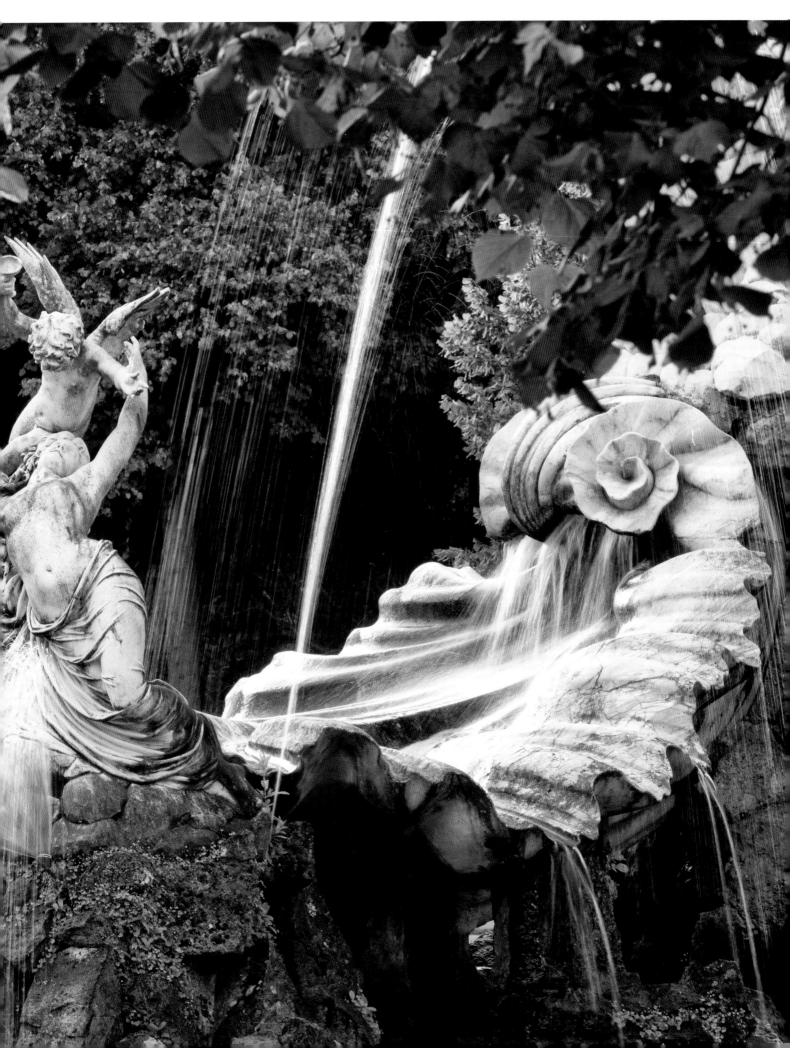

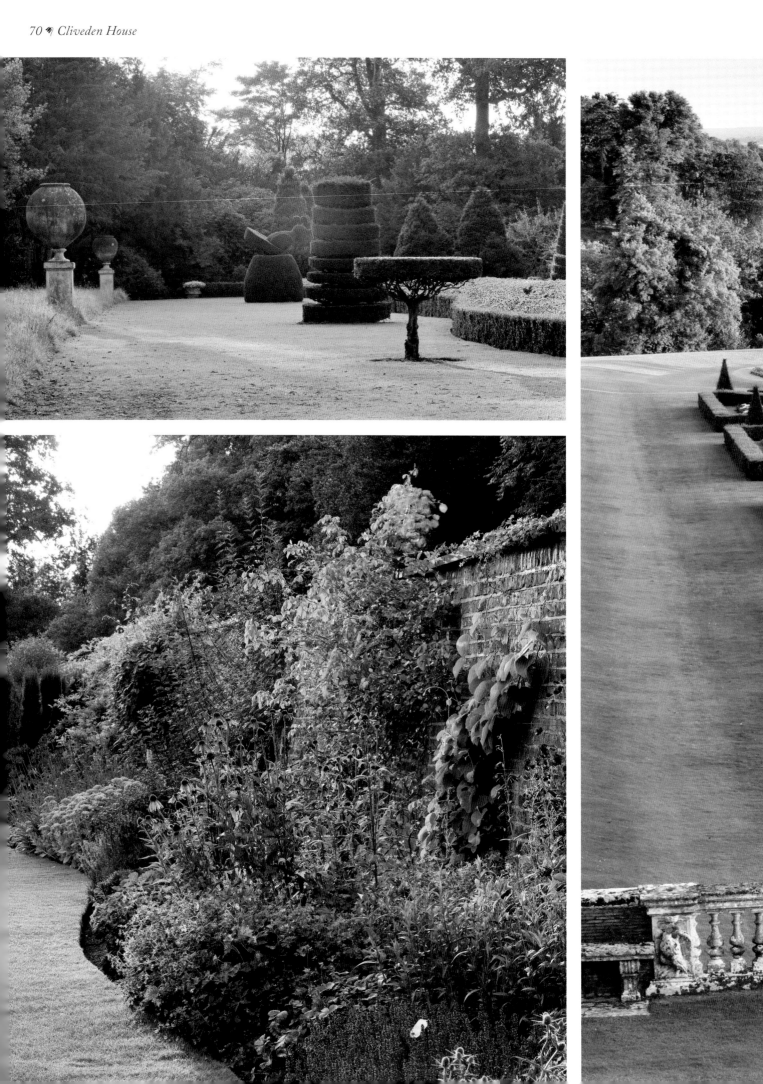

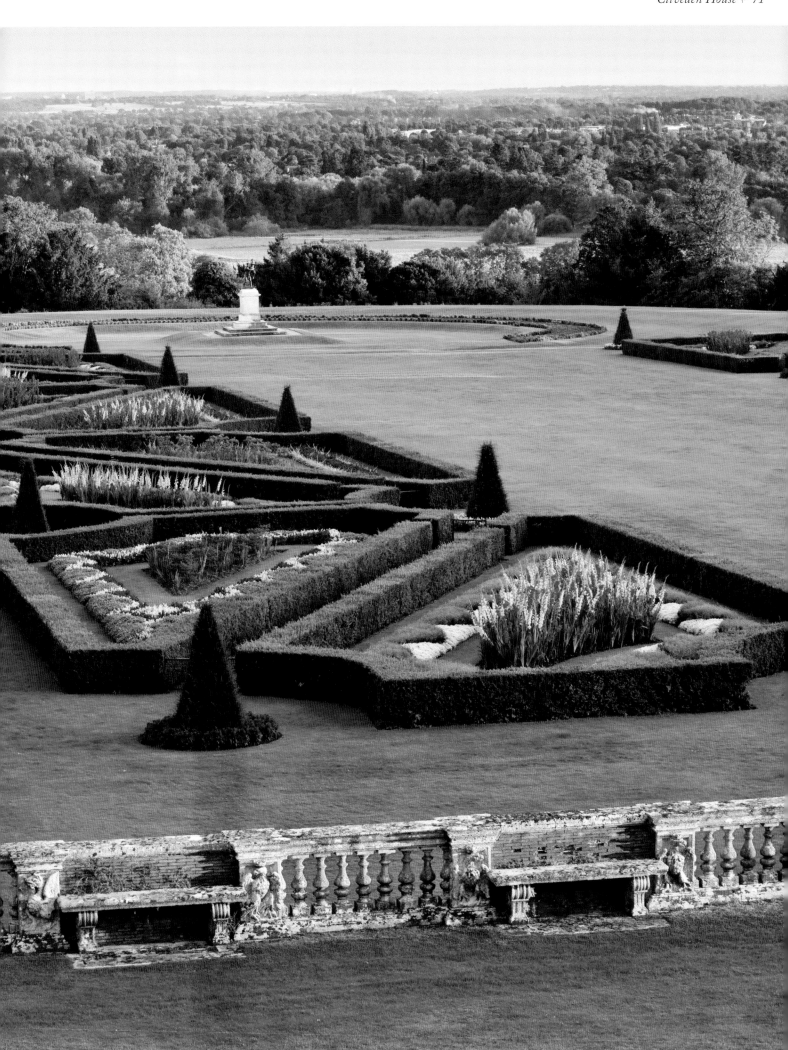

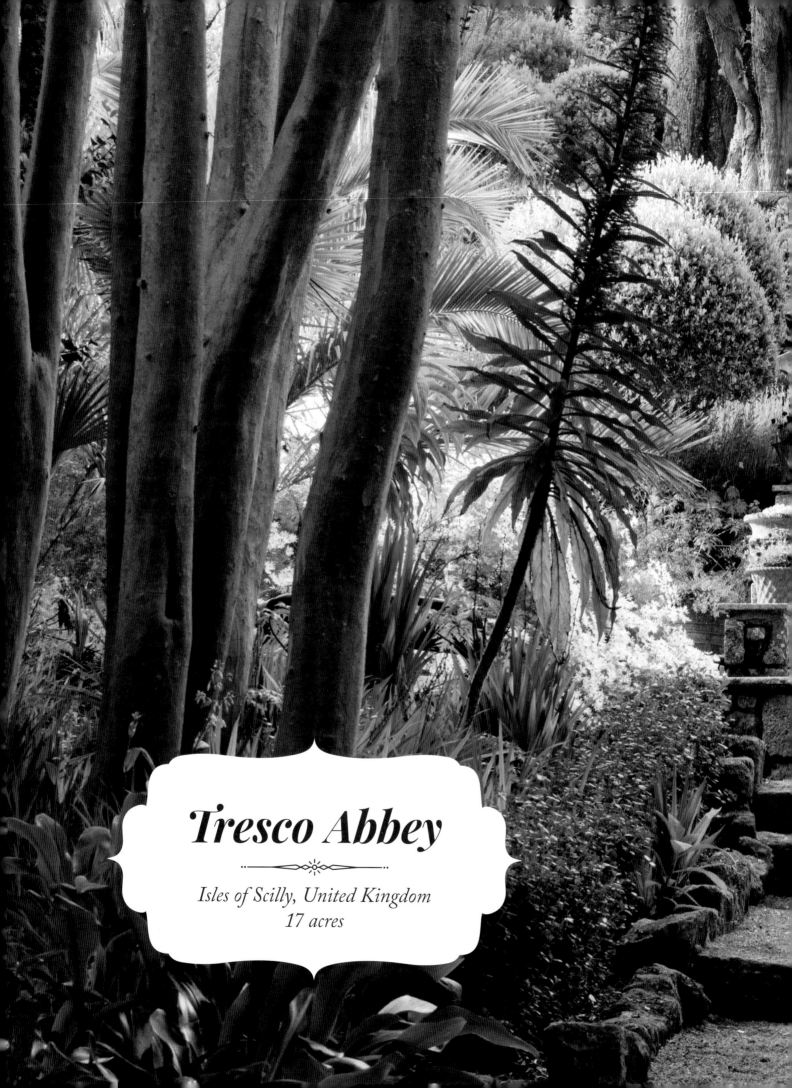

Tresco Abbey

Isles of Scilly, United Kingdom
17 acres

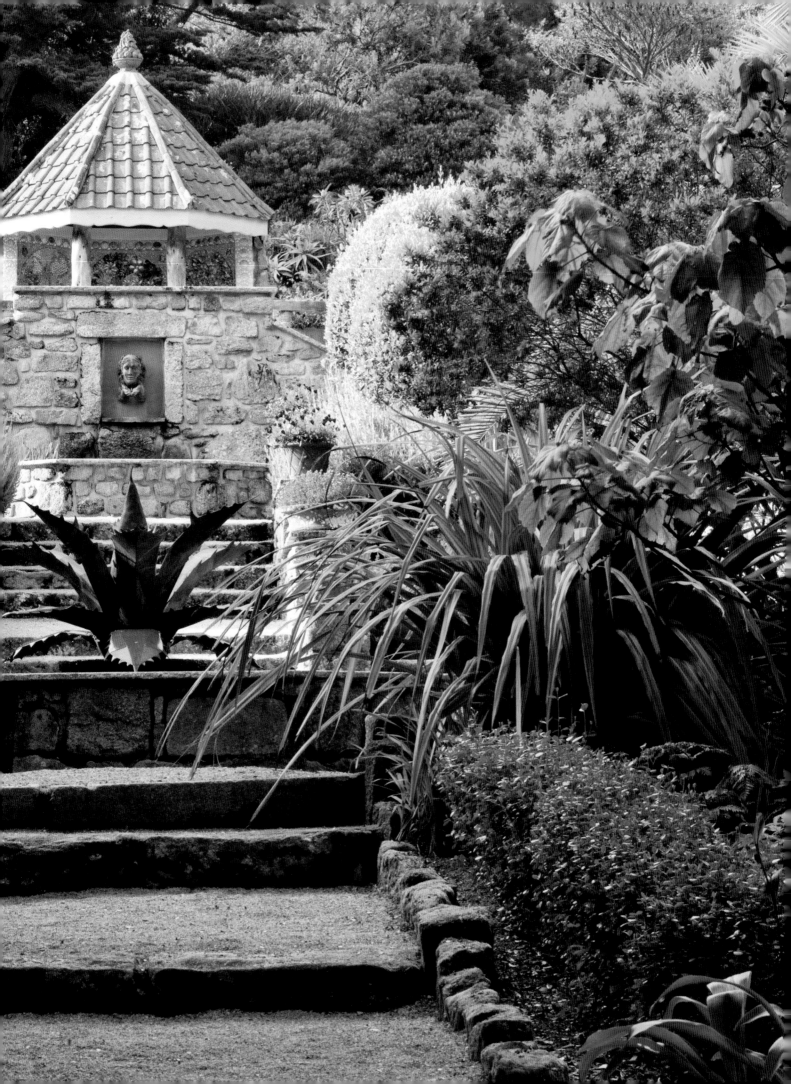

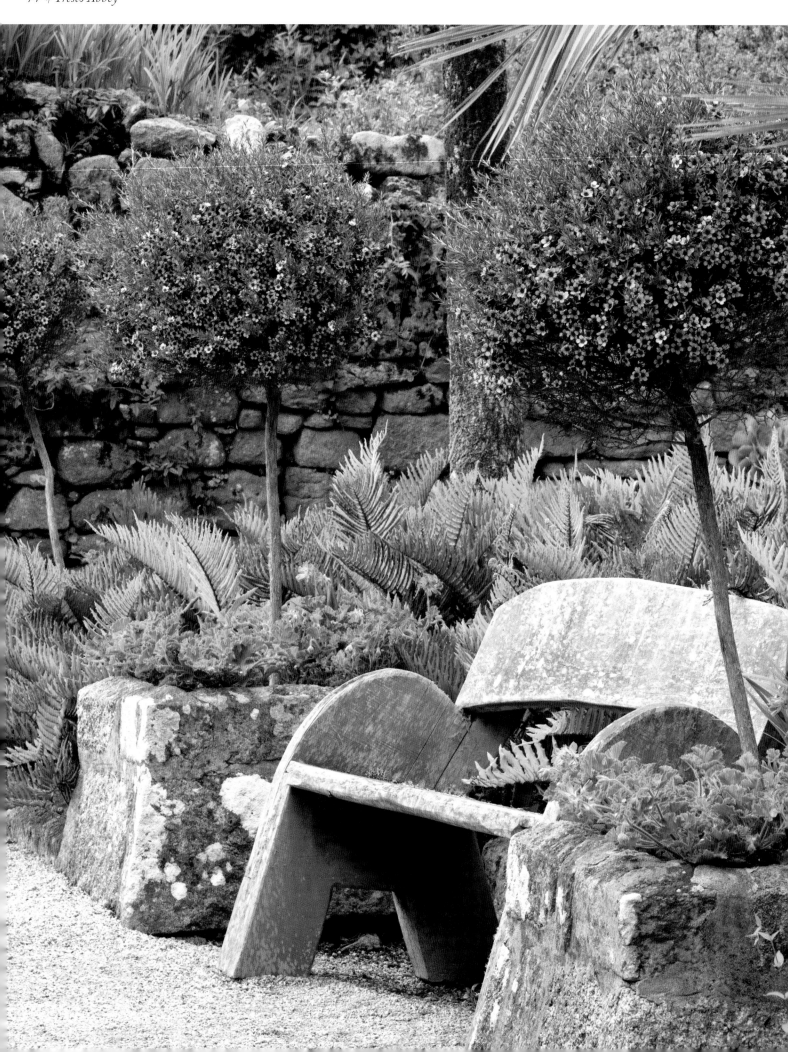

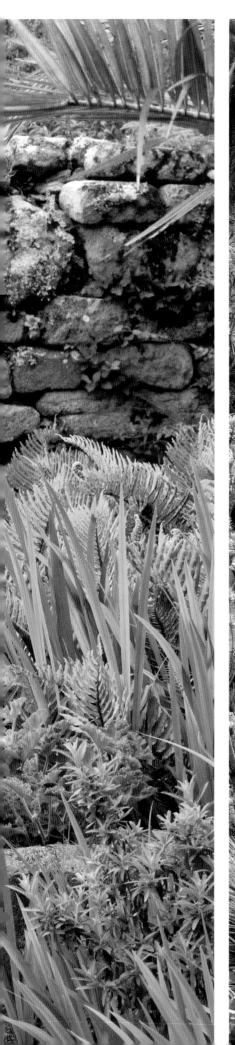

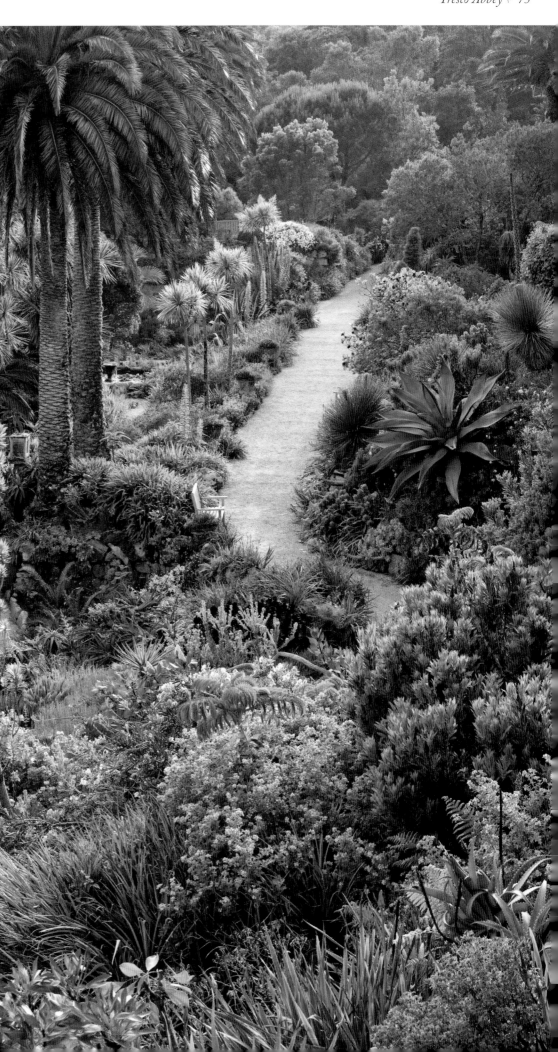

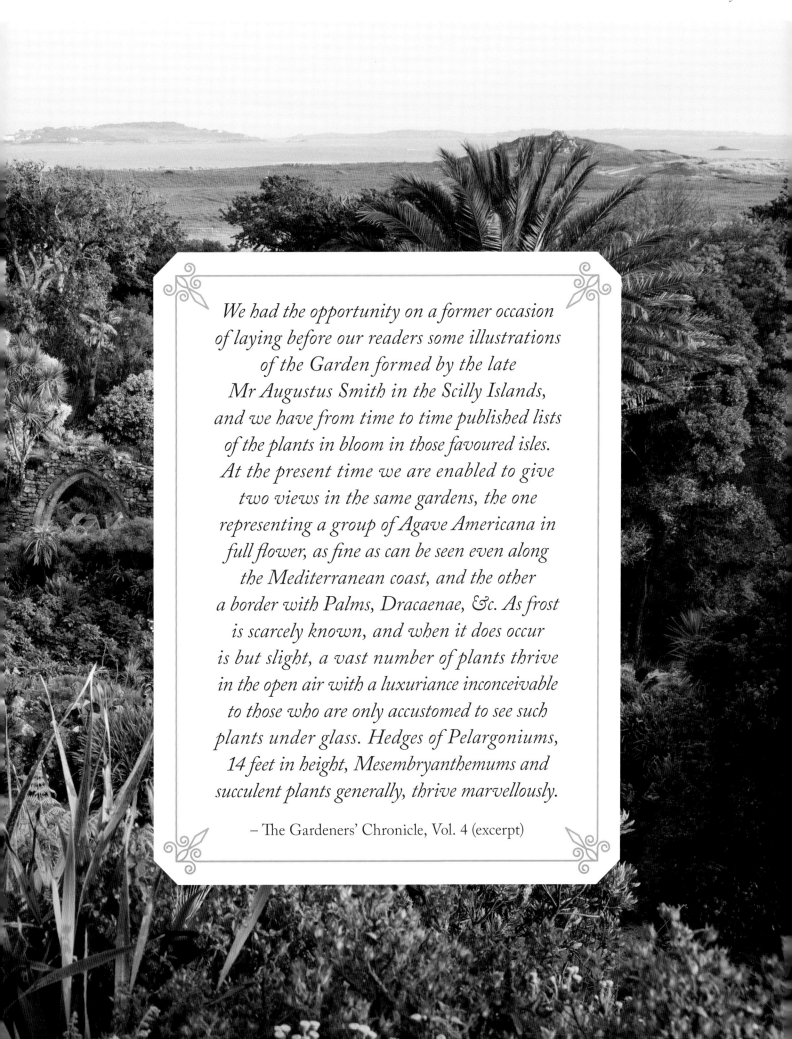

*We had the opportunity on a former occasion
of laying before our readers some illustrations
of the Garden formed by the late
Mr Augustus Smith in the Scilly Islands,
and we have from time to time published lists
of the plants in bloom in those favoured isles.
At the present time we are enabled to give
two views in the same gardens, the one
representing a group of Agave Americana in
full flower, as fine as can be seen even along
the Mediterranean coast, and the other
a border with Palms, Dracaenae, &c. As frost
is scarcely known, and when it does occur
is but slight, a vast number of plants thrive
in the open air with a luxuriance inconceivable
to those who are only accustomed to see such
plants under glass. Hedges of Pelargoniums,
14 feet in height, Mesembryanthemums and
succulent plants generally, thrive marvellously.*

– The Gardeners' Chronicle, Vol. 4 (excerpt)

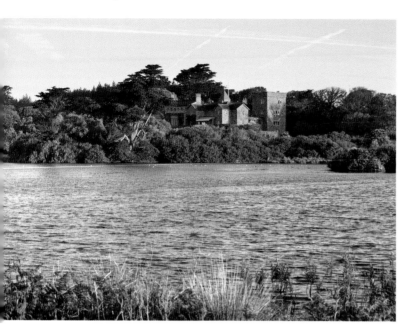

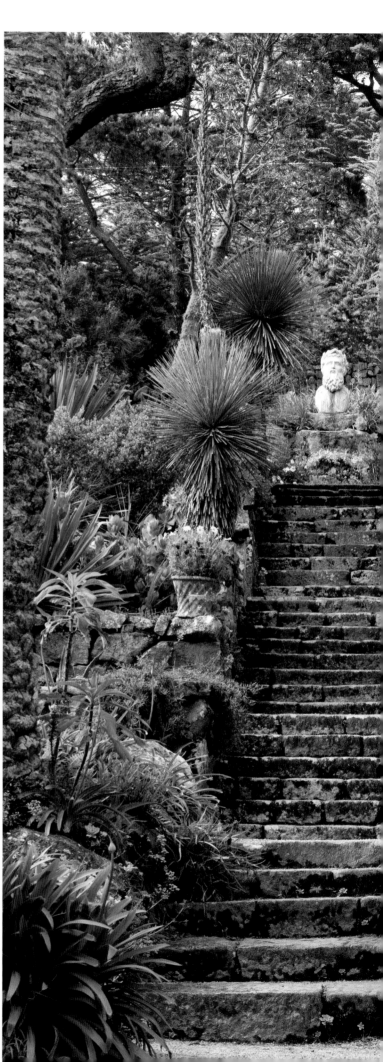

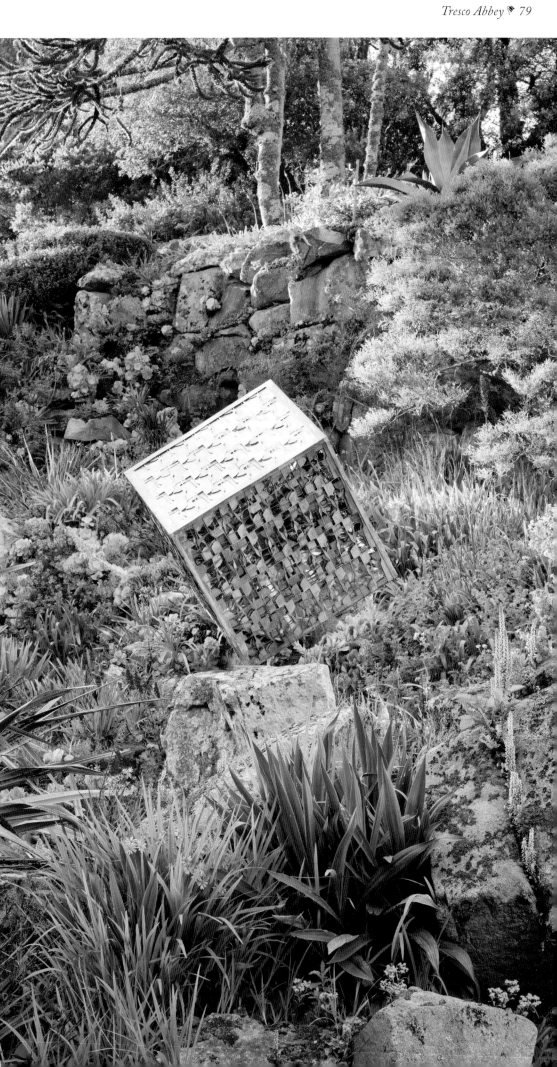

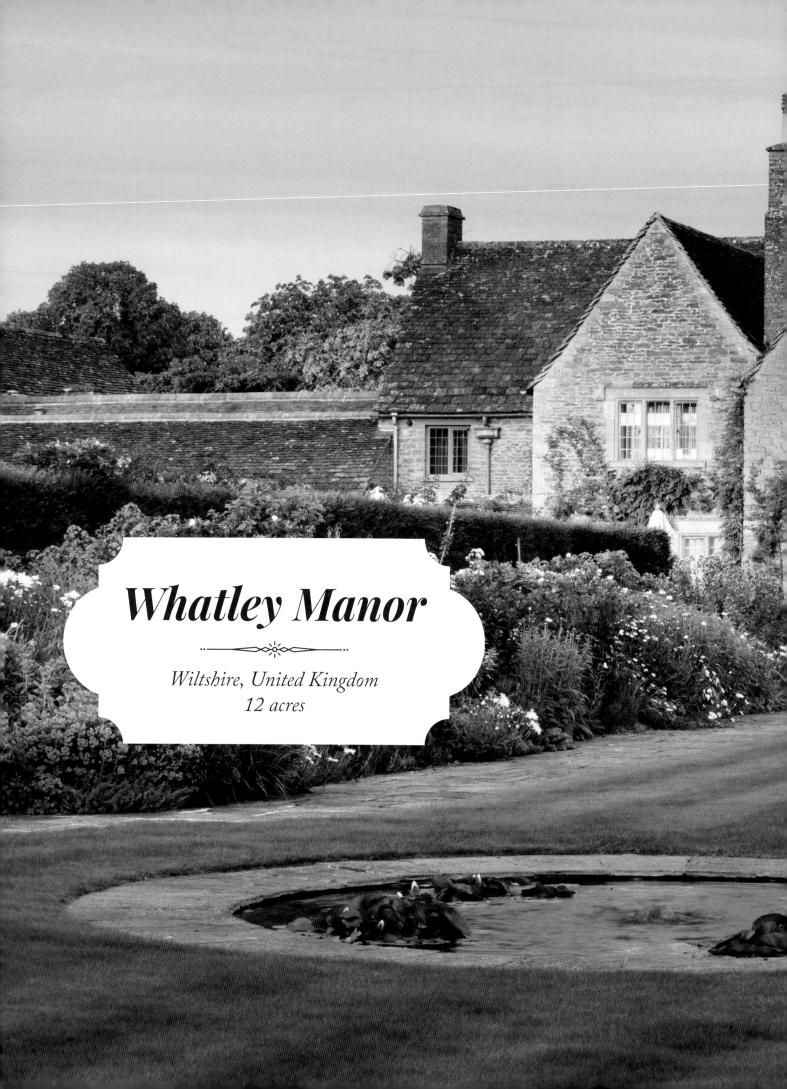

Whatley Manor

꘎꘎꘎ ❖ ꘎꘎꘎

Wiltshire, United Kingdom
12 acres

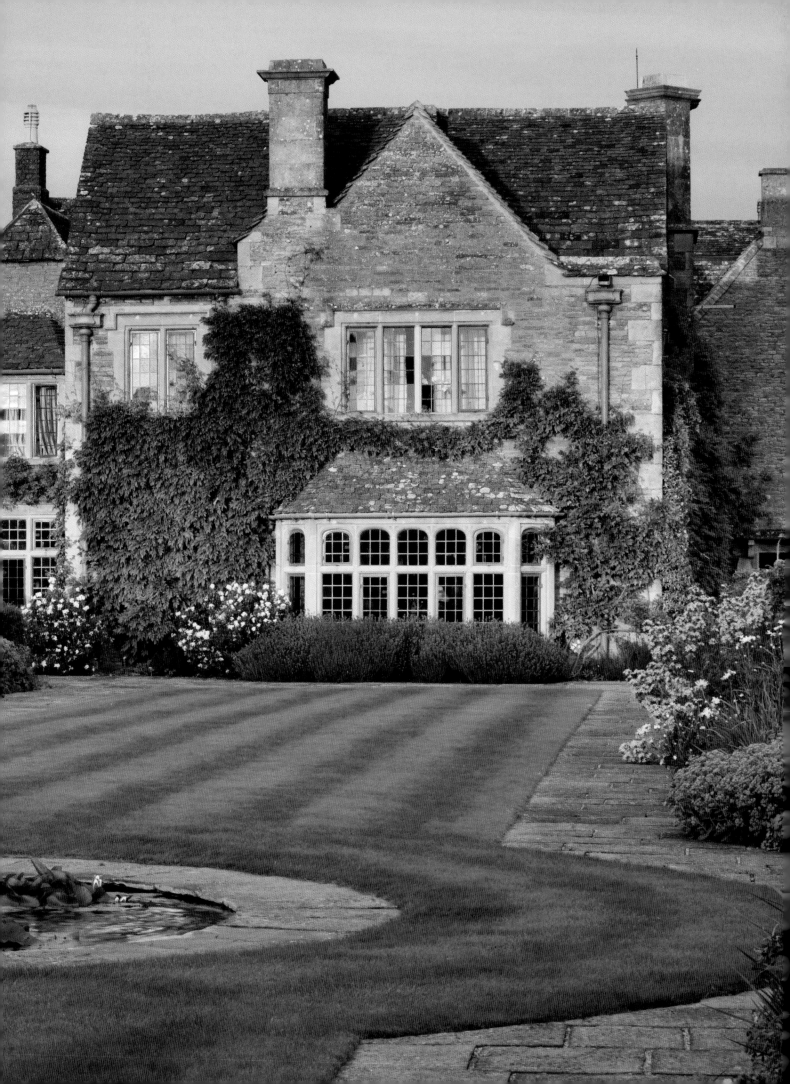

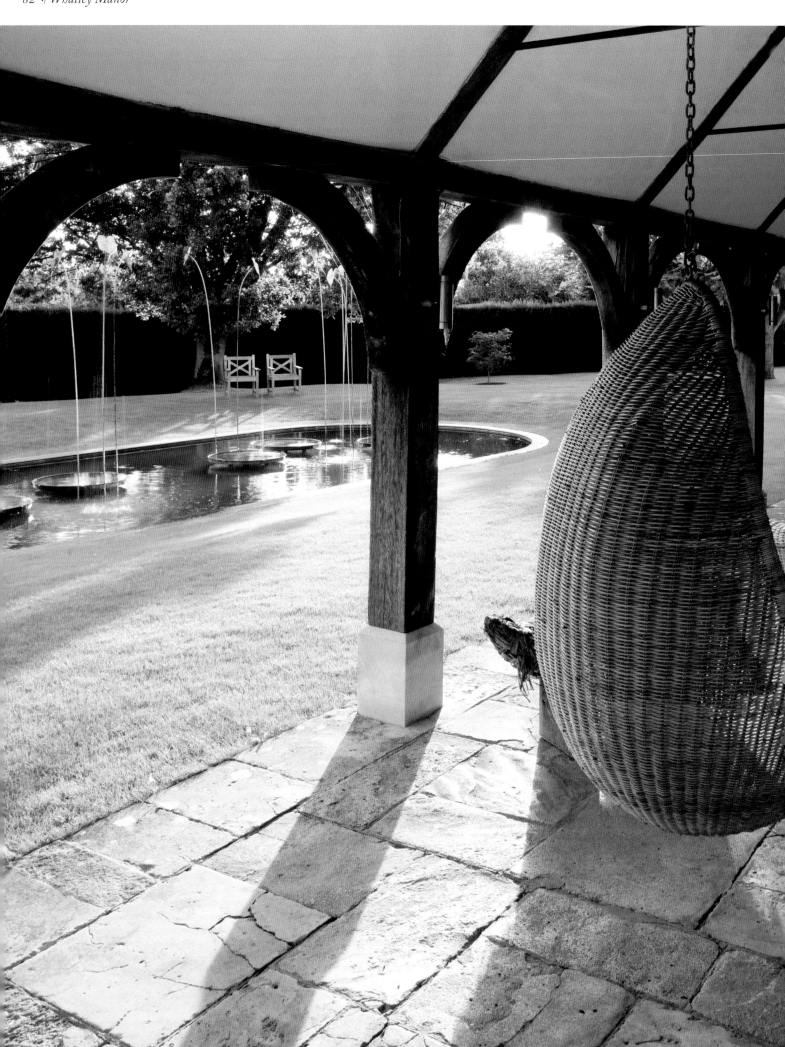

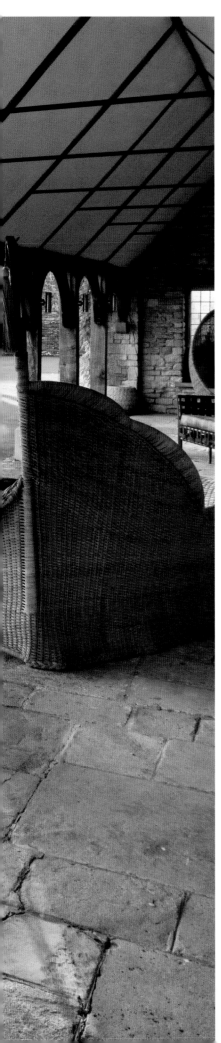

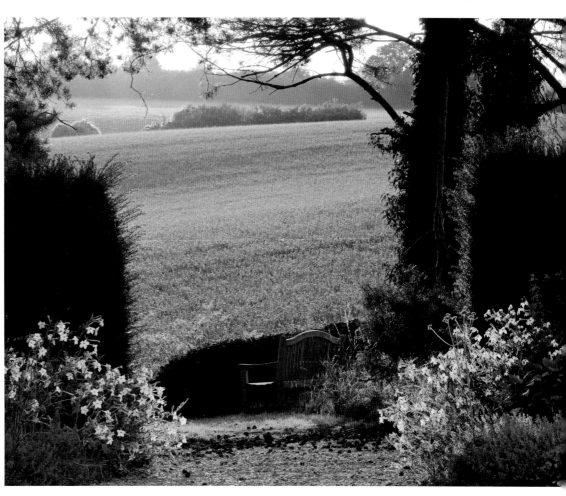

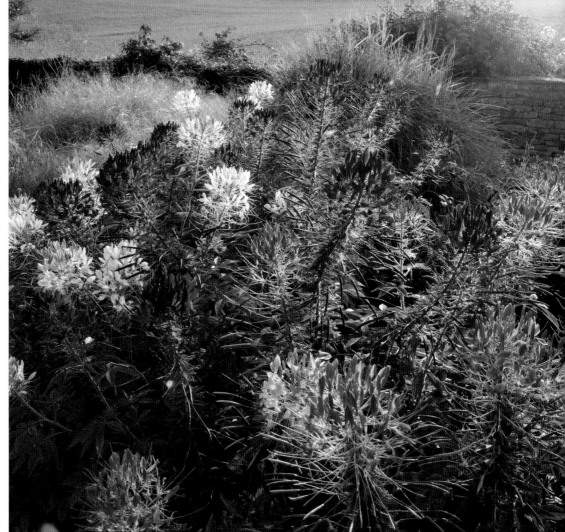

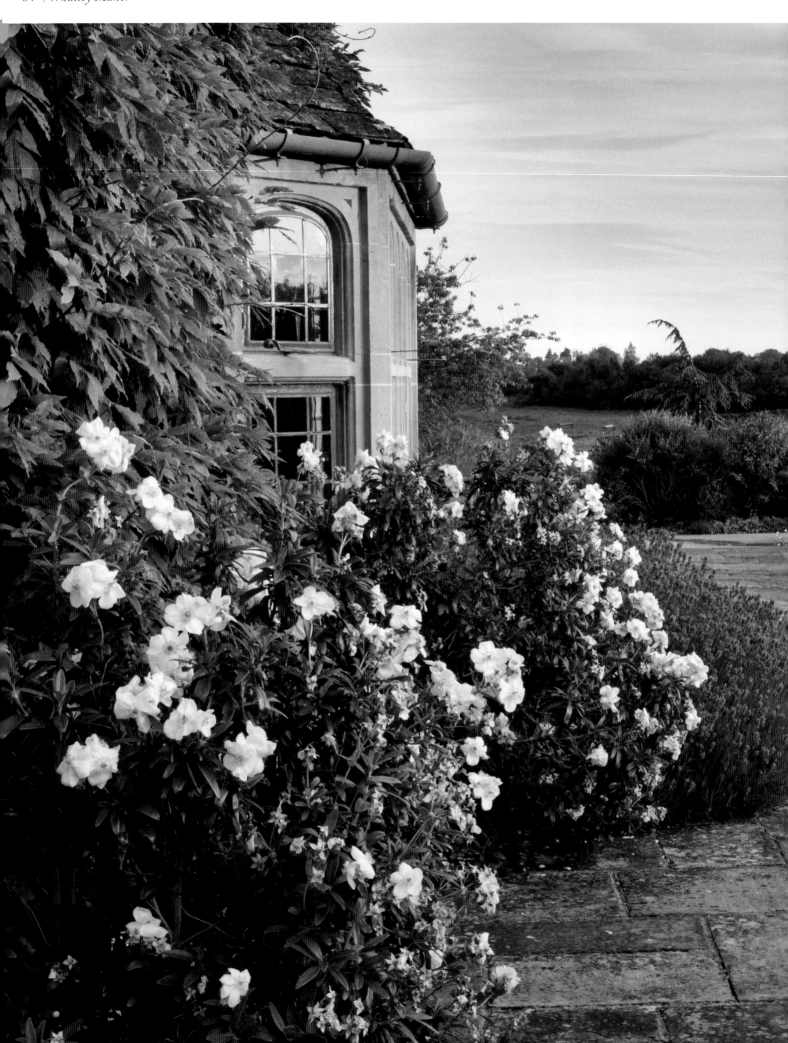

*Following a walk marked by an intangible
mist of bloom that followed the white
border stones she came to a space overlooking
the sea where there were lanterns asleep
in the fig trees and a big table and wicker chairs
and a great market umbrella from Sienna,
all gathered about an enormous pine,
the biggest tree in the garden. She paused there
a moment, looking absently at a growth
of nasturtiums and iris tangled at its foot,
as though sprung from a careless handful
of seeds, listening to the plaints and
accusations of some nursery squabble in
the house. When this died away on
the summer air, she walked on, between
kaleidoscopic peonies massed in pink clouds,
black and brown tulips and fragile mauve-
stemmed roses, transparent like sugar flowers
in a confectioner's window—until, as if
the scherzo of color could reach no further
intensity, it broke off suddenly in mid-air,
and moist steps went down to a level
five feet below.*

– F. Scott Fitzgerald, *Tender is the Night* (excerpt)

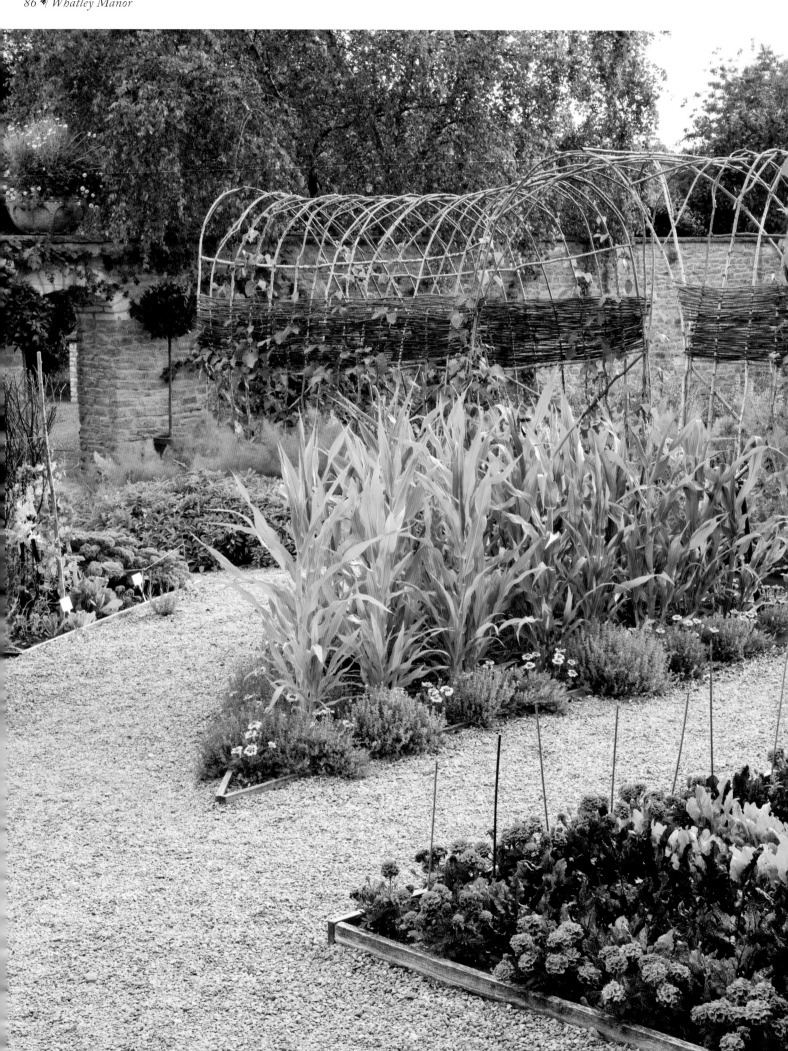

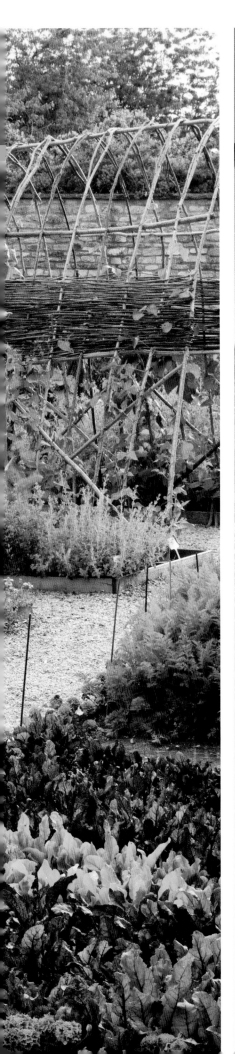
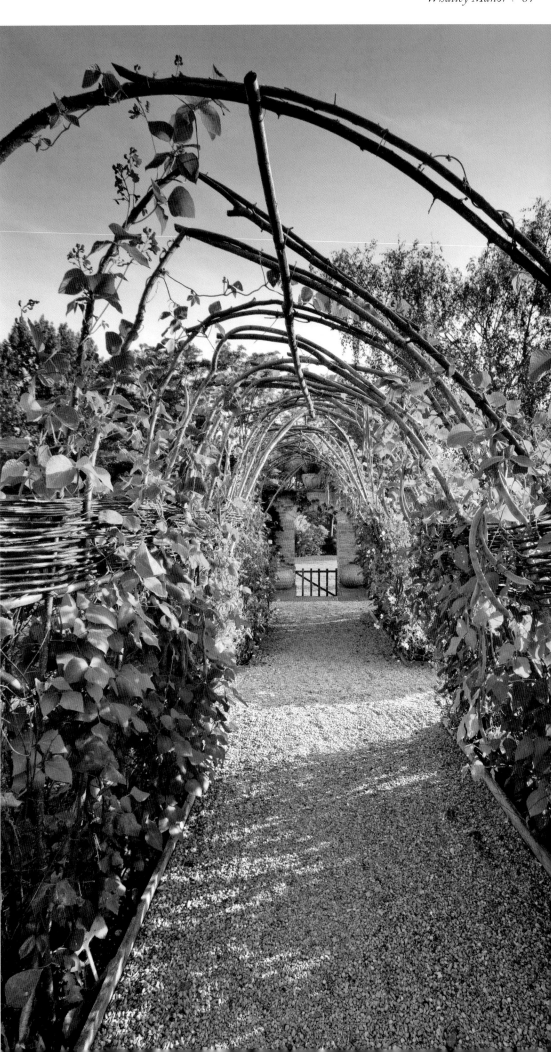

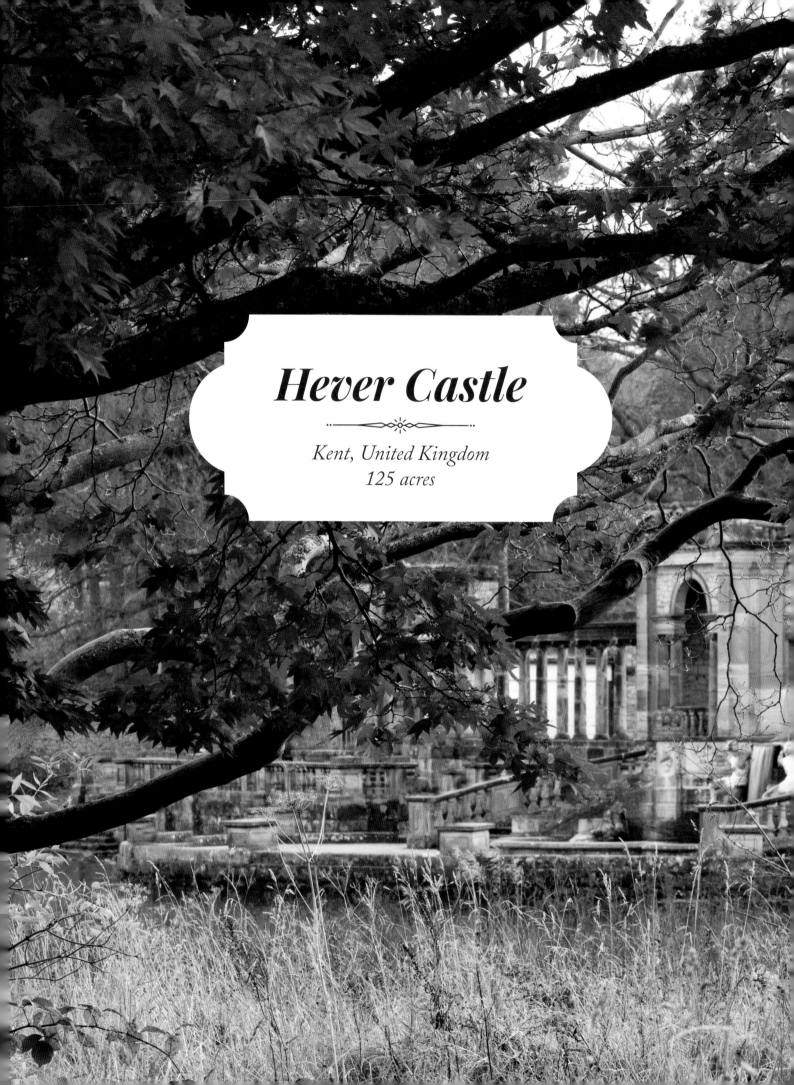

Hever Castle

Kent, United Kingdom
125 acres

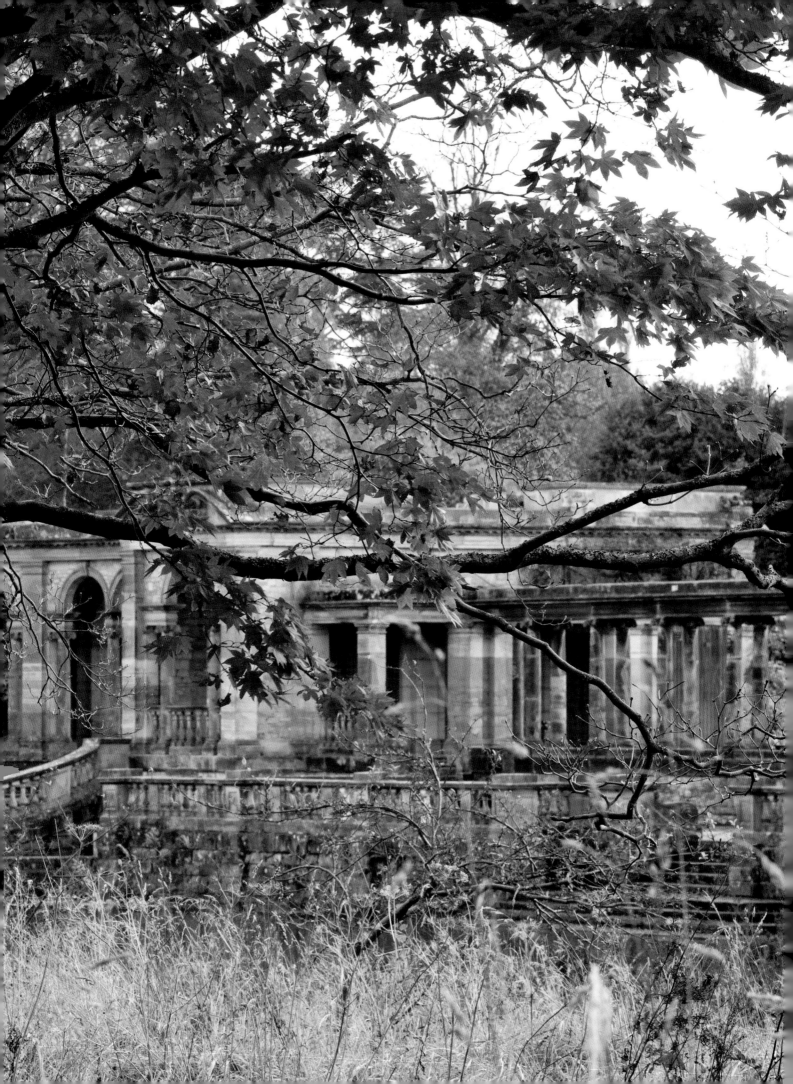

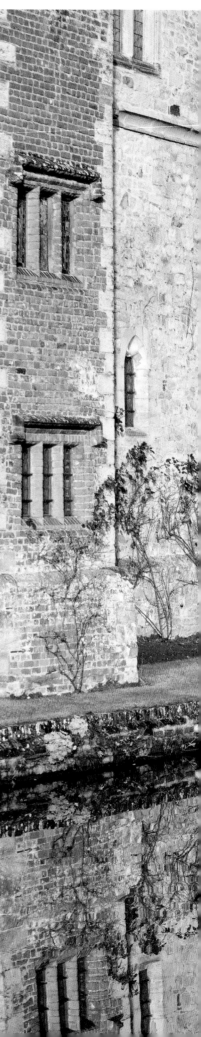

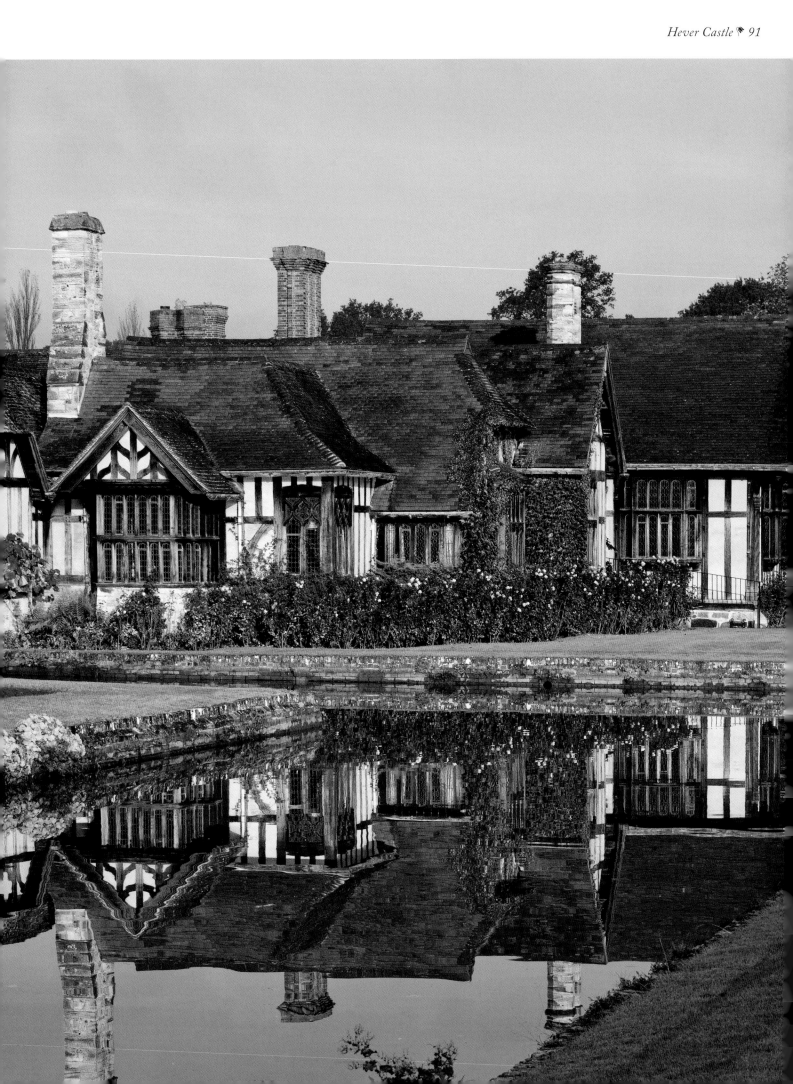

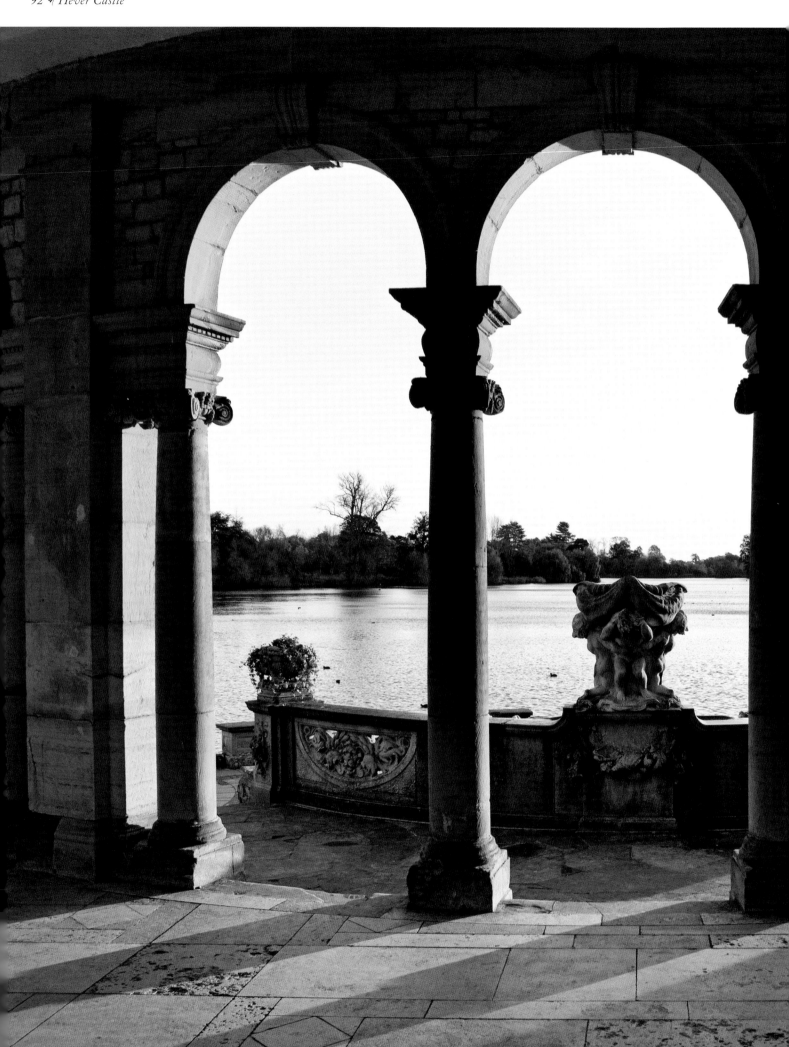

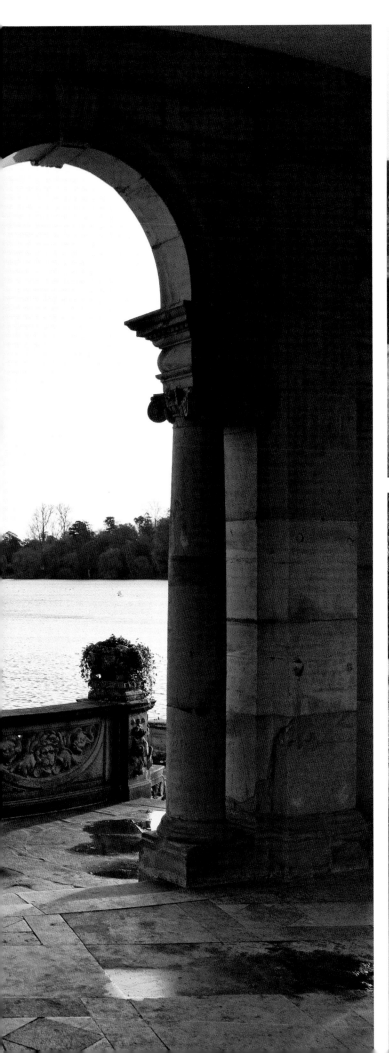

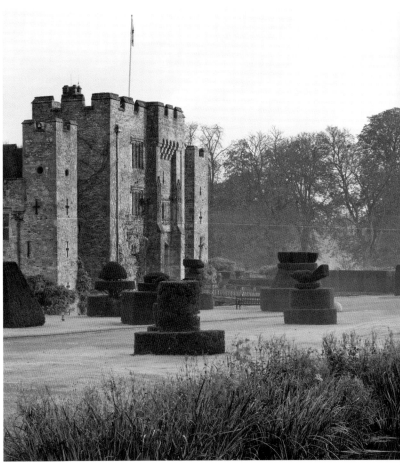

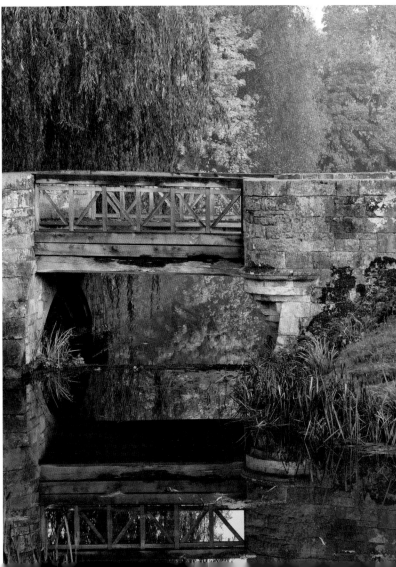

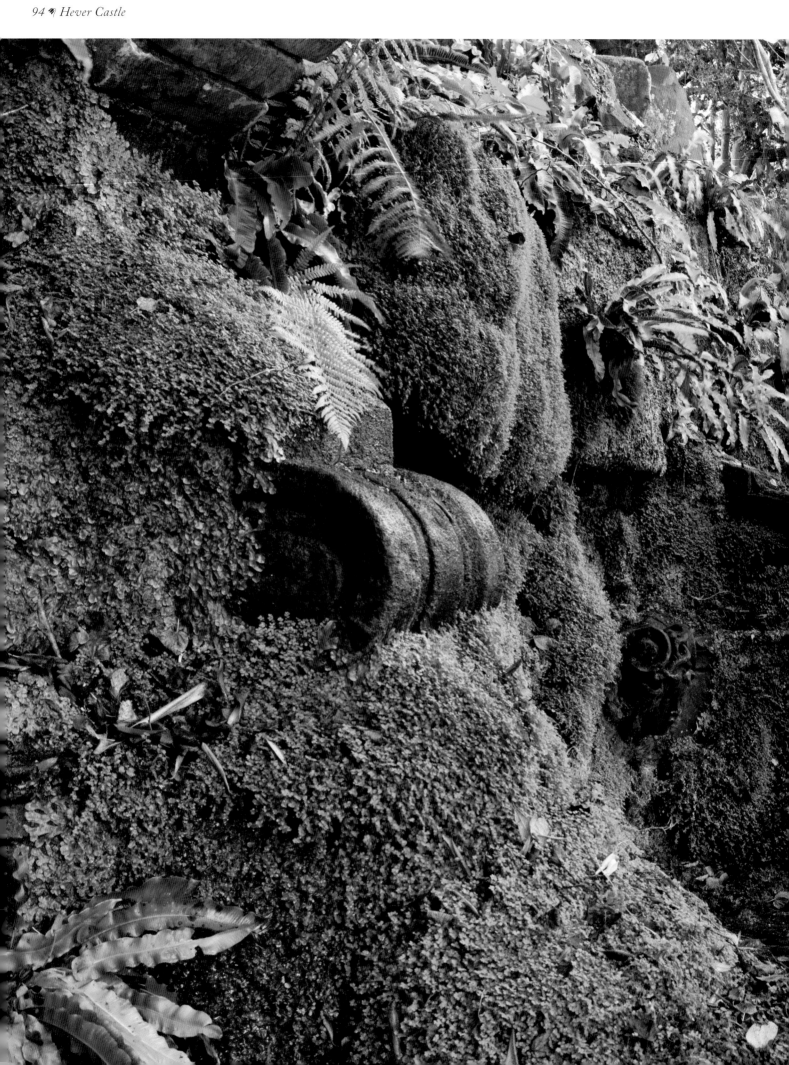

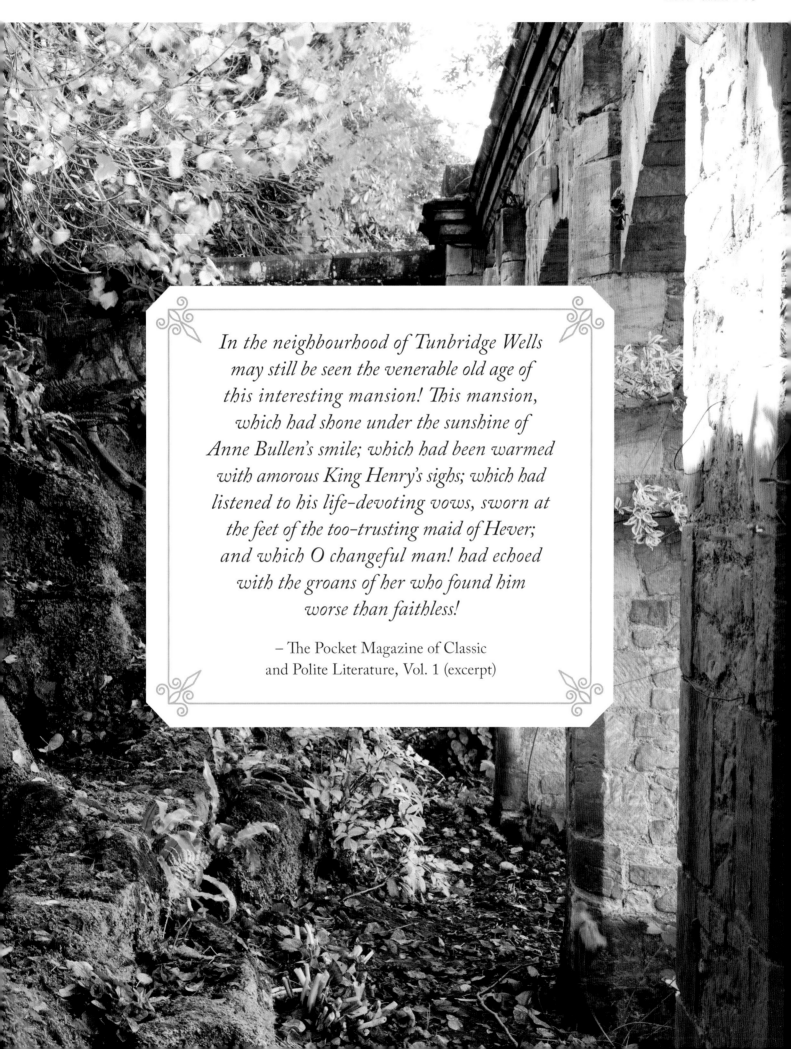

In the neighbourhood of Tunbridge Wells may still be seen the venerable old age of this interesting mansion! This mansion, which had shone under the sunshine of Anne Bullen's smile; which had been warmed with amorous King Henry's sighs; which had listened to his life-devoting vows, sworn at the feet of the too-trusting maid of Hever; and which O changeful man! had echoed with the groans of her who found him worse than faithless!

– The Pocket Magazine of Classic
and Polite Literature, Vol. 1 (excerpt)

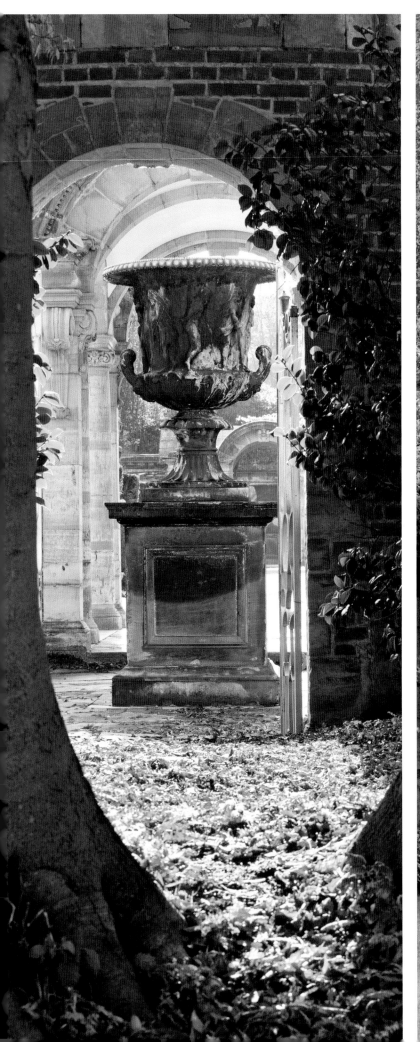

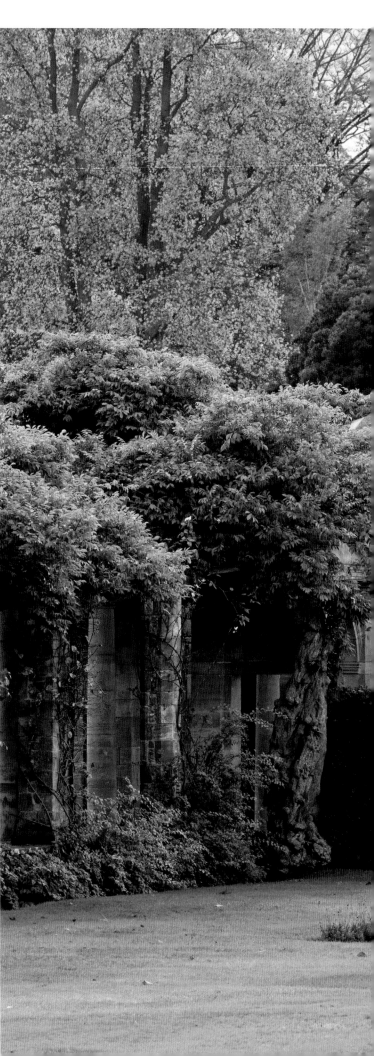

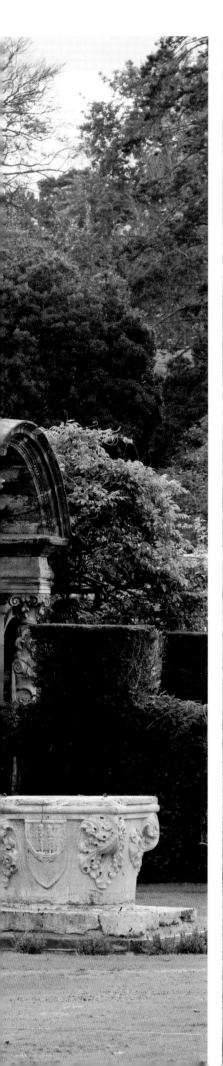

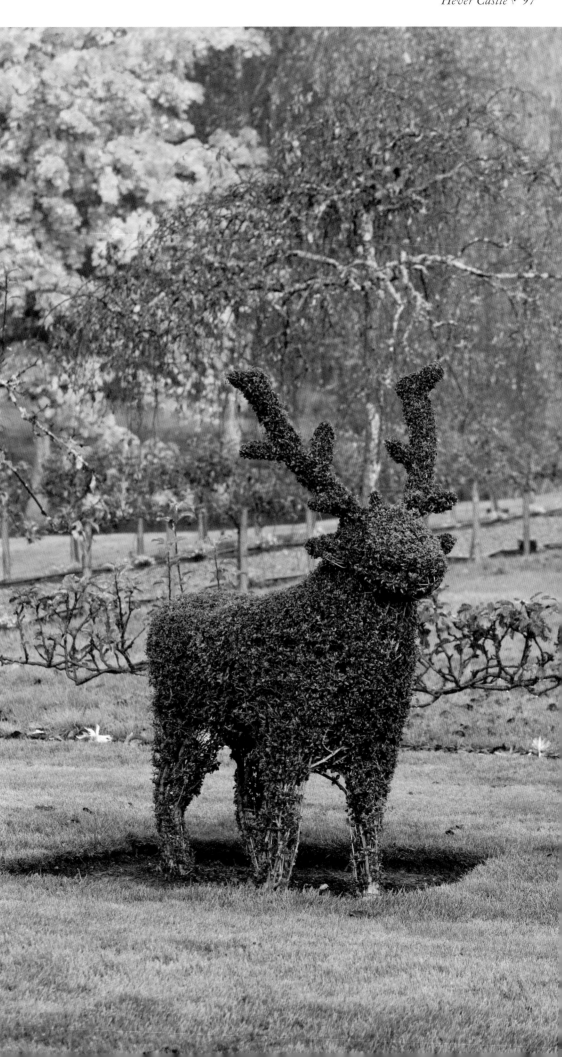

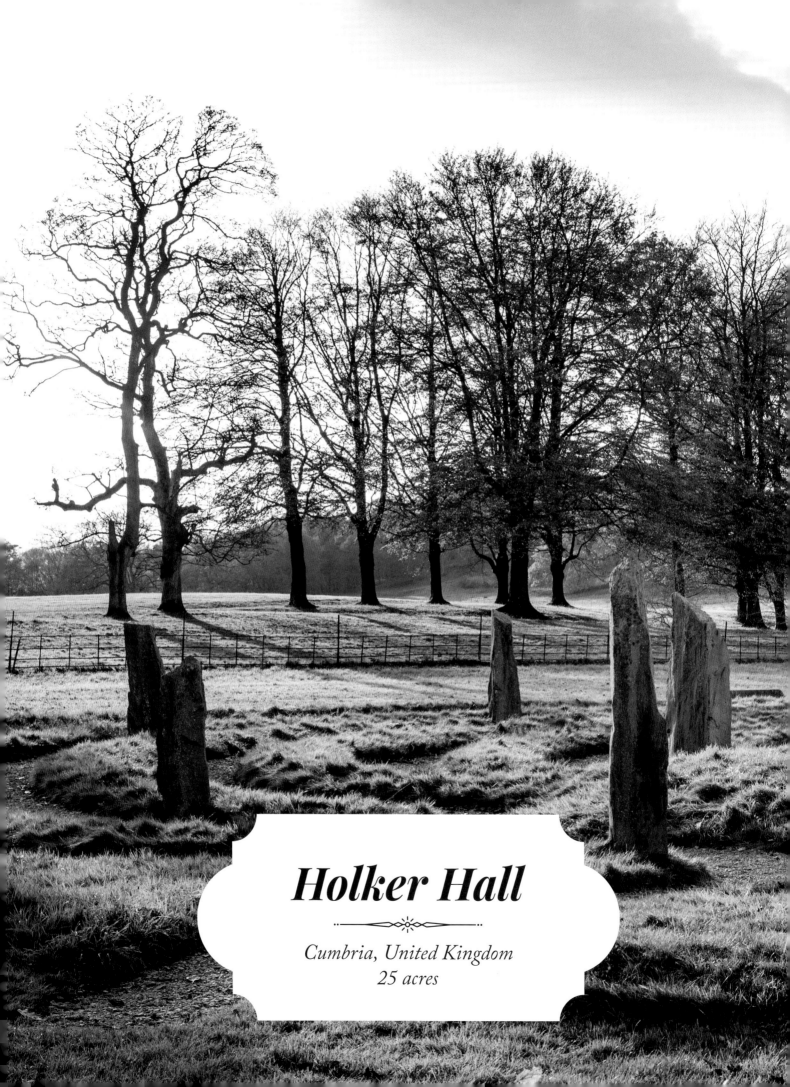

Holker Hall

❖

Cumbria, United Kingdom
25 acres

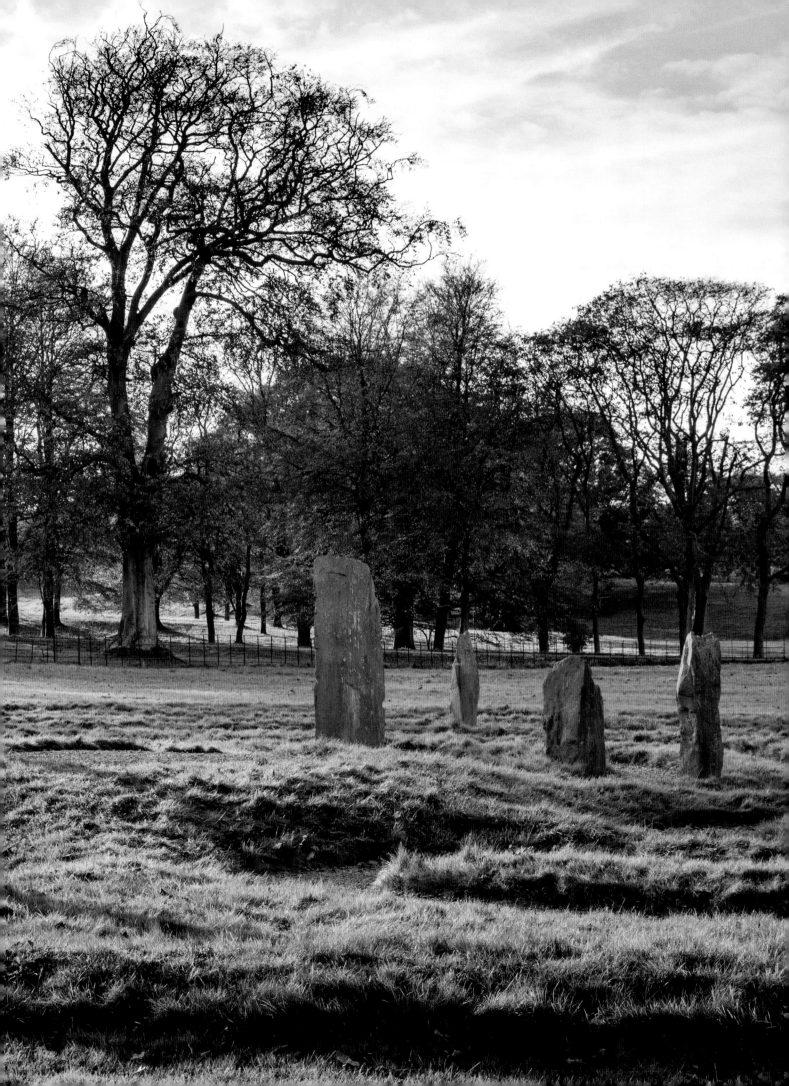

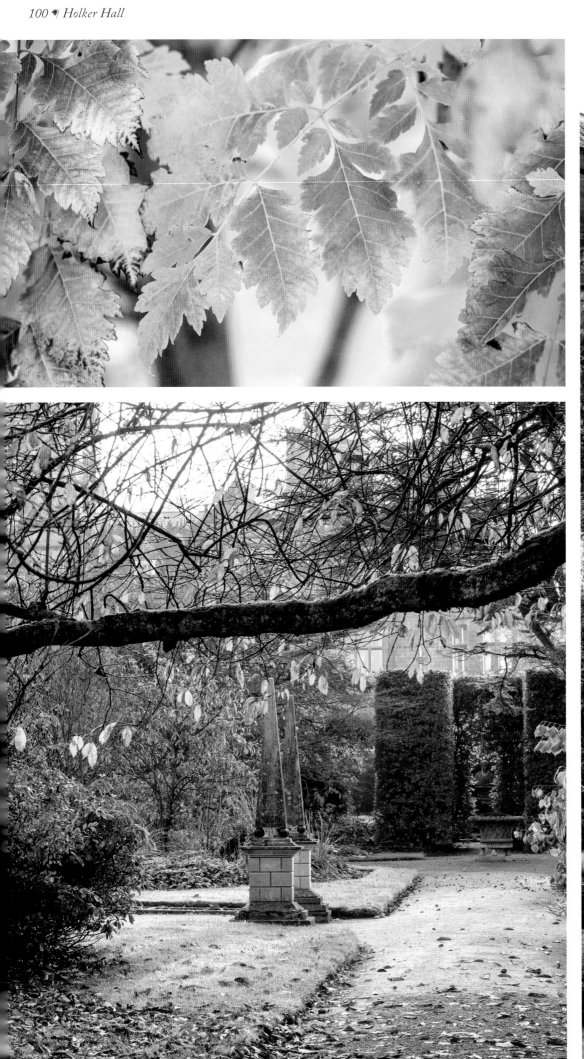

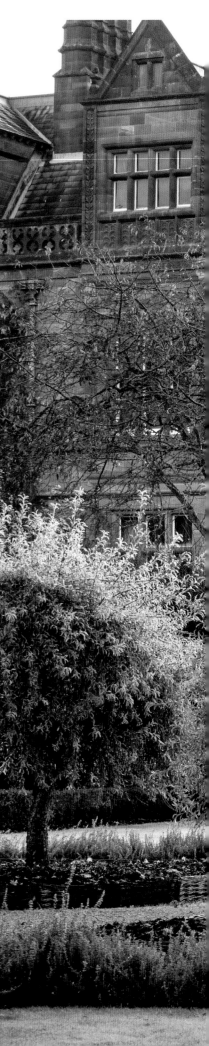

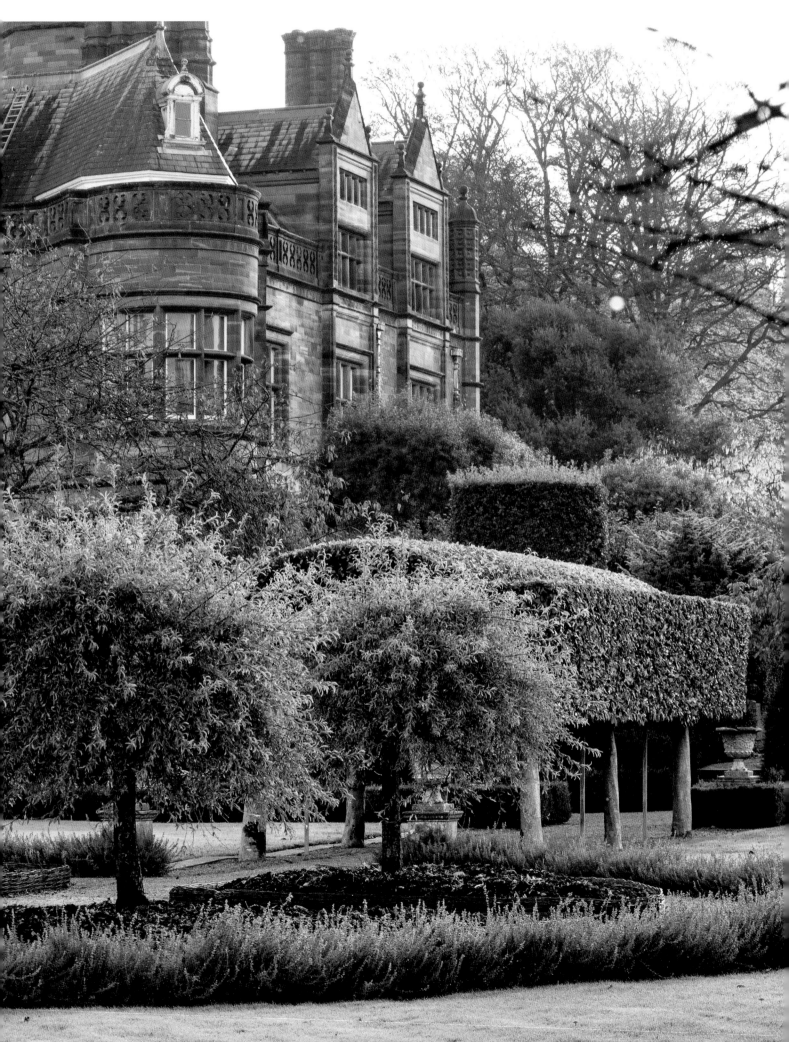

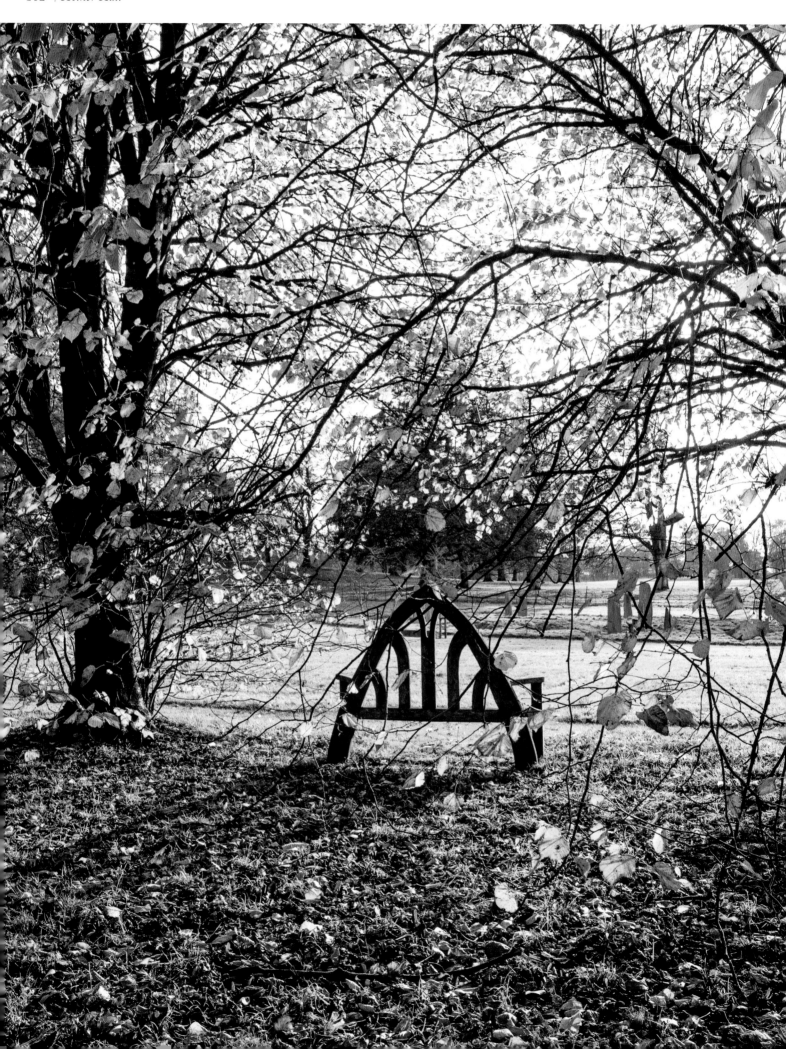

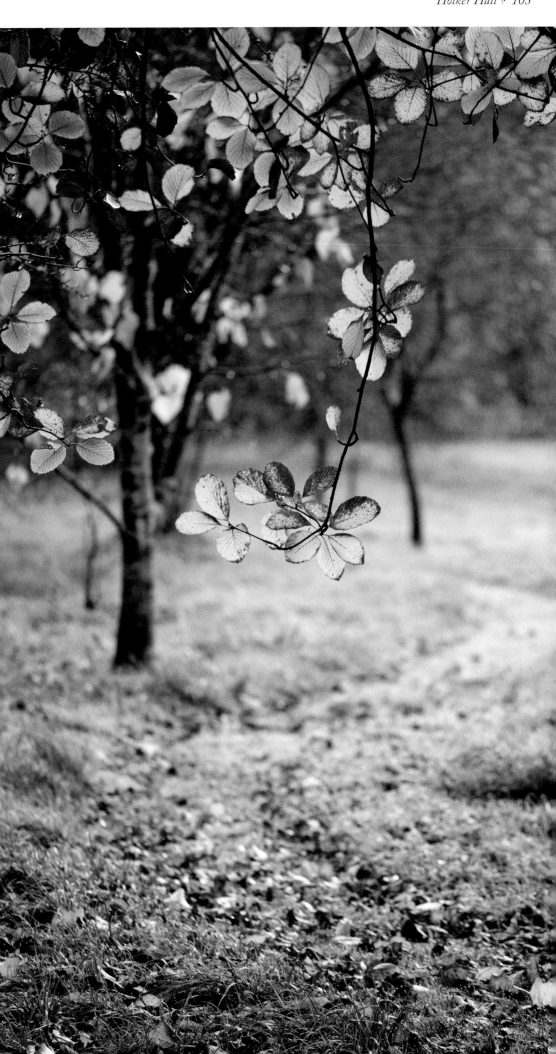

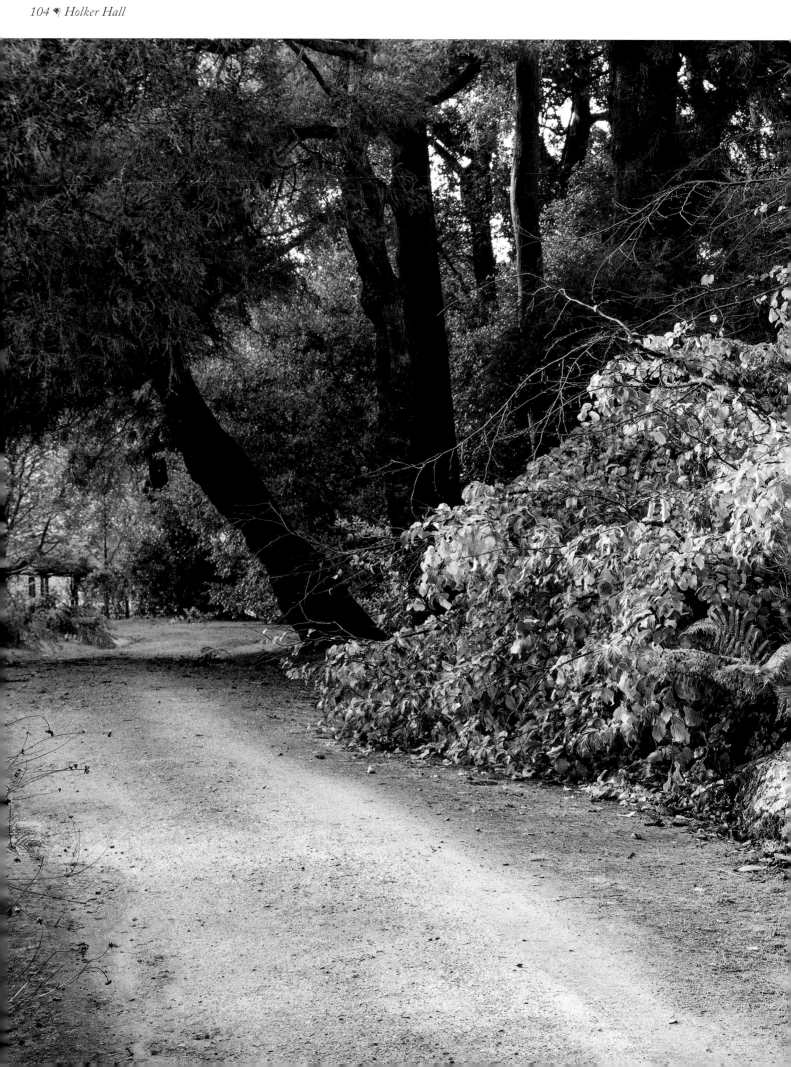

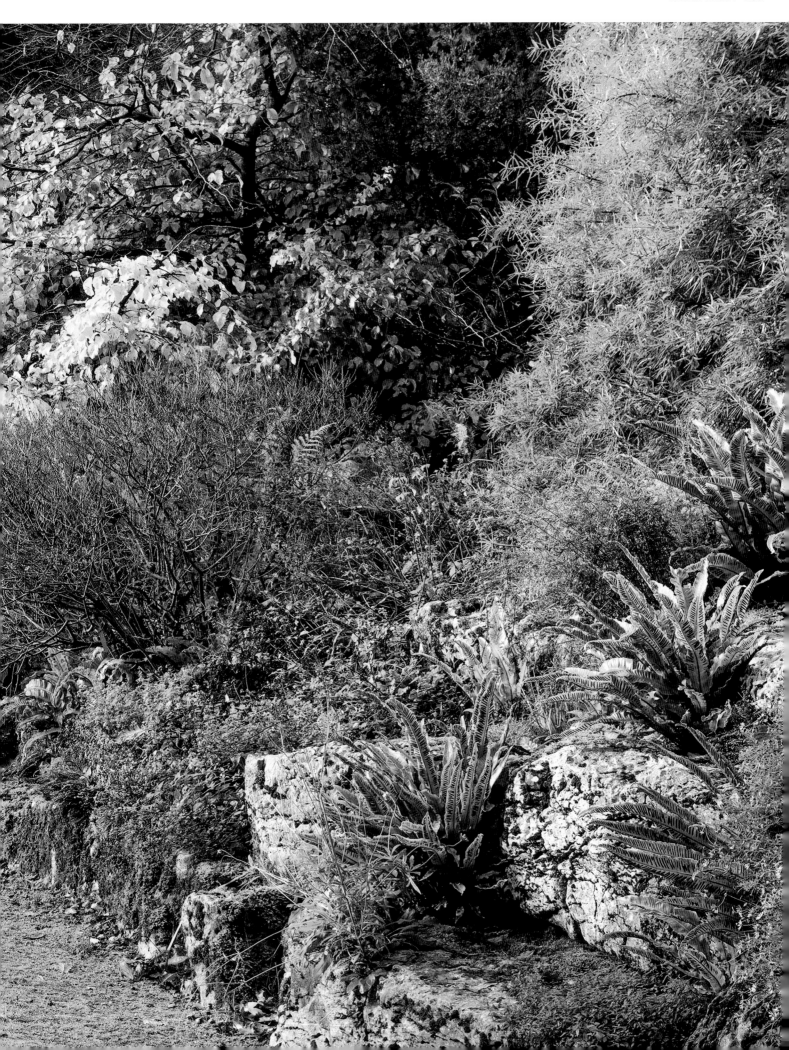

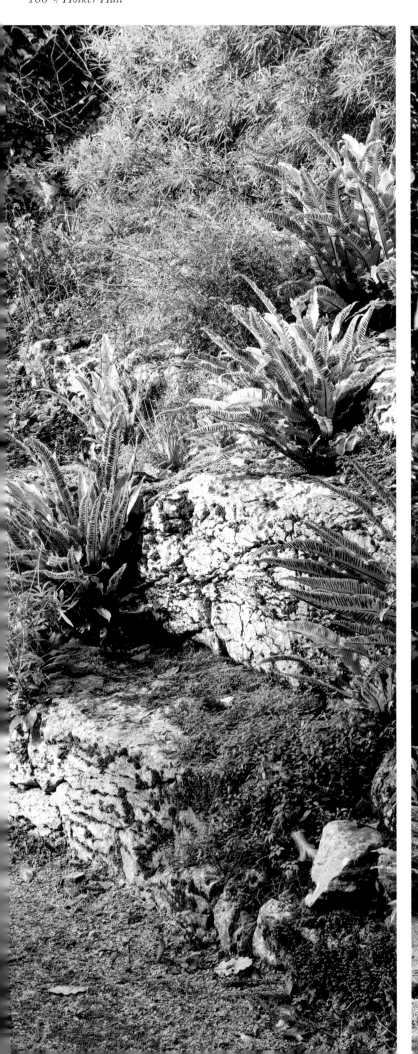

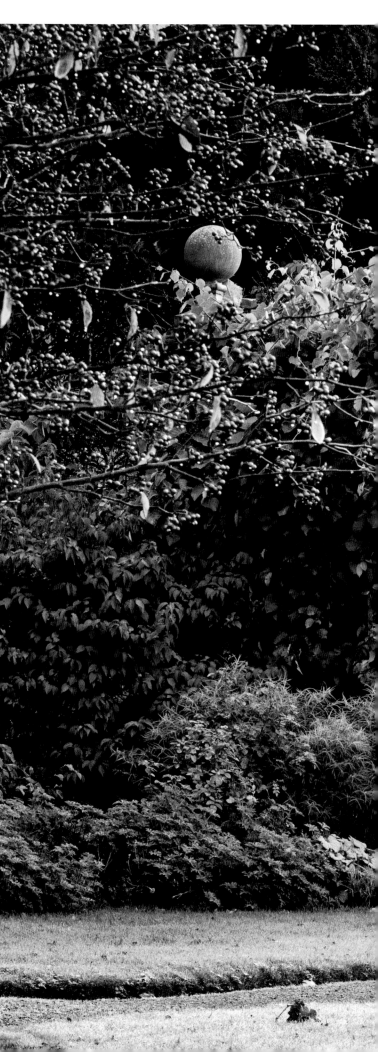

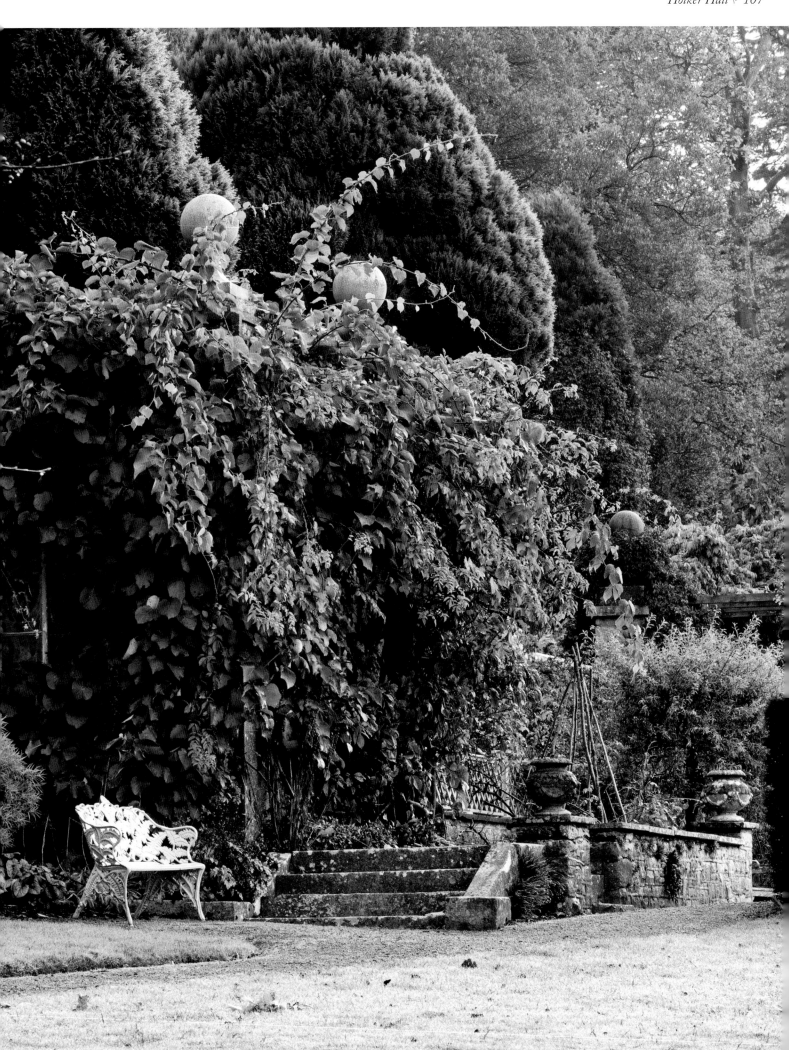

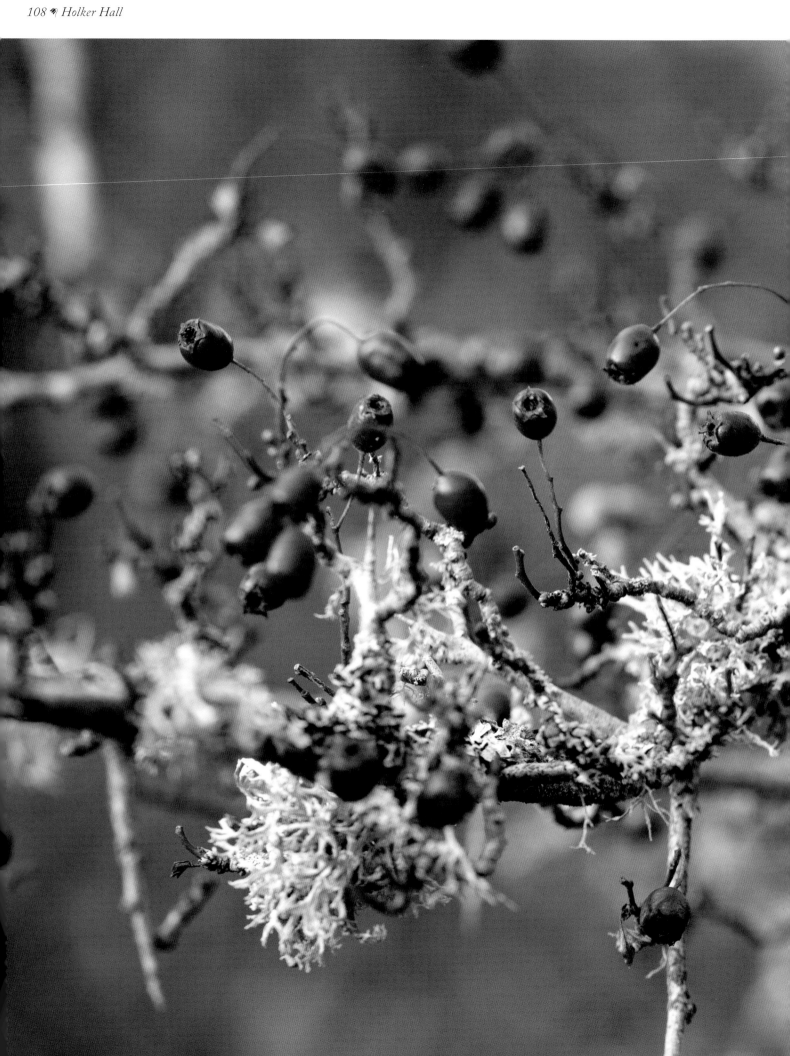

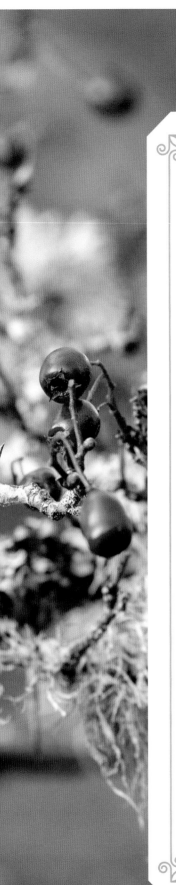

Season of mists and mellow fruitfulness!
Close bosom-friend of the maturing sun;
Conspiring with him how to load and bless
With fruit the vines that round the thatch-eaves run;
To bend with apples the mossed cottage-trees,
And fill all fruit with ripeness to the core;
To swell the gourd, and plump the hazel shells
With a sweet kernel; to set budding more,
And still more, later flowers for the bees,
Until they think warm days will never cease,
For Summer has o'er-brimm'd their clammy cells.

Who hath not seen thee oft amid thy store?
Sometimes whoever seeks abroad may find
Thee sitting careless on a granary floor,
Thy hair soft-lifted by the winnowing wind;
Or on a half-reap'd furrow sound asleep,
Drowsed with the fume of poppies, while thy hook
Spares the next swath and all its twined flowers;
And sometime like a gleaner thou dost keep
Steady thy laden head across a brook;
Or by a cider-press, with patient look,
Thou watchest the last oozings, hours by hours.

Where are the songs of Spring? Ay, where are they?
Think not of them, thou hast thy music too,
While barred clouds bloom the soft-dying day,
And touch the stubble-plains with rosy hue;
Then in a wailful choir the small gnats mourn
Among the river sallows, borne aloft
Or sinking as the light wind lives or dies;
And full-grown lambs loud bleat from hilly bourn;
Hedge-crickets sing, and now with treble soft
The redbreast whistles from a garden-croft;
And gathering swallows twitter in the skies.

– John Keats, *Ode to Autumn*

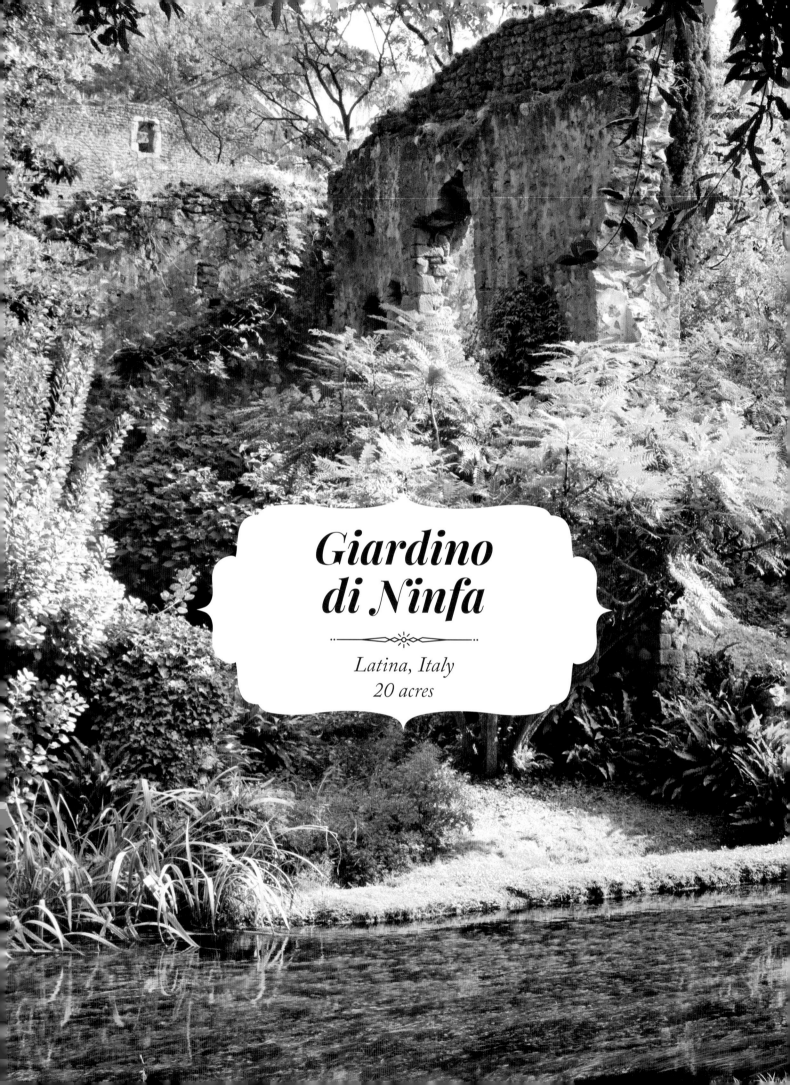

Giardino di Ninfa

·····✦·····

Latina, Italy
20 acres

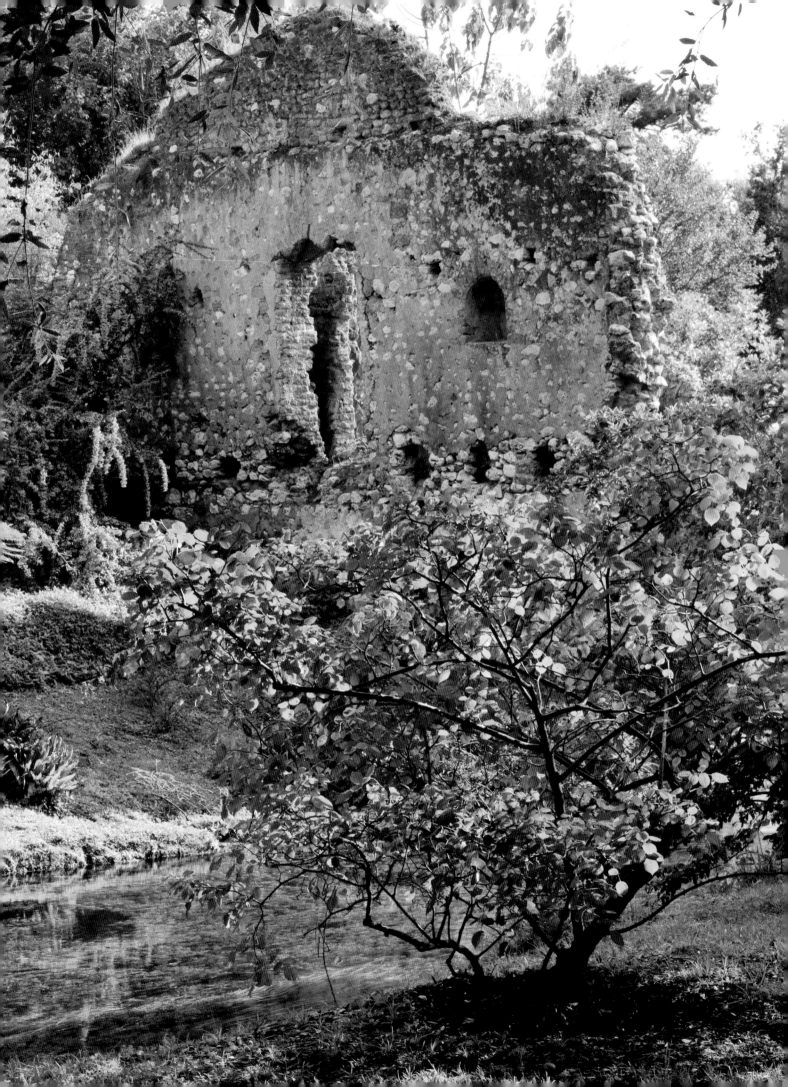

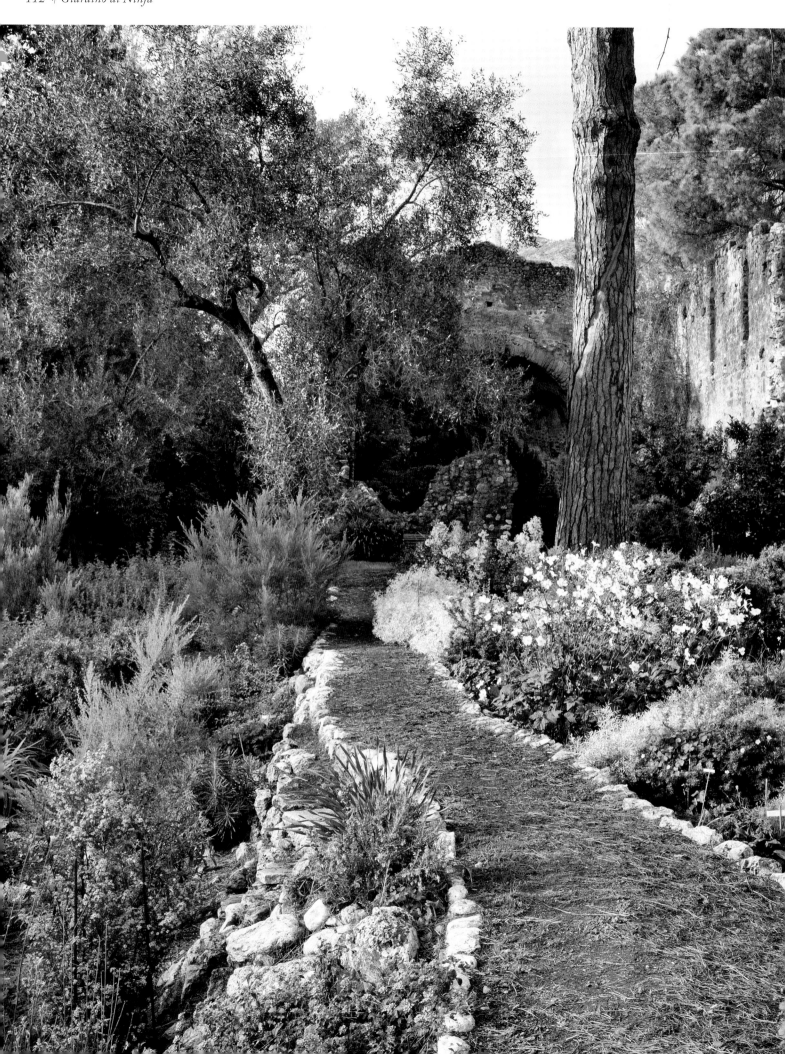

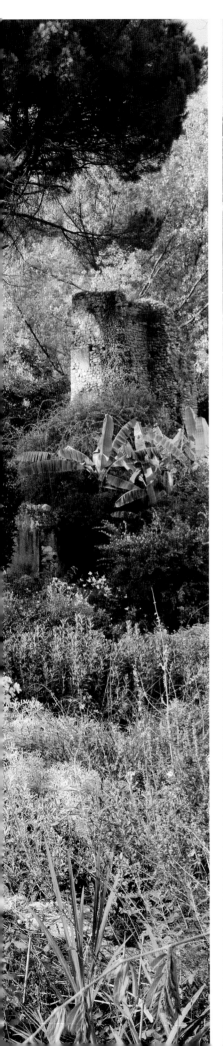

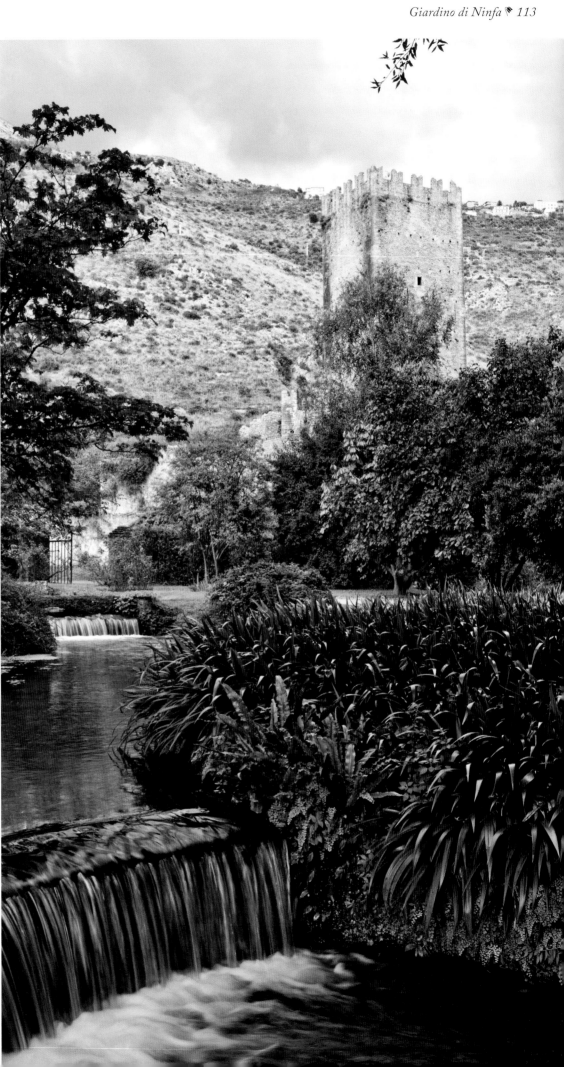

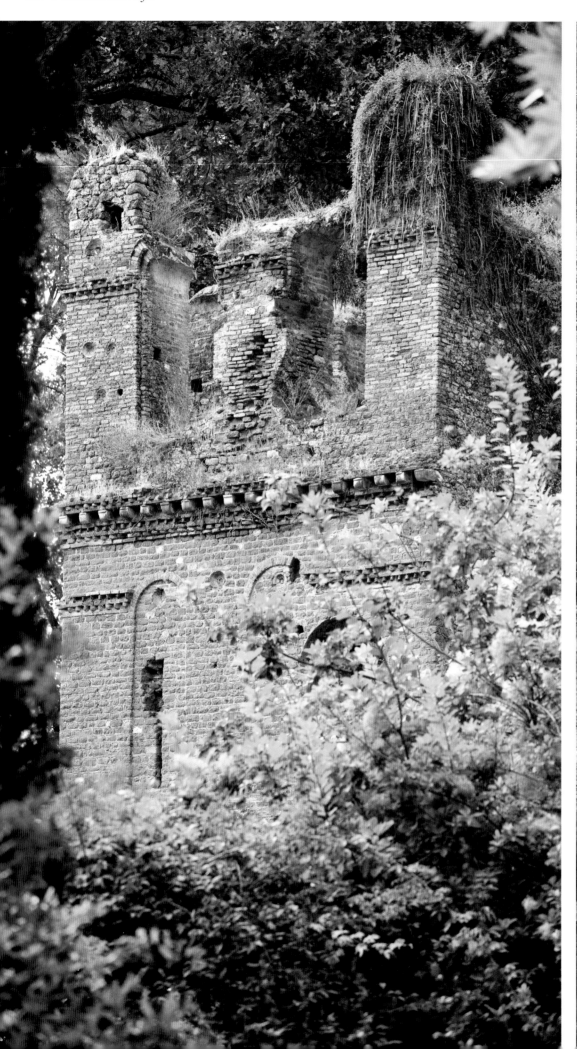
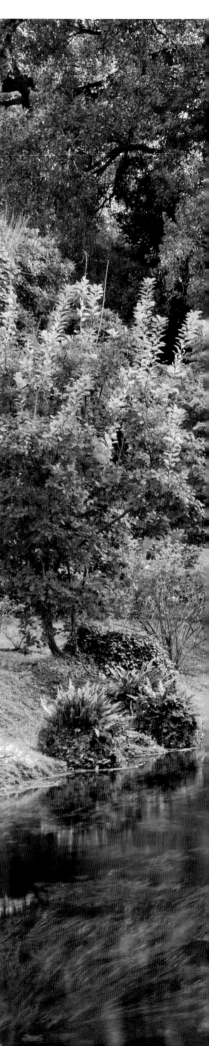

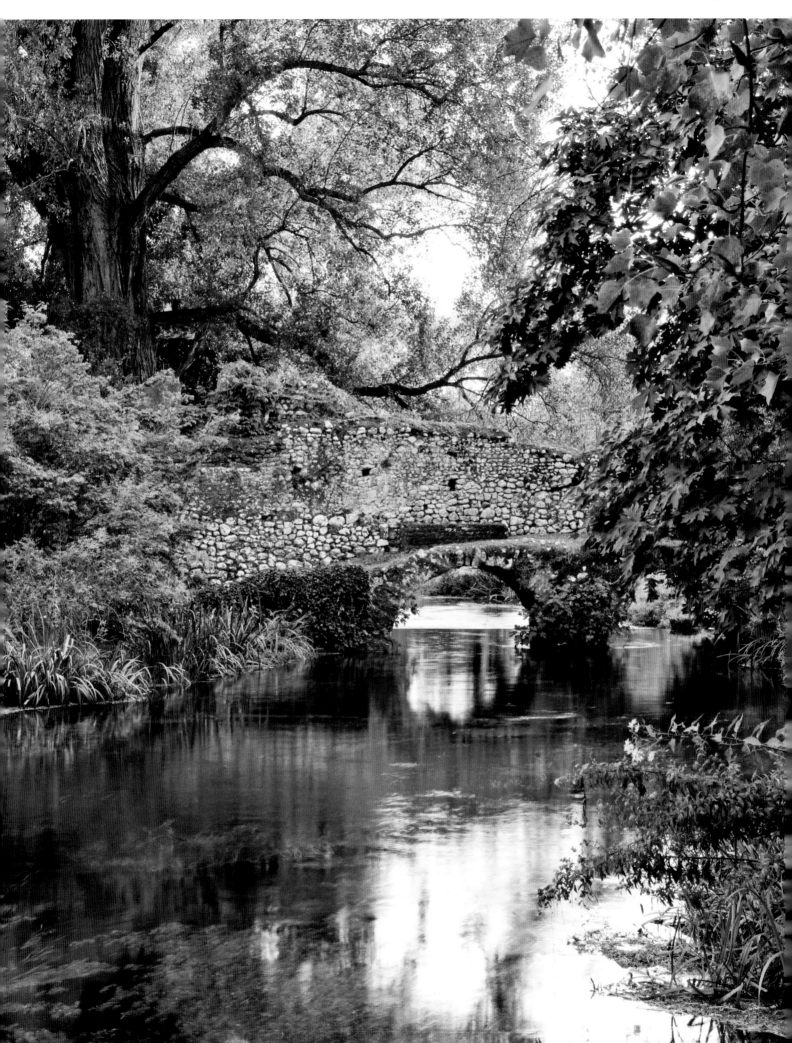

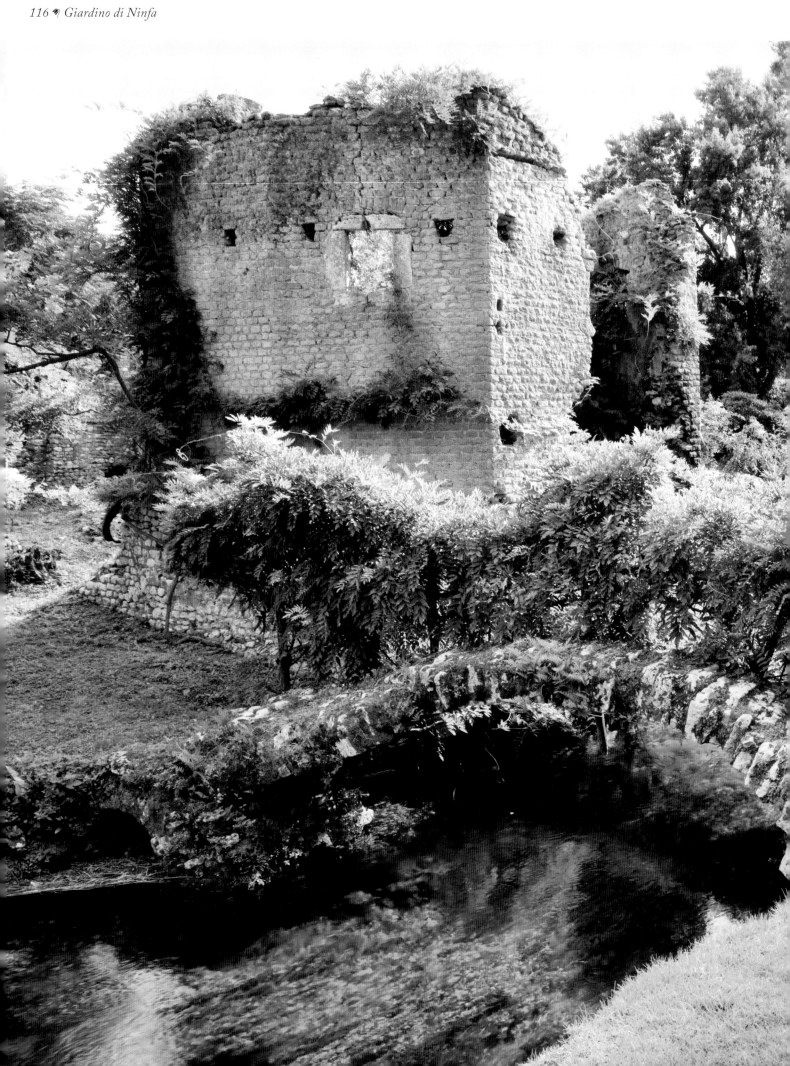

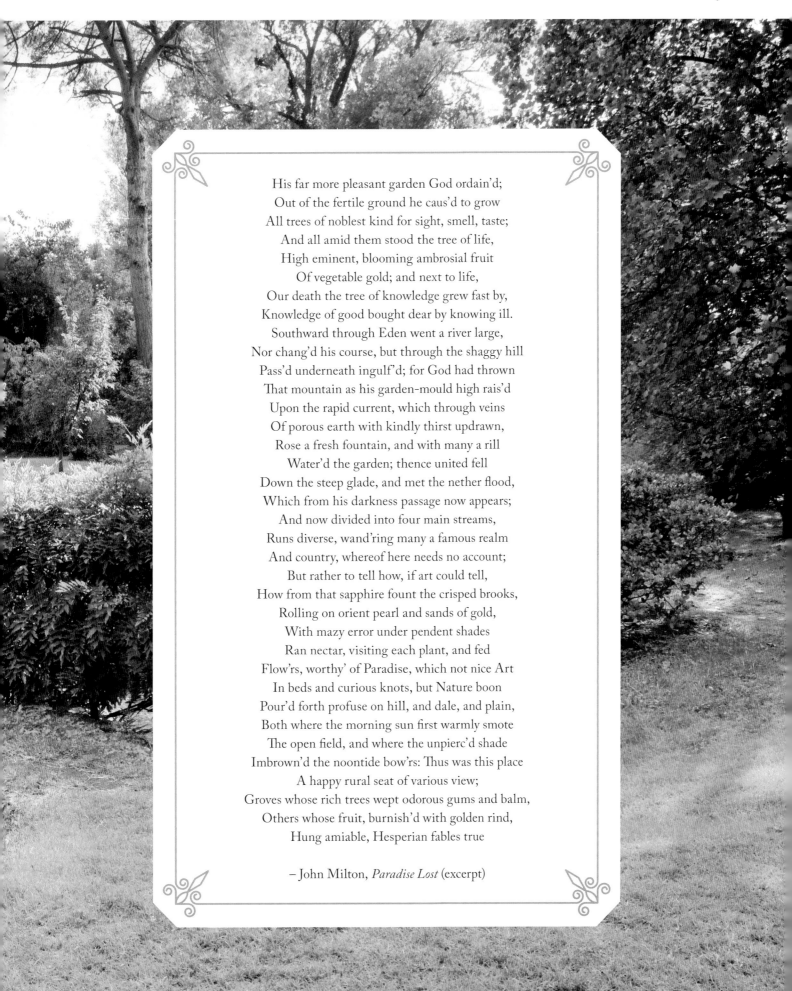

His far more pleasant garden God ordain'd;
Out of the fertile ground he caus'd to grow
All trees of noblest kind for sight, smell, taste;
And all amid them stood the tree of life,
High eminent, blooming ambrosial fruit
Of vegetable gold; and next to life,
Our death the tree of knowledge grew fast by,
Knowledge of good bought dear by knowing ill.
Southward through Eden went a river large,
Nor chang'd his course, but through the shaggy hill
Pass'd underneath ingulf'd; for God had thrown
That mountain as his garden-mould high rais'd
Upon the rapid current, which through veins
Of porous earth with kindly thirst updrawn,
Rose a fresh fountain, and with many a rill
Water'd the garden; thence united fell
Down the steep glade, and met the nether flood,
Which from his darkness passage now appears;
And now divided into four main streams,
Runs diverse, wand'ring many a famous realm
And country, whereof here needs no account;
But rather to tell how, if art could tell,
How from that sapphire fount the crisped brooks,
Rolling on orient pearl and sands of gold,
With mazy error under pendent shades
Ran nectar, visiting each plant, and fed
Flow'rs, worthy' of Paradise, which not nice Art
In beds and curious knots, but Nature boon
Pour'd forth profuse on hill, and dale, and plain,
Both where the morning sun first warmly smote
The open field, and where the unpierc'd shade
Imbrown'd the noontide bow'rs: Thus was this place
A happy rural seat of various view;
Groves whose rich trees wept odorous gums and balm,
Others whose fruit, burnish'd with golden rind,
Hung amiable, Hesperian fables true

– John Milton, *Paradise Lost* (excerpt)

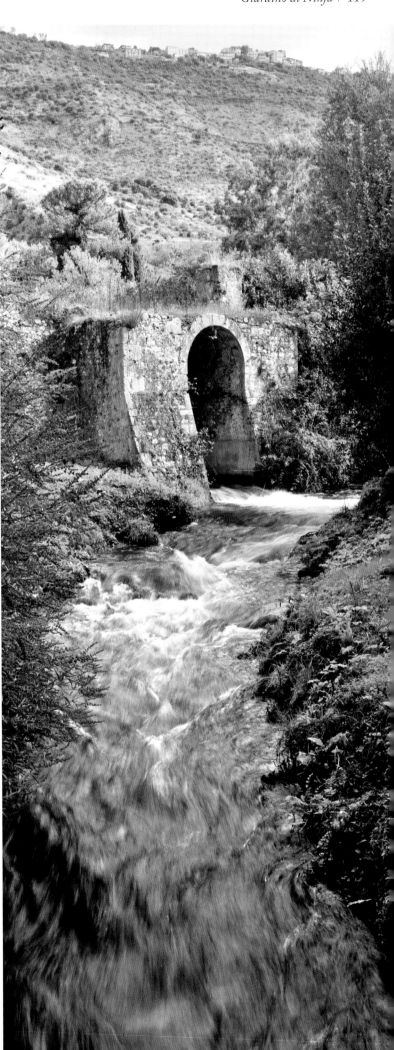

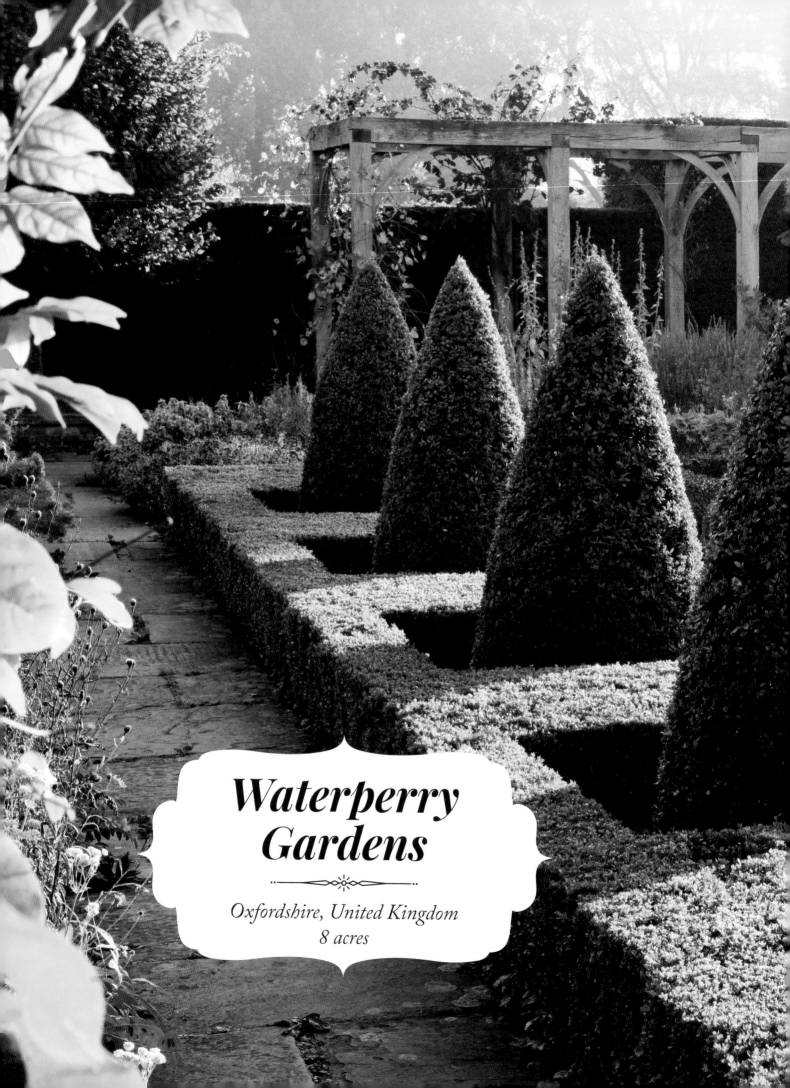

Waterperry Gardens

Oxfordshire, United Kingdom
8 acres

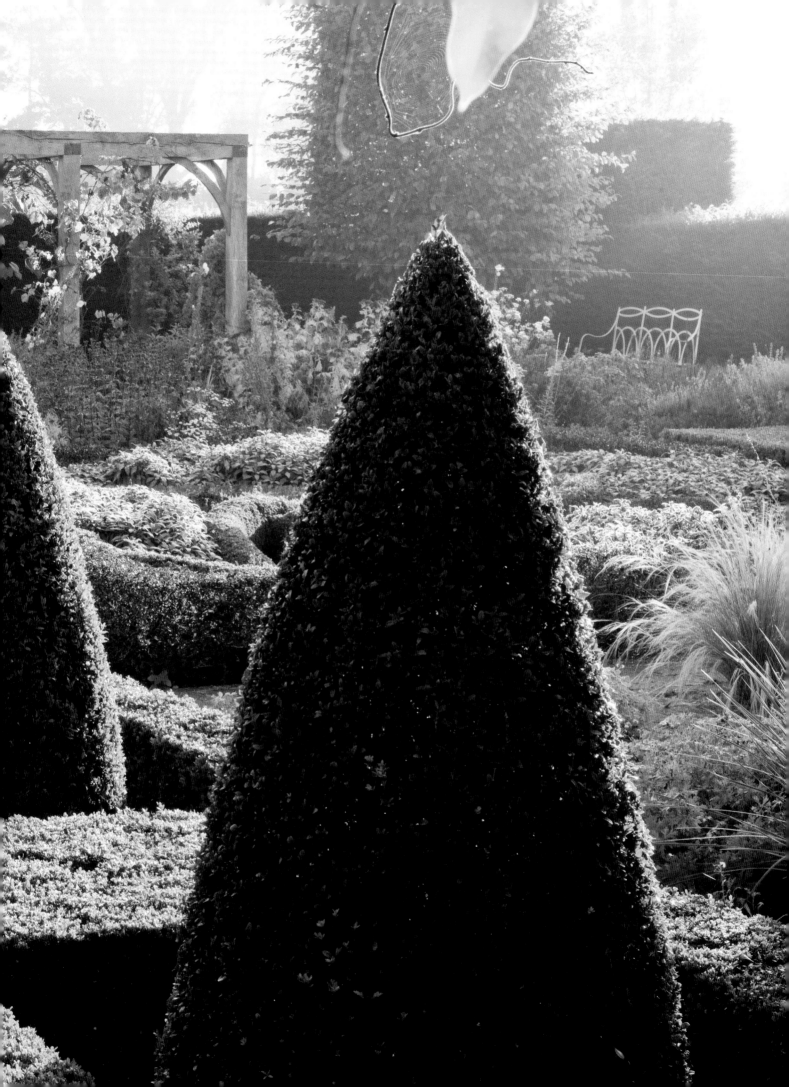

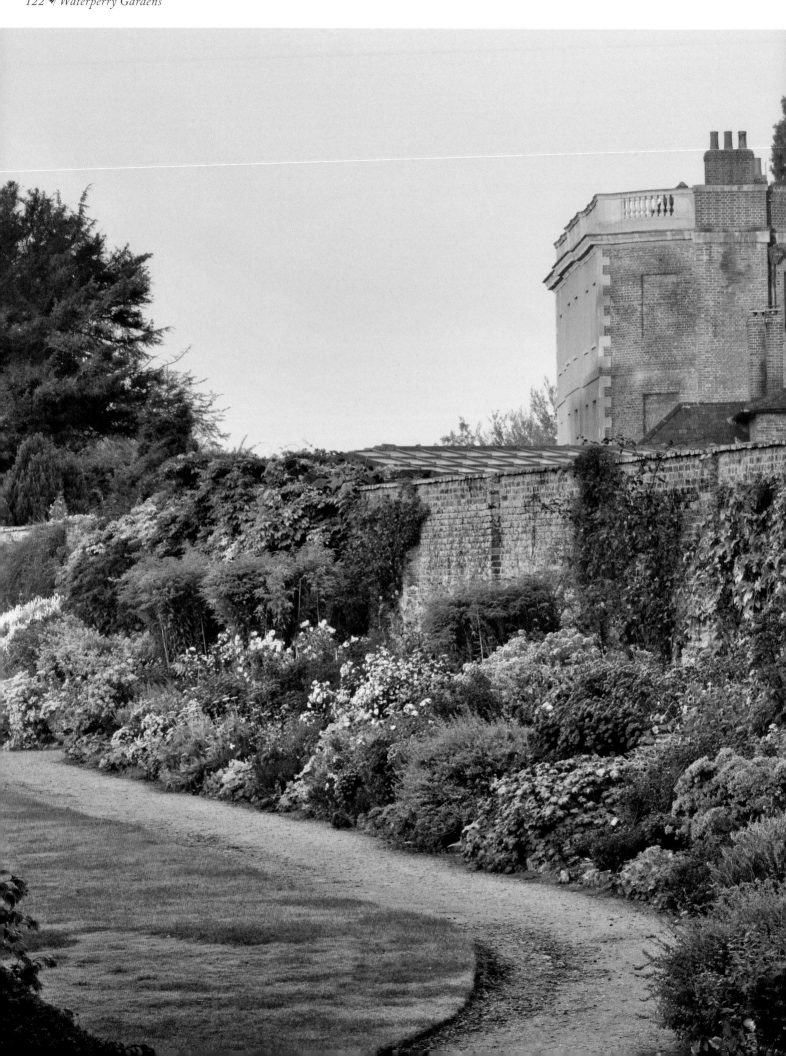

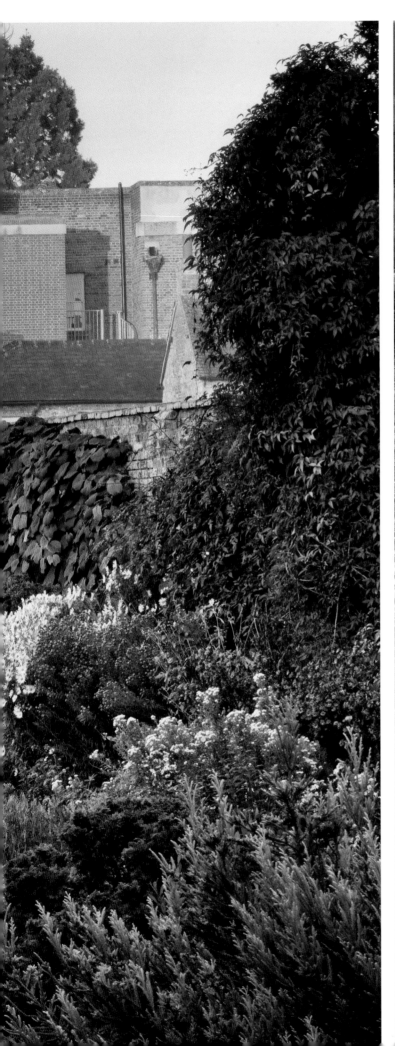
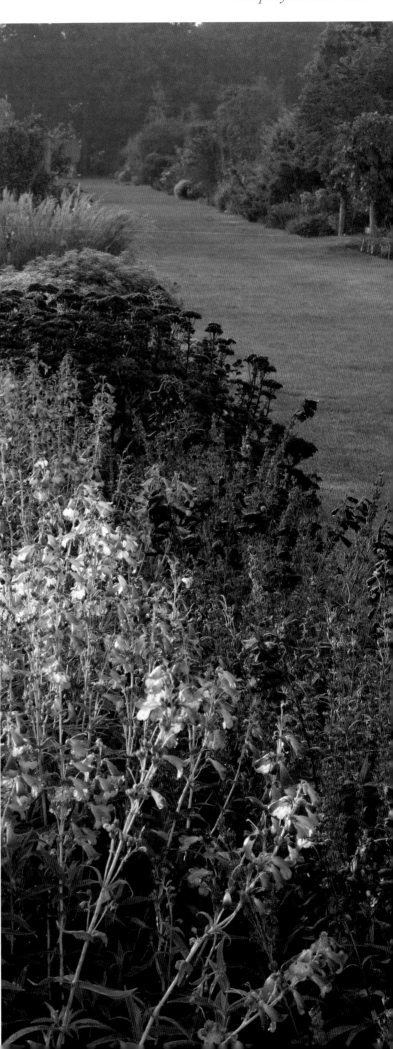

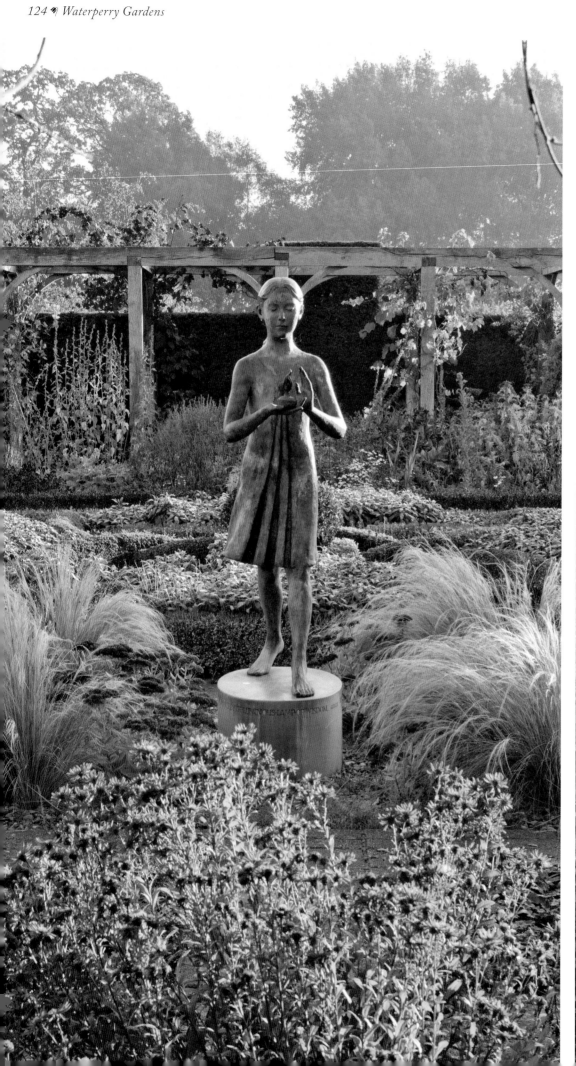
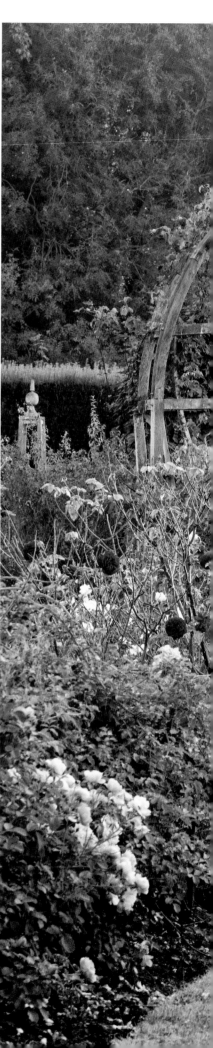

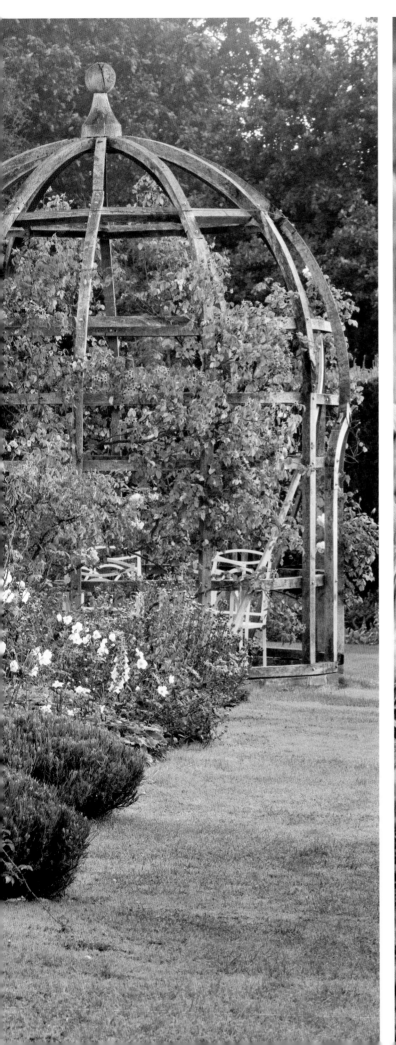

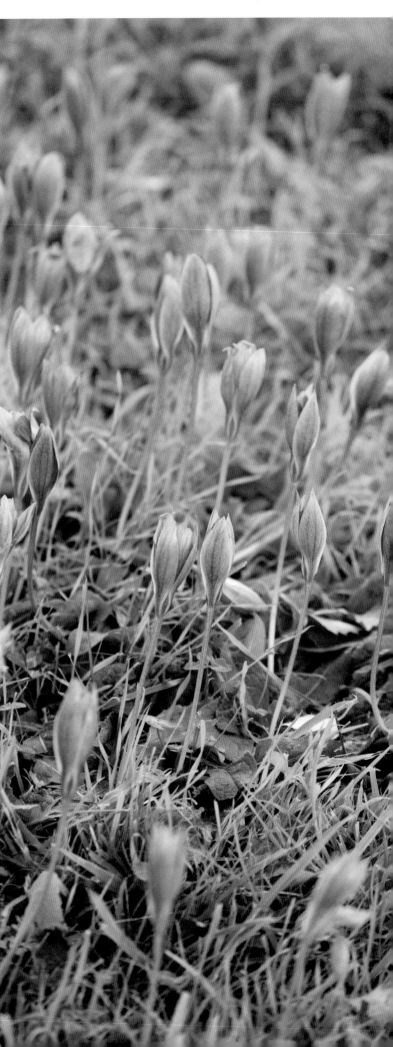

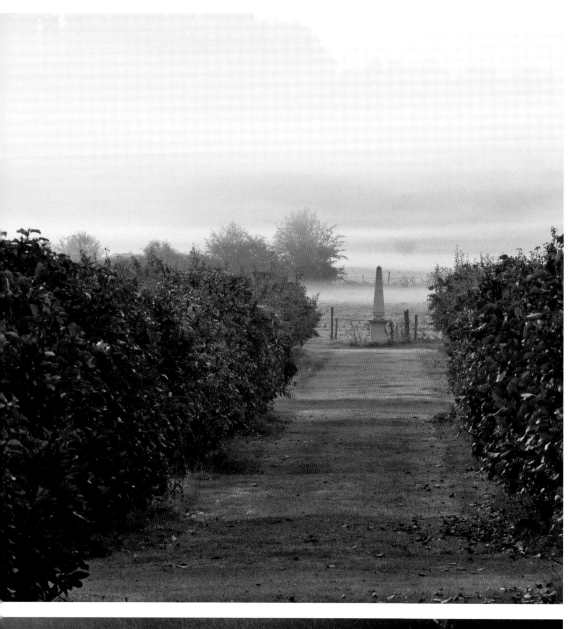

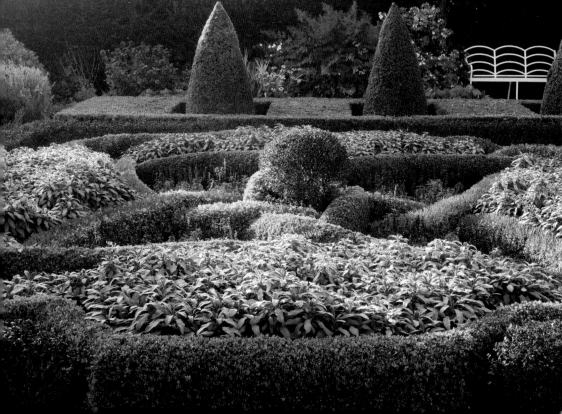

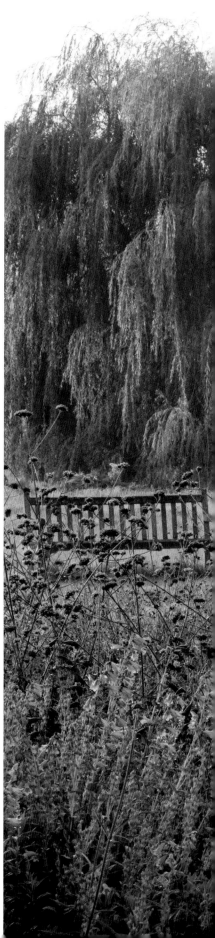

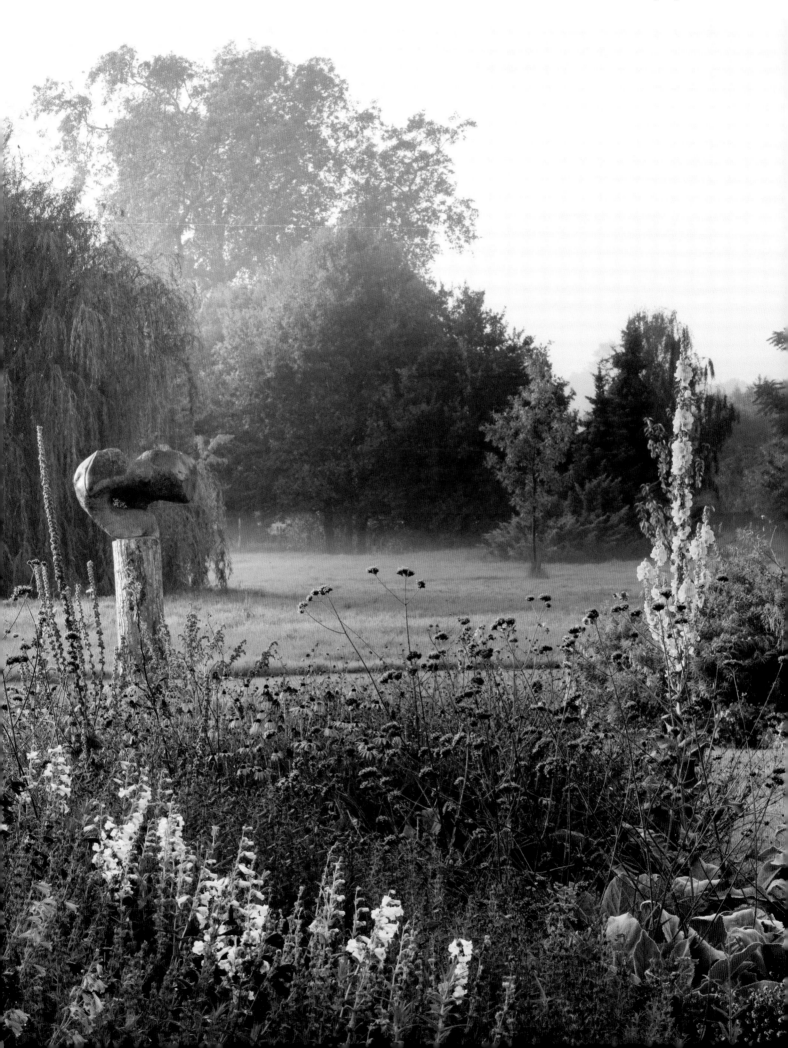

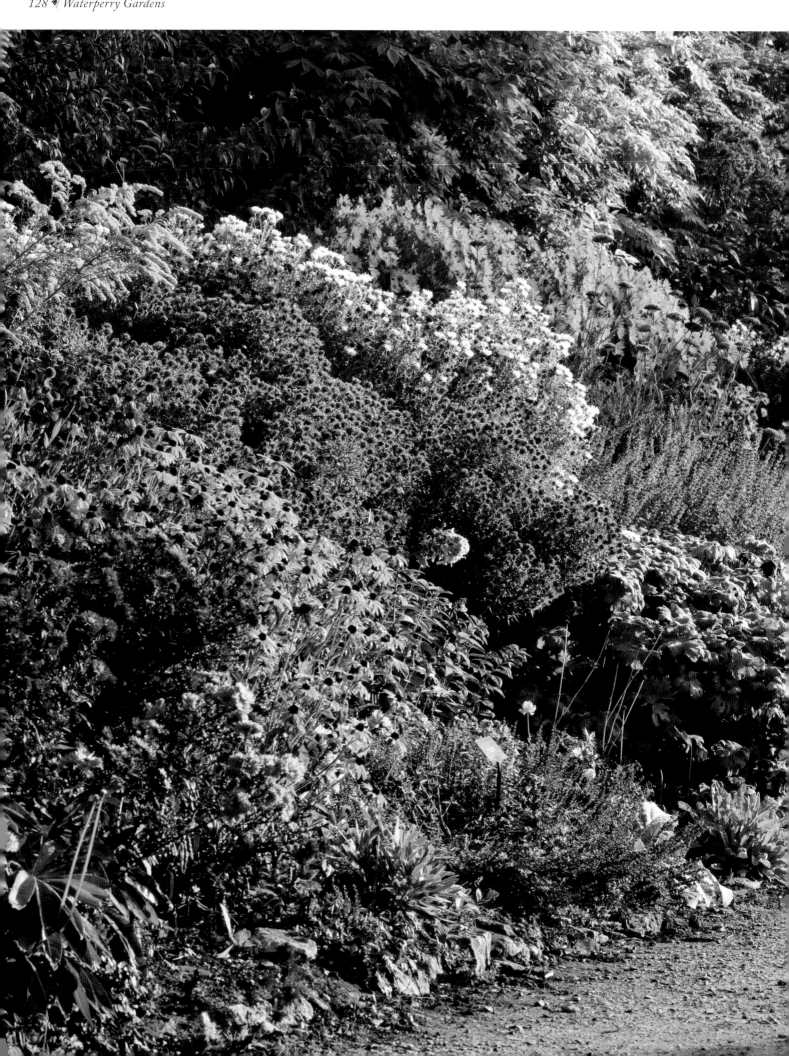

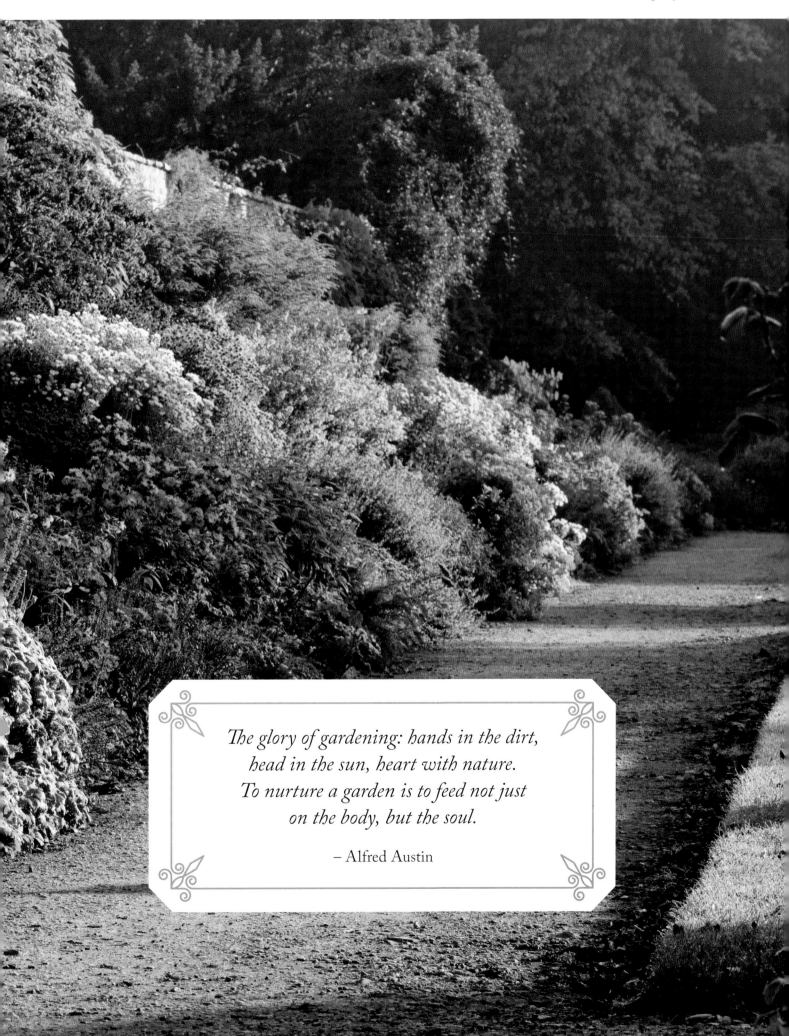

The glory of gardening: hands in the dirt,
head in the sun, heart with nature.
To nurture a garden is to feed not just
on the body, but the soul.

– Alfred Austin

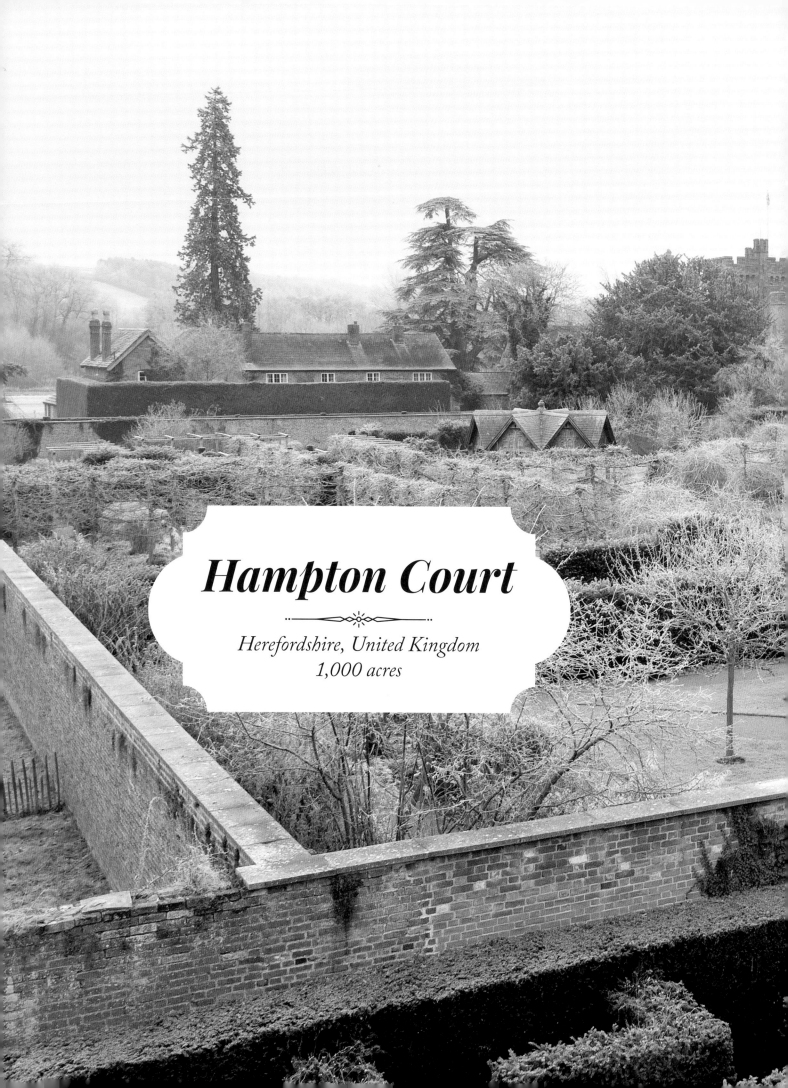

Hampton Court

·····✦·····

Herefordshire, United Kingdom
1,000 acres

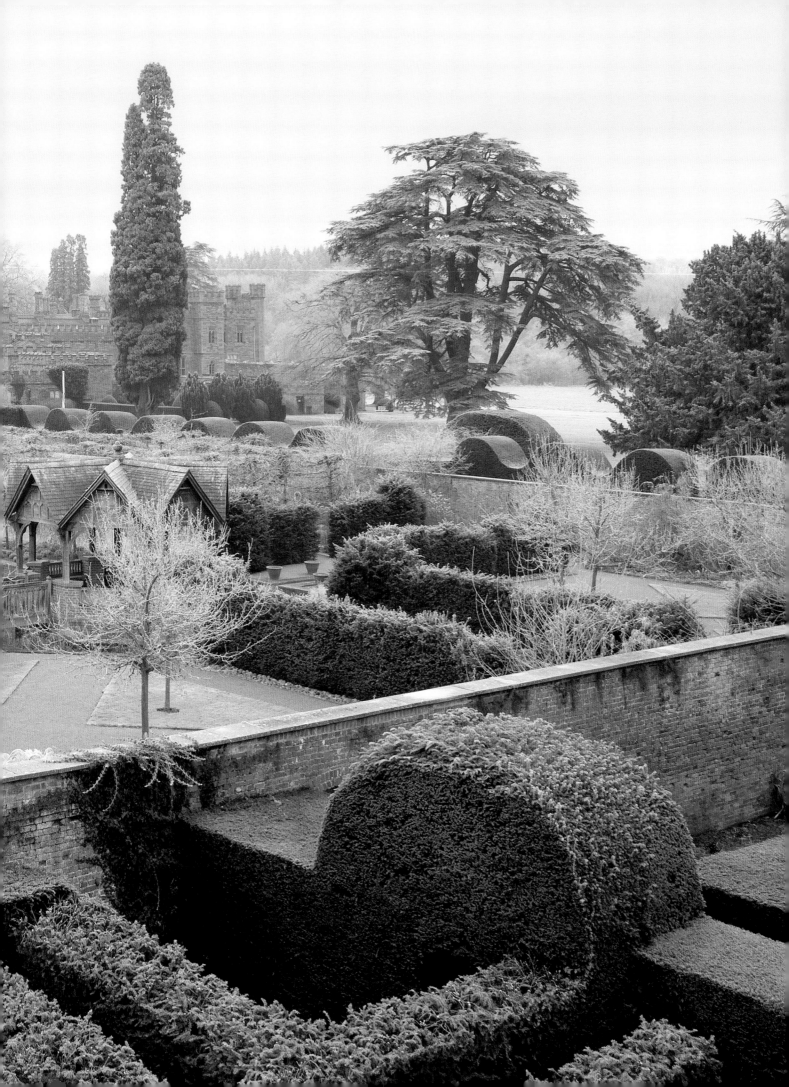

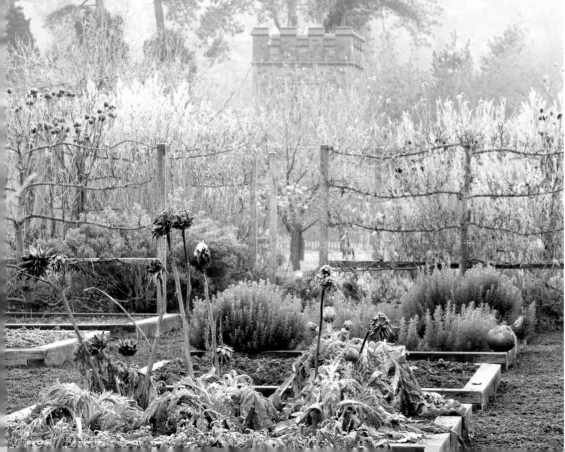

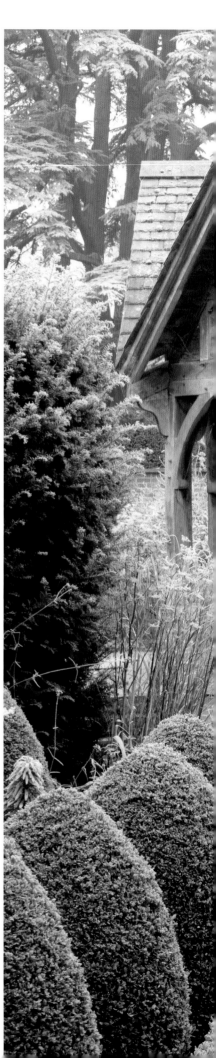

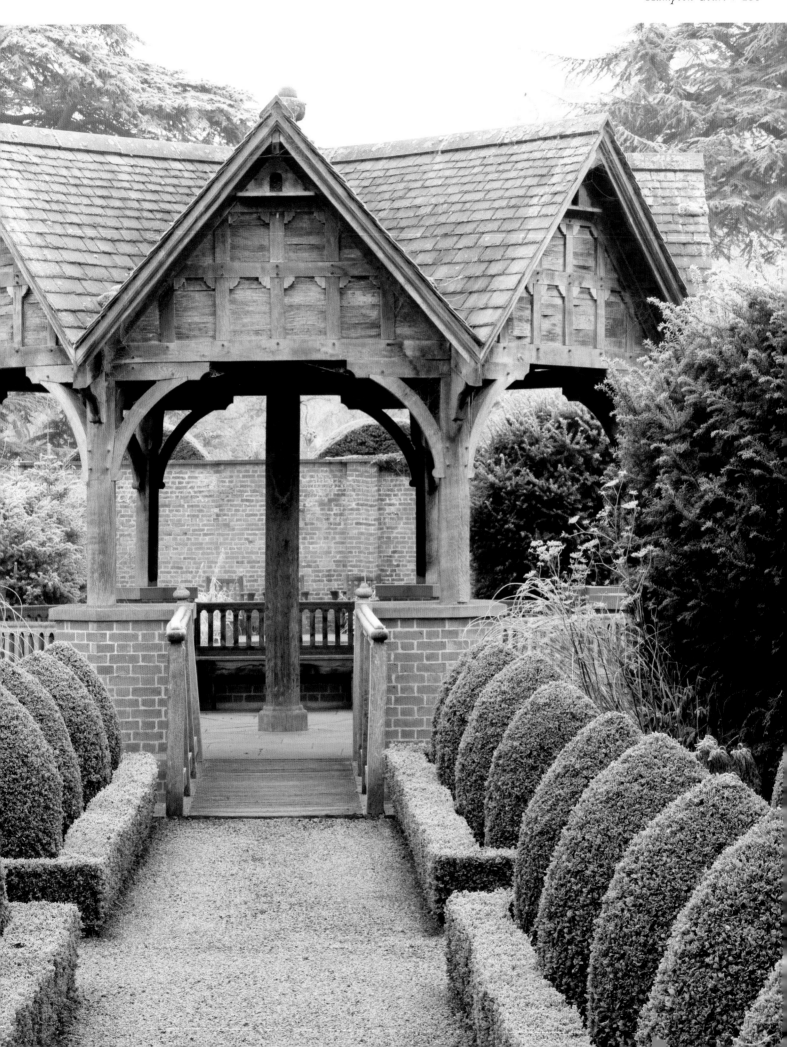

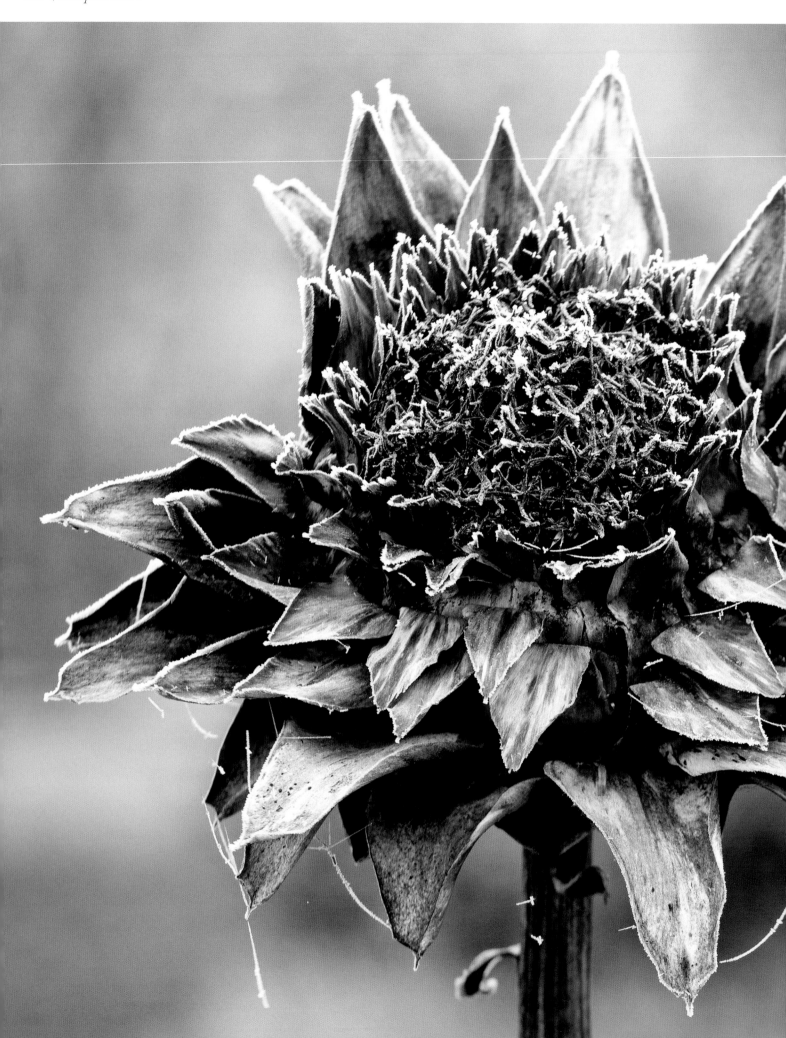

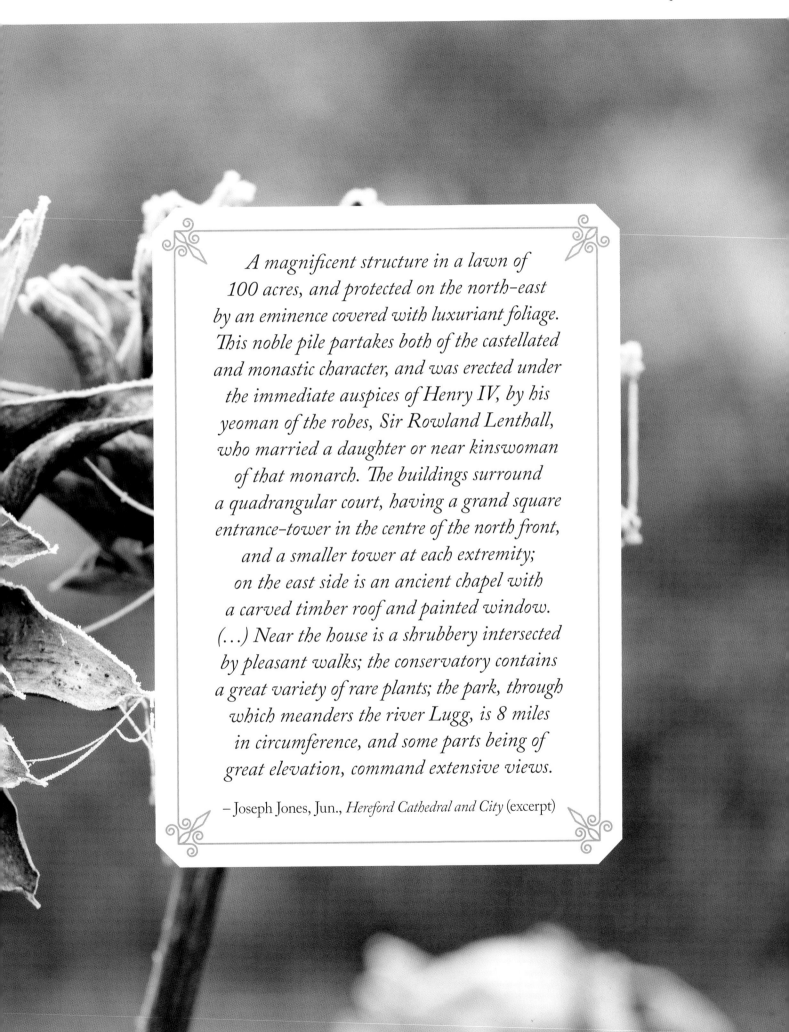

A magnificent structure in a lawn of
100 acres, and protected on the north-east
by an eminence covered with luxuriant foliage.
This noble pile partakes both of the castellated
and monastic character, and was erected under
the immediate auspices of Henry IV, by his
yeoman of the robes, Sir Rowland Lenthall,
who married a daughter or near kinswoman
of that monarch. The buildings surround
a quadrangular court, having a grand square
entrance-tower in the centre of the north front,
and a smaller tower at each extremity;
on the east side is an ancient chapel with
a carved timber roof and painted window.
(…) Near the house is a shrubbery intersected
by pleasant walks; the conservatory contains
a great variety of rare plants; the park, through
which meanders the river Lugg, is 8 miles
in circumference, and some parts being of
great elevation, command extensive views.

– Joseph Jones, Jun., *Hereford Cathedral and City* (excerpt)

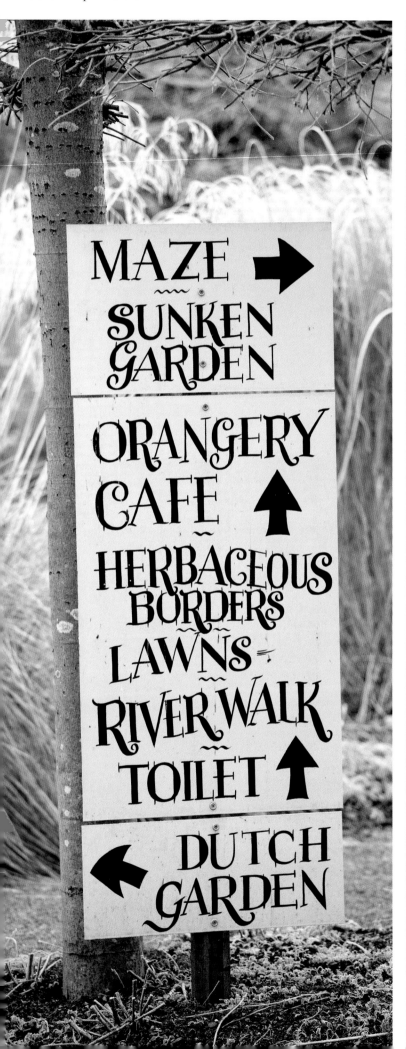

MAZE →
SUNKEN
GARDEN

ORANGERY
CAFE ↑
HERBACEOUS
BORDERS
LAWNS
RIVER WALK
TOILET ↑

← DUTCH
GARDEN

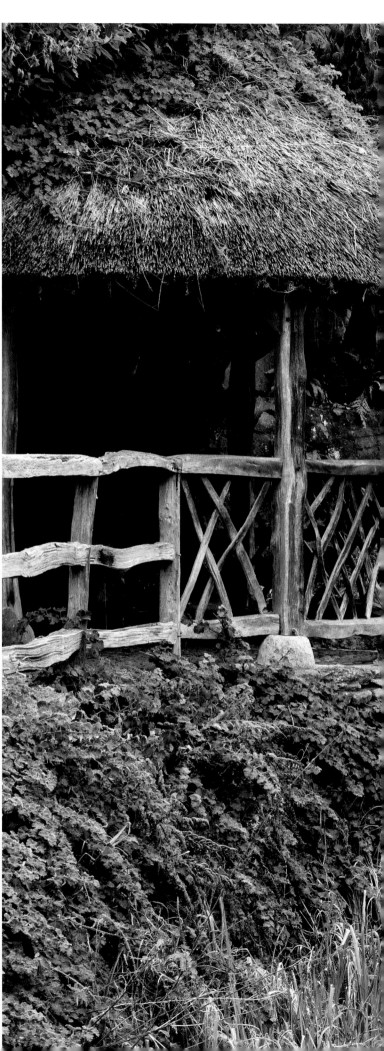

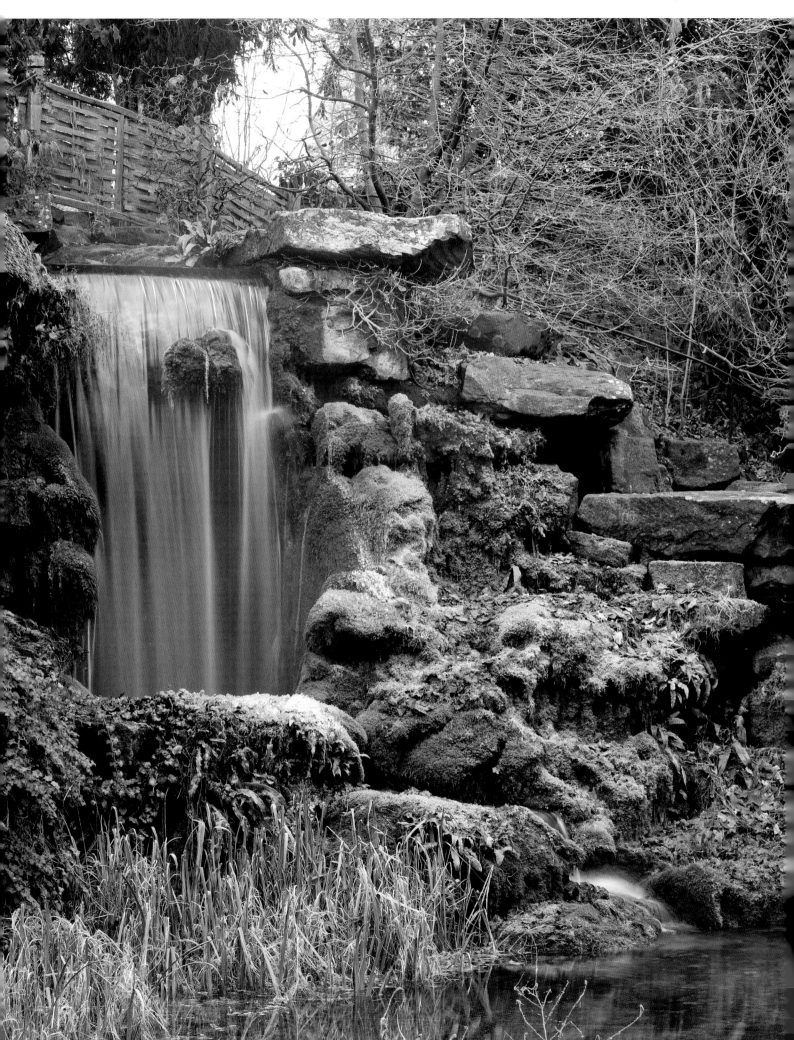

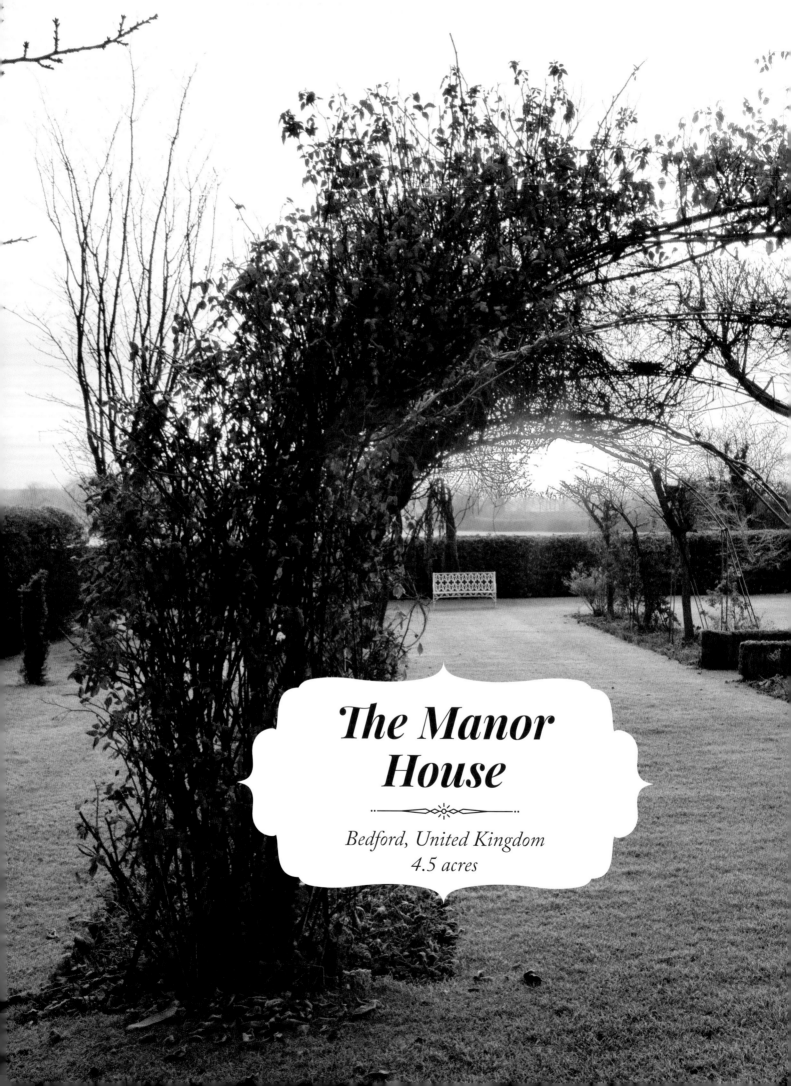

The Manor House

····•◦✦◦•····

Bedford, United Kingdom
4.5 acres

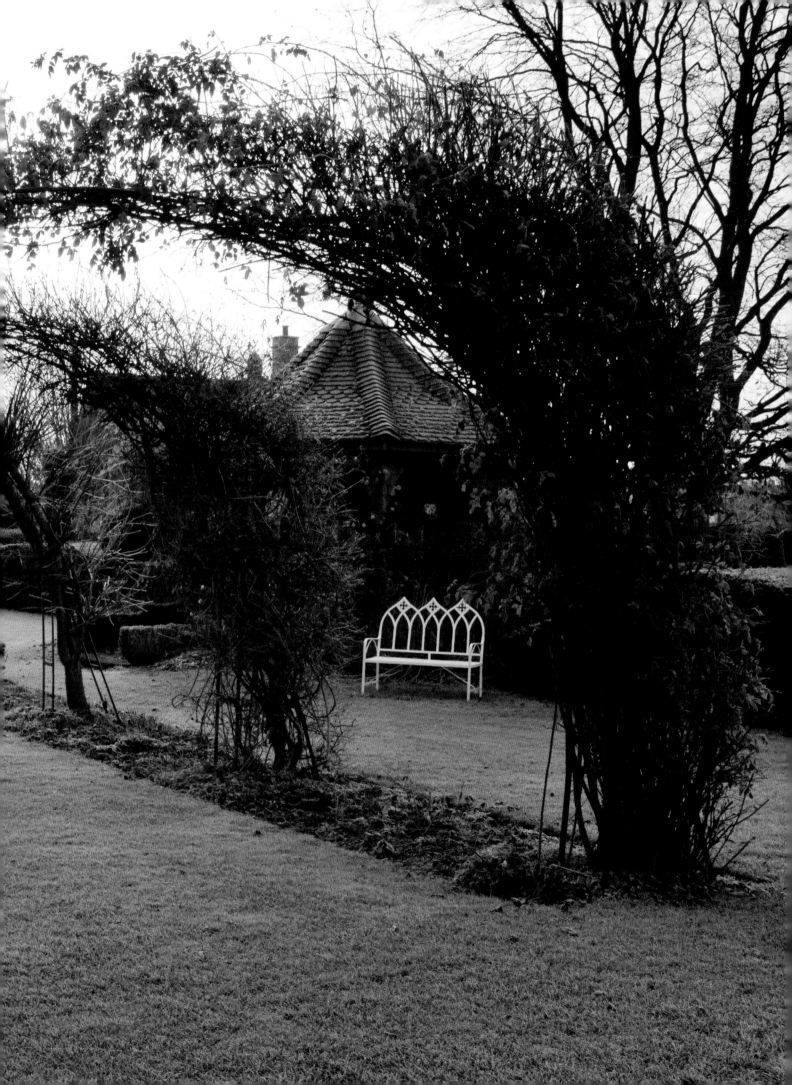

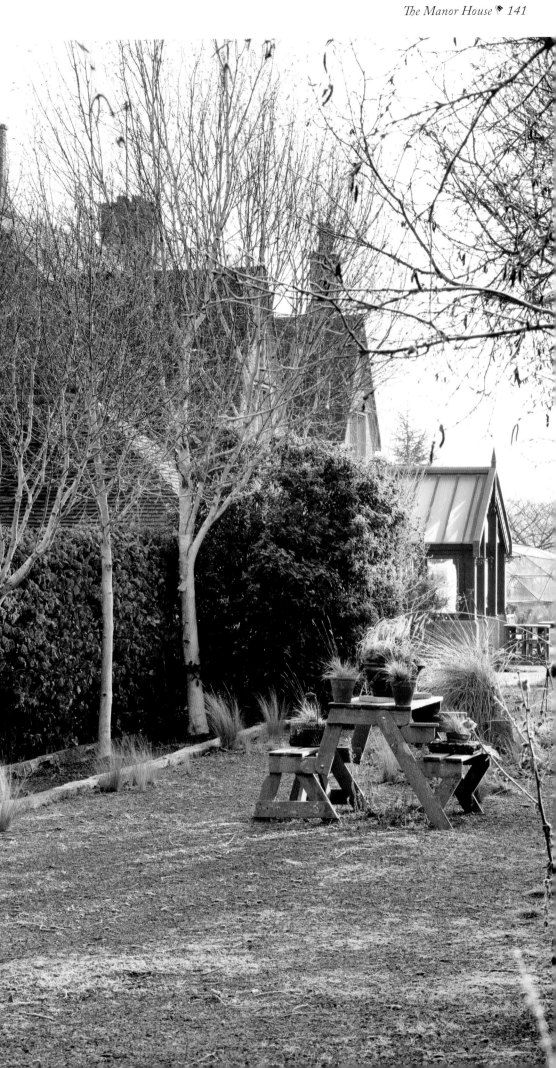

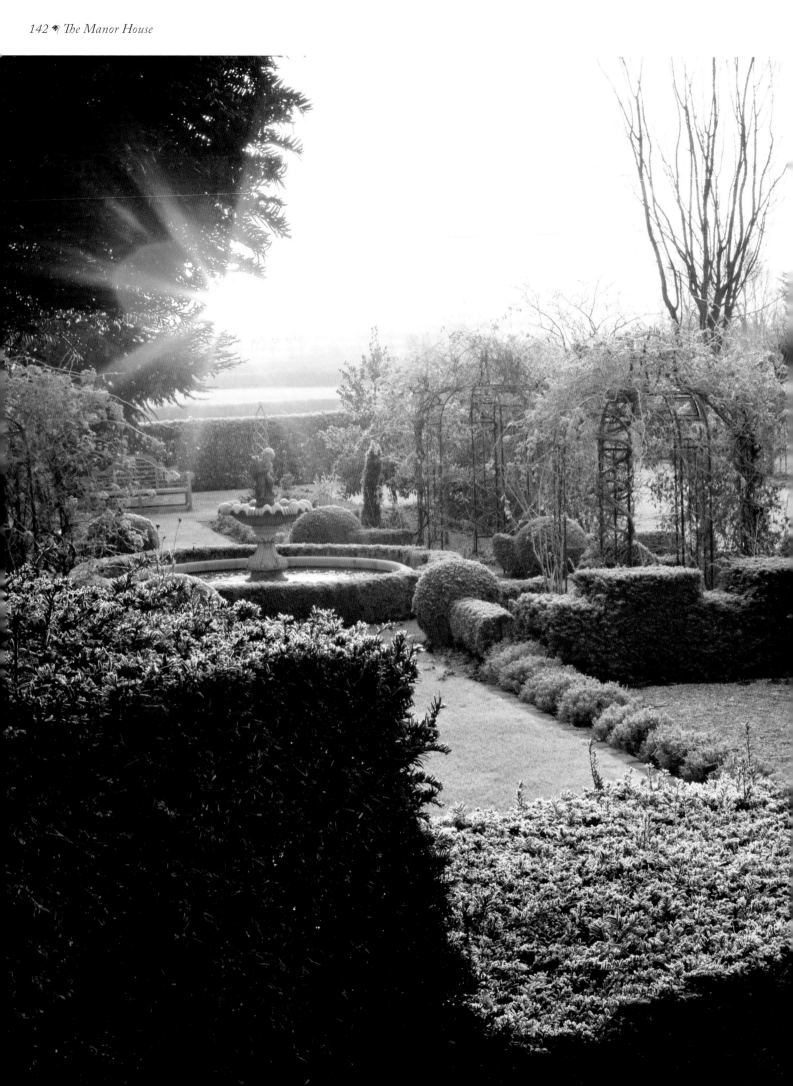

Mary did not shout, but she looked at things. There was nothing else to do. She walked round and round the gardens and wandered about the paths in the park. Sometimes she looked for Ben Weatherstaff, but though several times she saw him at work he was too busy to look at her or was too surly. Once when she was walking toward him he picked up his spade and turned away as if he did it on purpose.

One place she went to oftener than to any other. It was the long walk outside the gardens with the walls round them. There were bare flower-beds on either side of it and against the walls ivy grew thickly. There was one part of the wall where the creeping dark green leaves were more bushy than elsewhere. It seemed as if for a long time that part had been neglected. The rest of it had been clipped and made to look neat, but at this lower end of the walk it had not been trimmed at all.

A few days after she had talked to Ben Weatherstaff Mary stopped to notice this and wondered why it was so. She had just paused and was looking up at a long spray of ivy swinging in the wind when she saw a gleam of scarlet and heard a brilliant chirp, and there, on the top of the wall, perched Ben Weatherstaff's robin redbreast, tilting forward to look at her with his small head on one side.

"Oh!" she cried out, "is it you—is it you?" And it did not seem at all queer to her that she spoke to him as if she was sure that he would understand and answer her.

He did answer. He twittered and chirped and hopped along the wall as if he were telling her all sorts of things. It seemed to Mistress Mary as if she understood him, too, though he was not speaking in words. It was as if he said:

"Good morning! Isn't the wind nice? Isn't the sun nice? Isn't everything nice? Let us both chirp and hop and twitter. Come on! Come on!"

Mary began to laugh, and as he hopped and took little flights along the wall she ran after him. Poor little thin, sallow, ugly Mary—she actually looked almost pretty for a moment.

"I like you! I like you!" she cried out, pattering down the walk; and she chirped and tried to whistle, which last she did not know how to do in the least. But the robin seemed to be quite satisfied and chirped and whistled back at her. At last he spread his wings and made a darting flight to the top of a tree, where he perched and sang loudly.

That reminded Mary of the first time she had seen him. He had been swinging on a tree-top then and she had been standing in the orchard. Now she was on the other side of the orchard and standing in the path outside a wall—much lower down—and there was the same tree inside.

"It's in the garden no one can go into," she said to herself. "It's the garden without a door. He lives in there. How I wish I could see what it is like!"

She ran up the walk to the green door she had entered the first morning. Then she ran down the path through the other door and then into the orchard, and when she stood and looked up there was the tree on the other side of the wall, and there was the robin just finishing his song and beginning to preen his feathers with his beak.

"It is the garden," she said. "I am sure it is."

She walked round and looked closely at that side of the orchard wall, but she only found what she had found before—that there was no door in it. Then she ran through the kitchen-gardens again and out into the walk outside the long ivy-covered wall, and she walked to the end of it and looked at it, but there was no door; and then she walked to the other end, looking again, but there was no door.

– Frances Hodgson Burnett, *The Secret Garden* (excerpt)

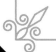
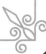

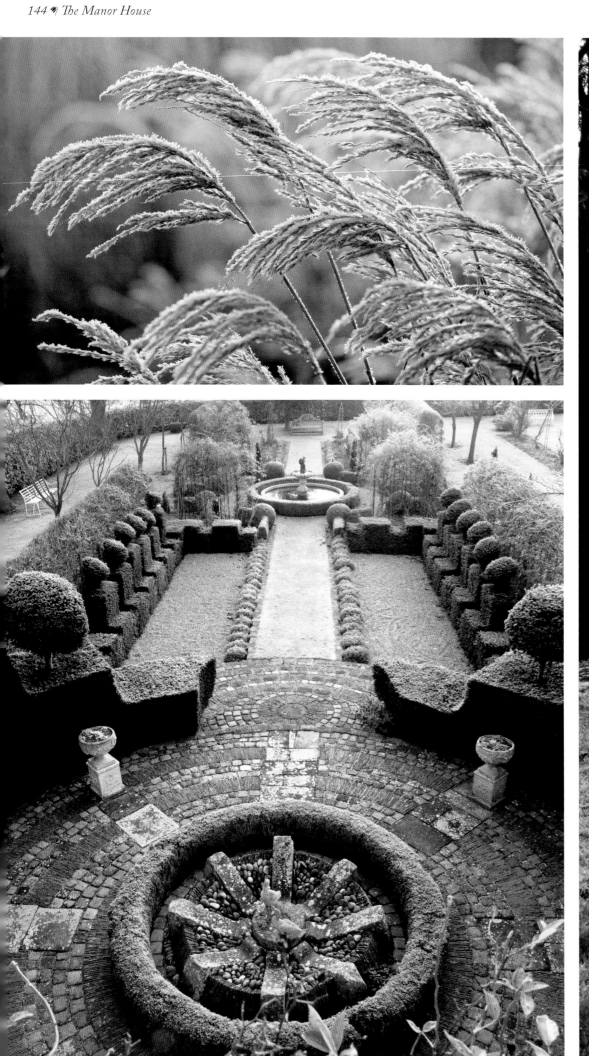
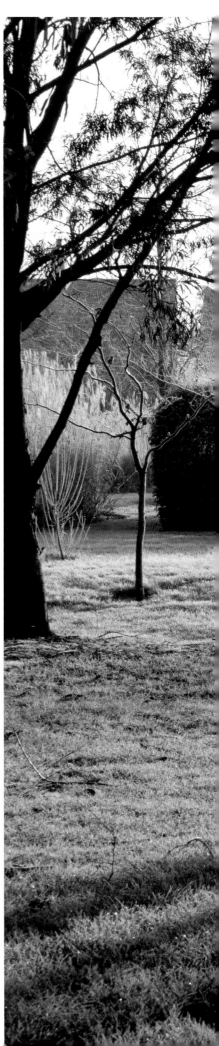

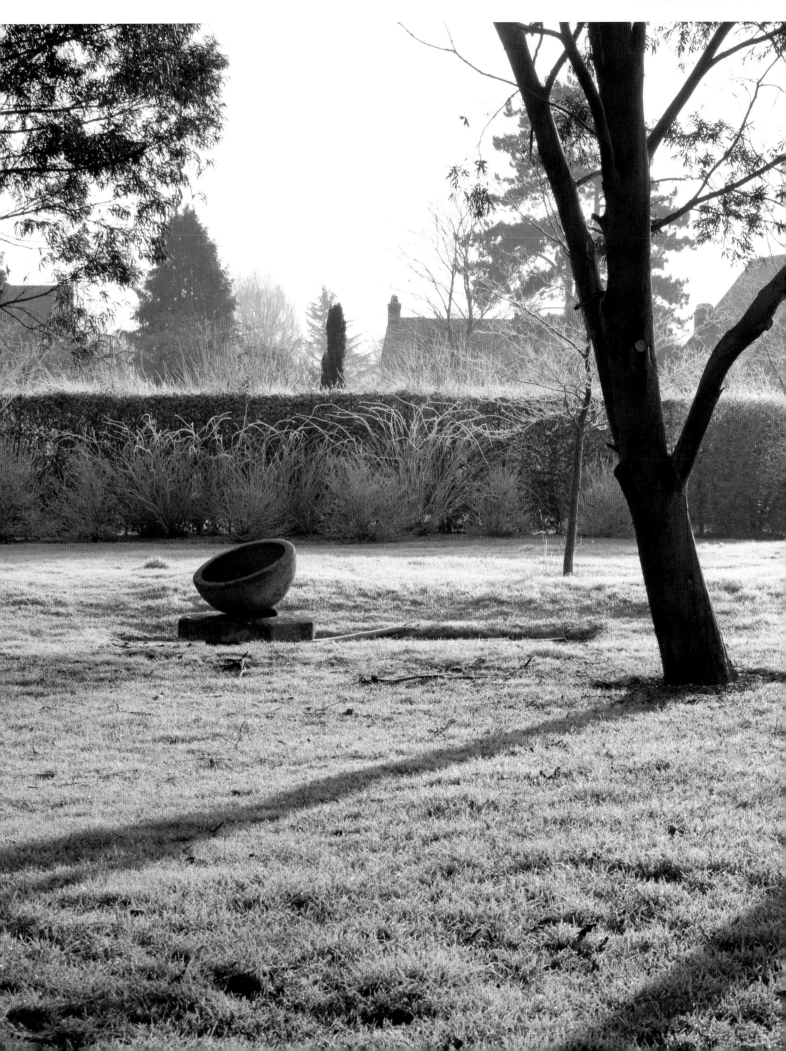

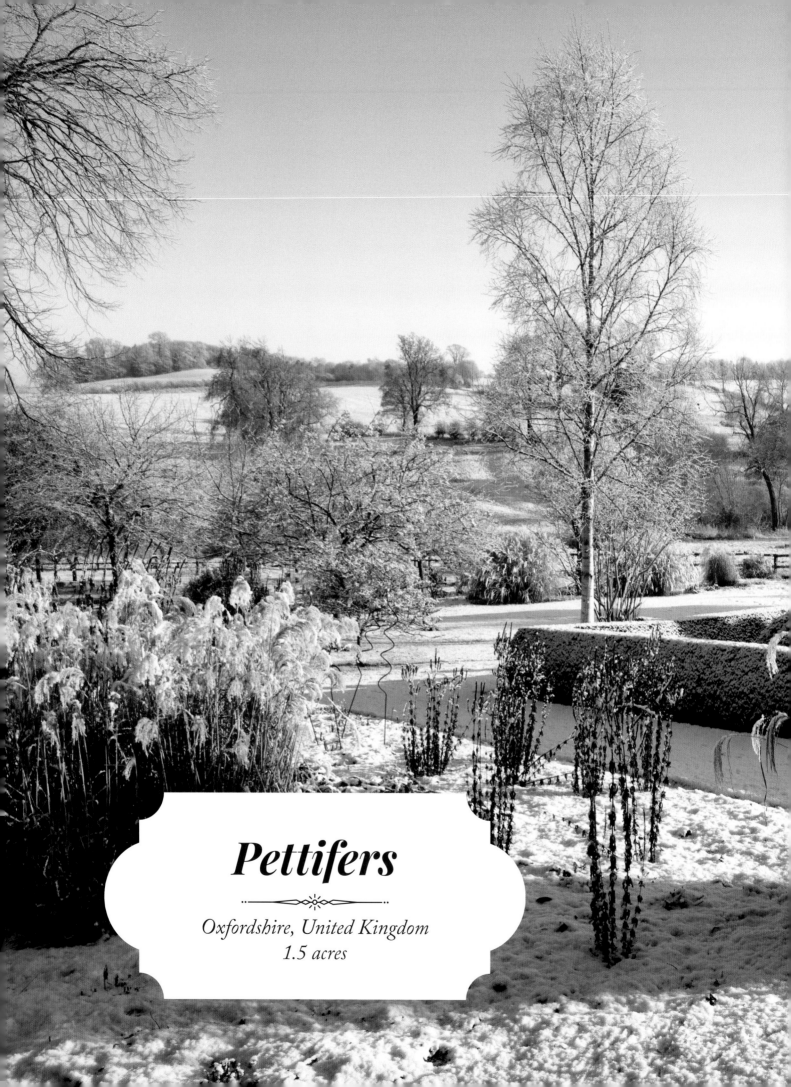

Pettifers

—◦◦⬦◦◦—

Oxfordshire, United Kingdom
1.5 acres

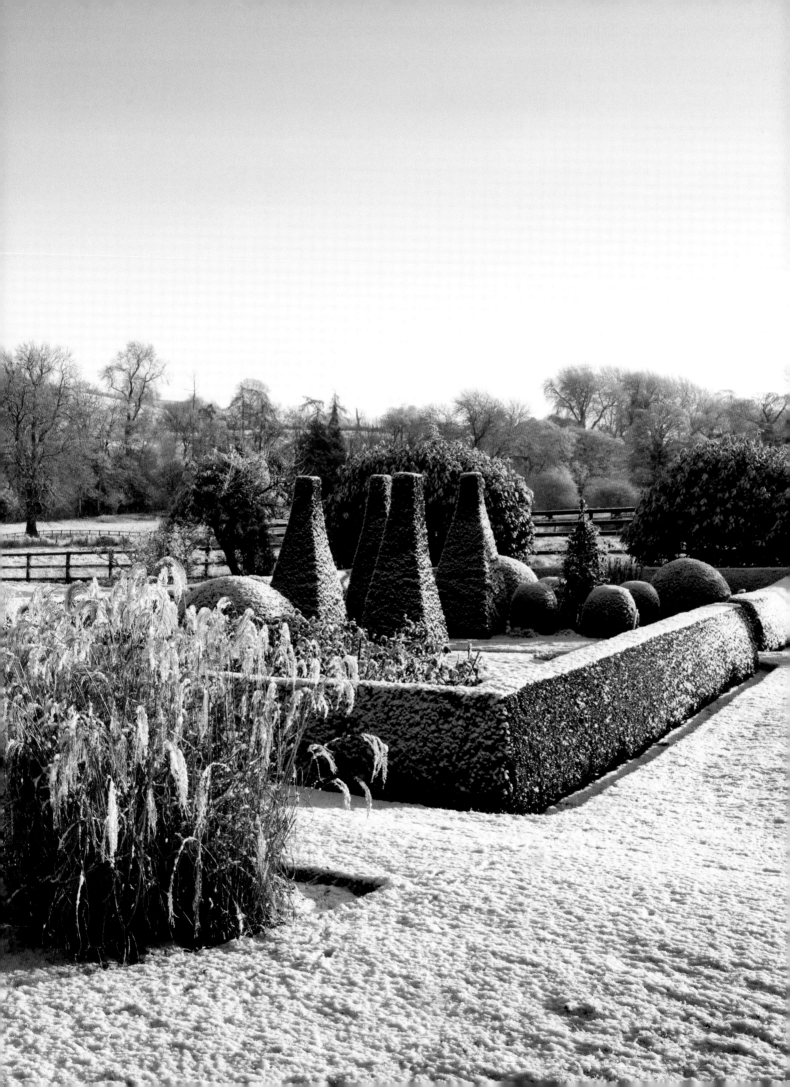

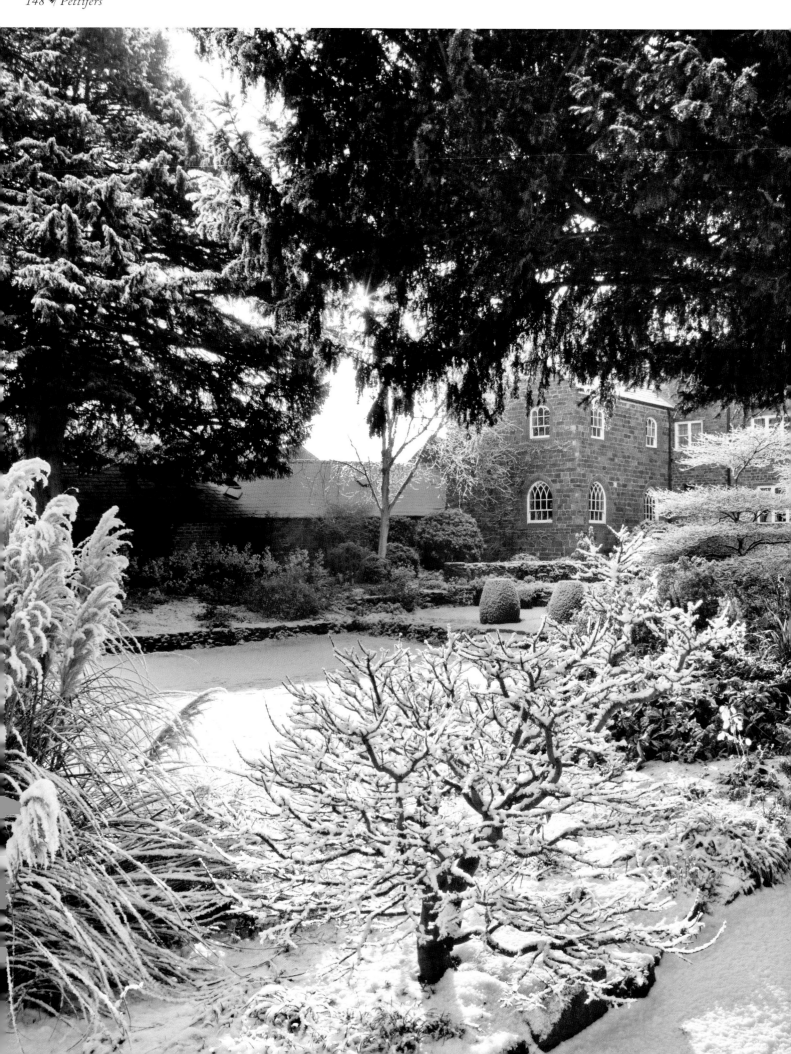

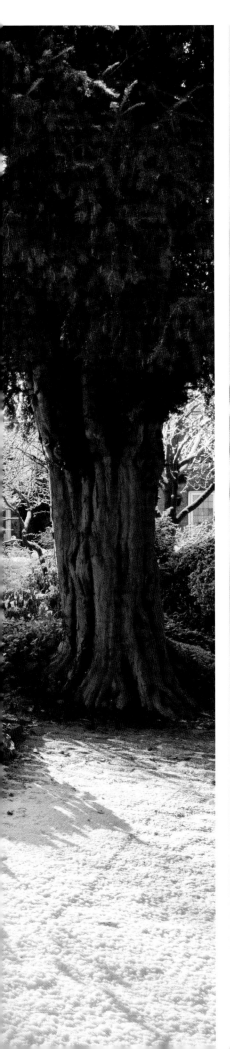
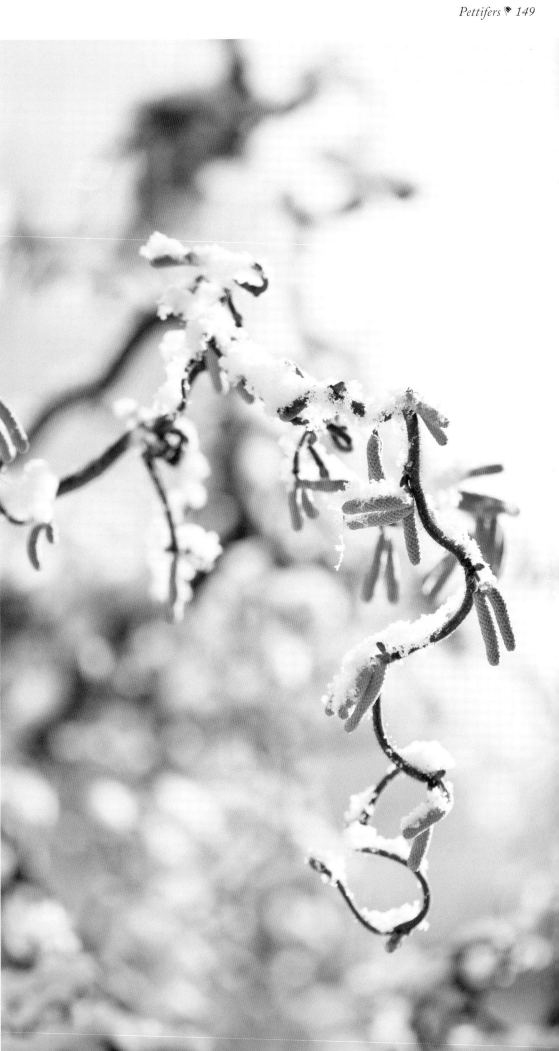

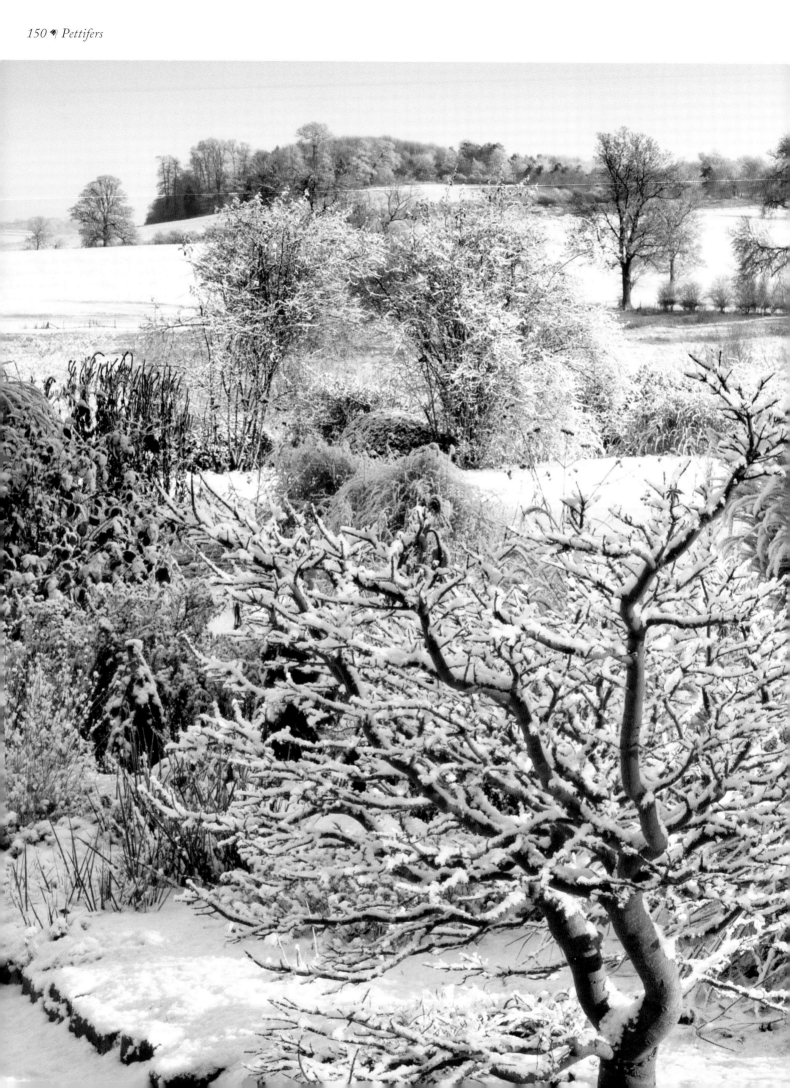

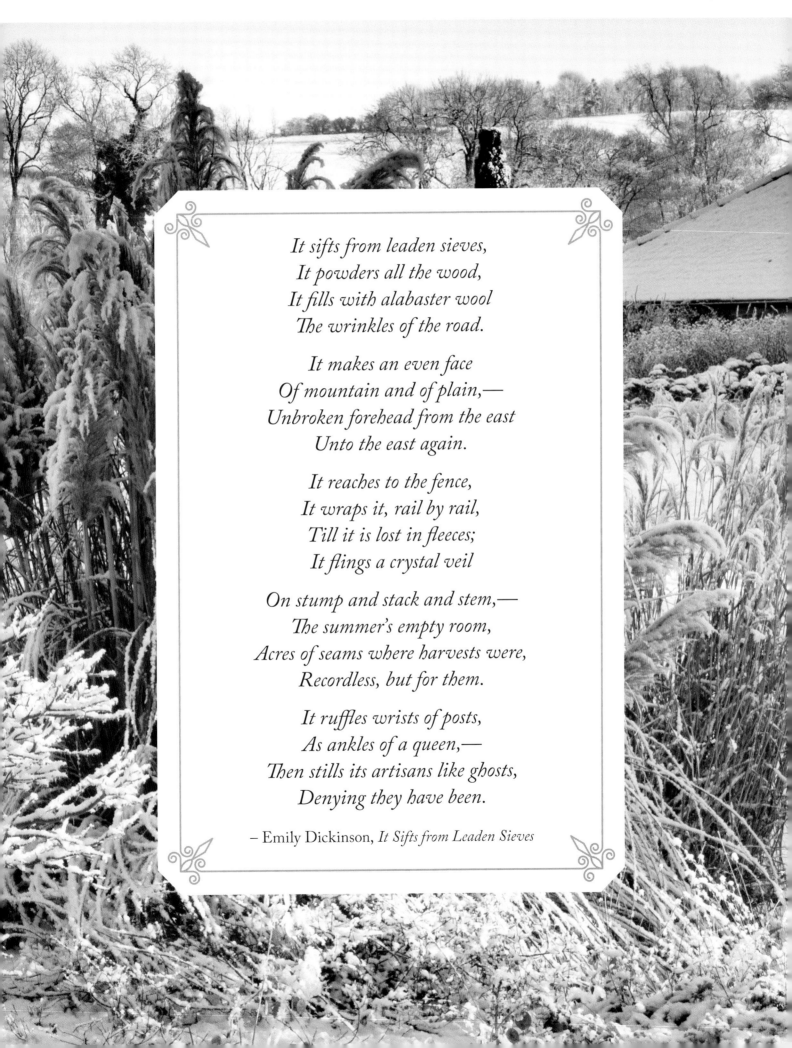

It sifts from leaden sieves,
It powders all the wood,
It fills with alabaster wool
The wrinkles of the road.

It makes an even face
Of mountain and of plain,—
Unbroken forehead from the east
Unto the east again.

It reaches to the fence,
It wraps it, rail by rail,
Till it is lost in fleeces;
It flings a crystal veil

On stump and stack and stem,—
The summer's empty room,
Acres of seams where harvests were,
Recordless, but for them.

It ruffles wrists of posts,
As ankles of a queen,—
Then stills its artisans like ghosts,
Denying they have been.

– Emily Dickinson, *It Sifts from Leaden Sieves*

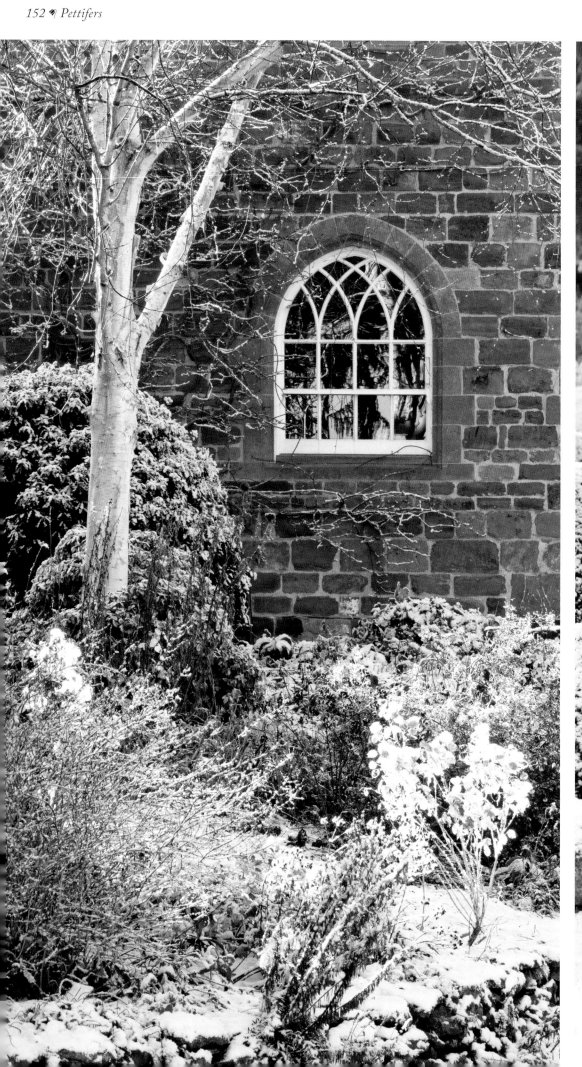

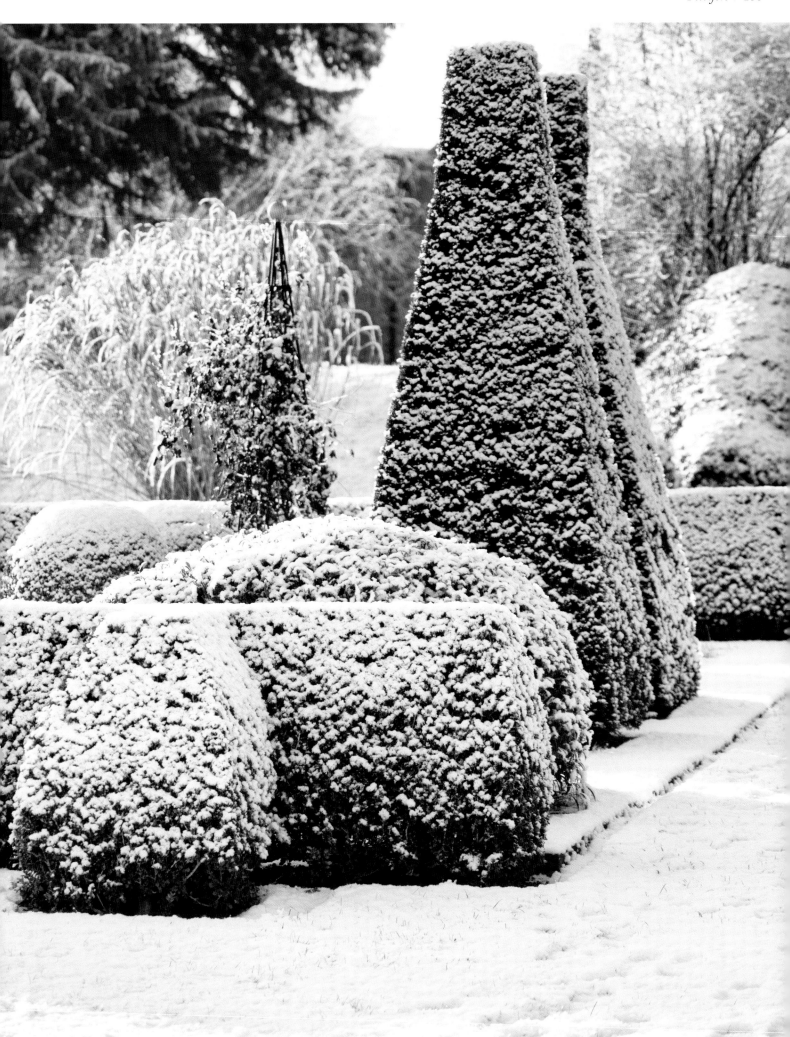

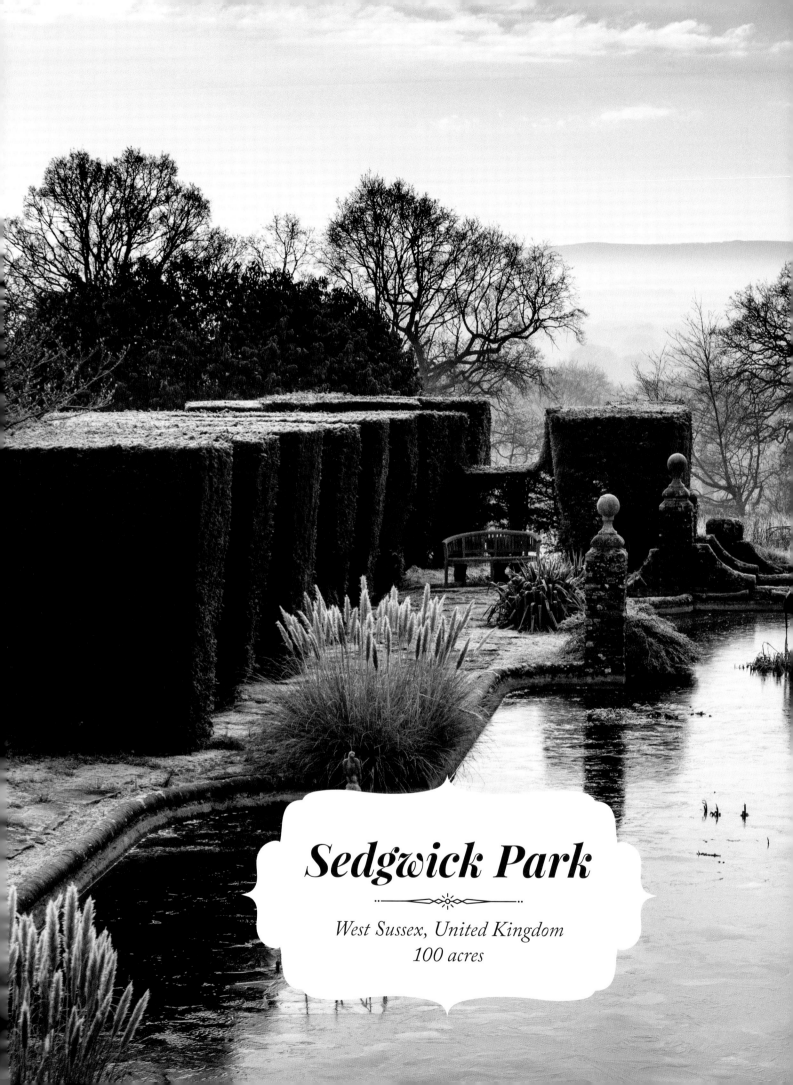

Sedgwick Park

West Sussex, United Kingdom
100 acres

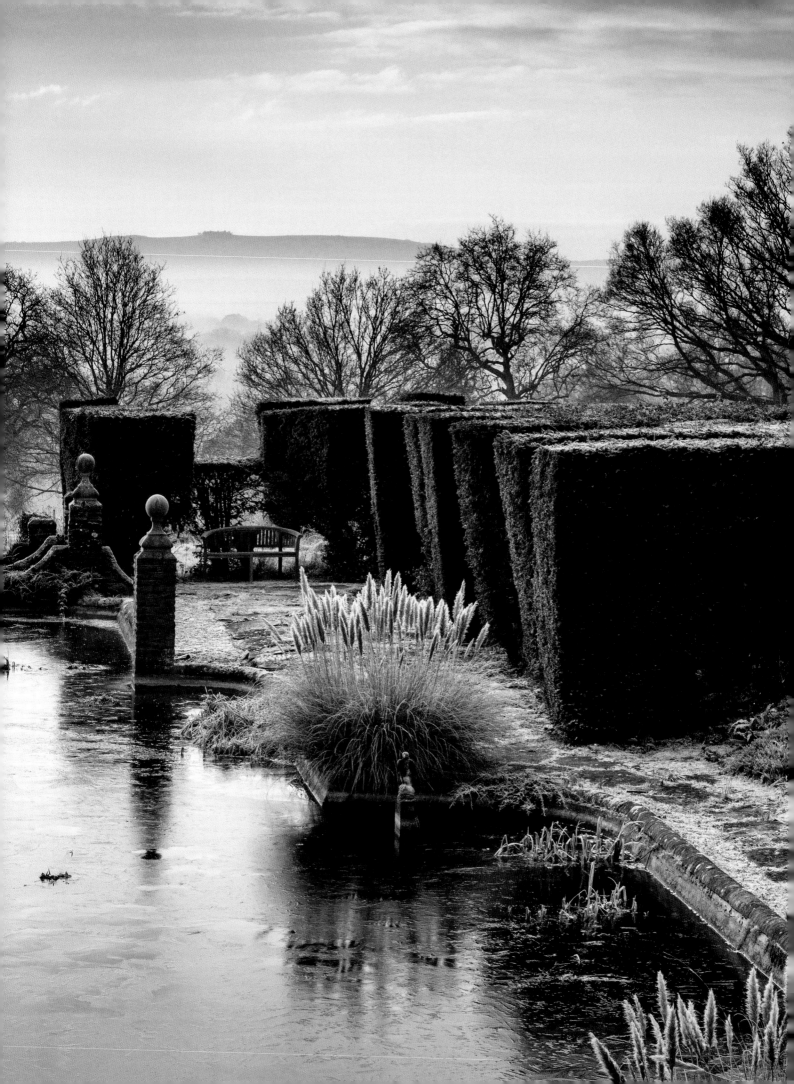

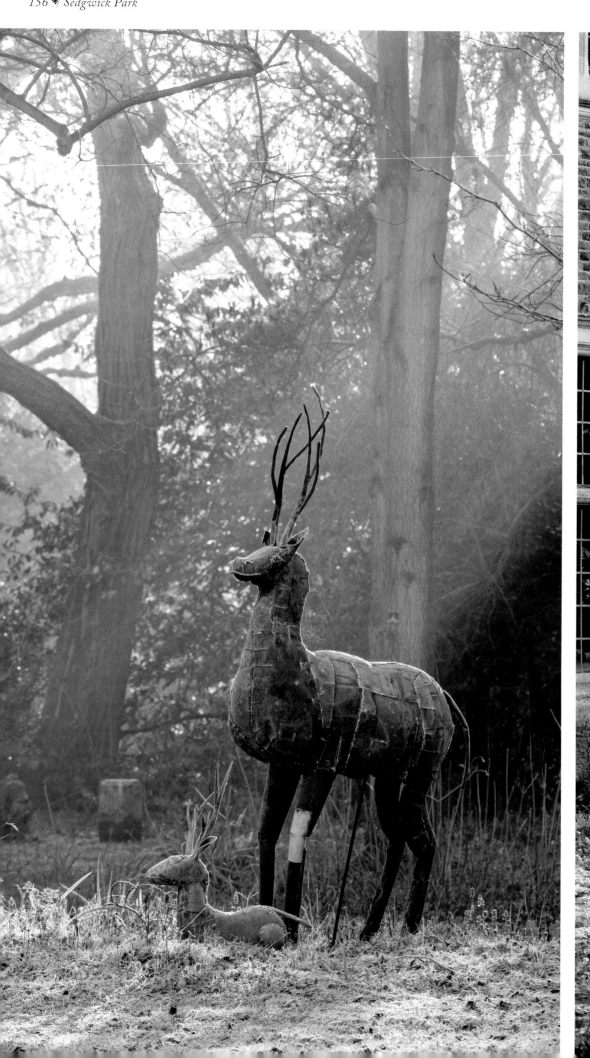

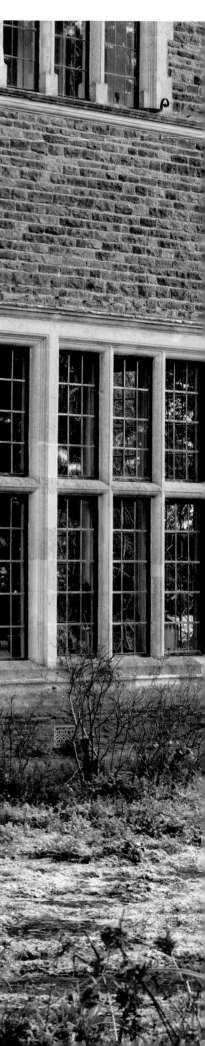

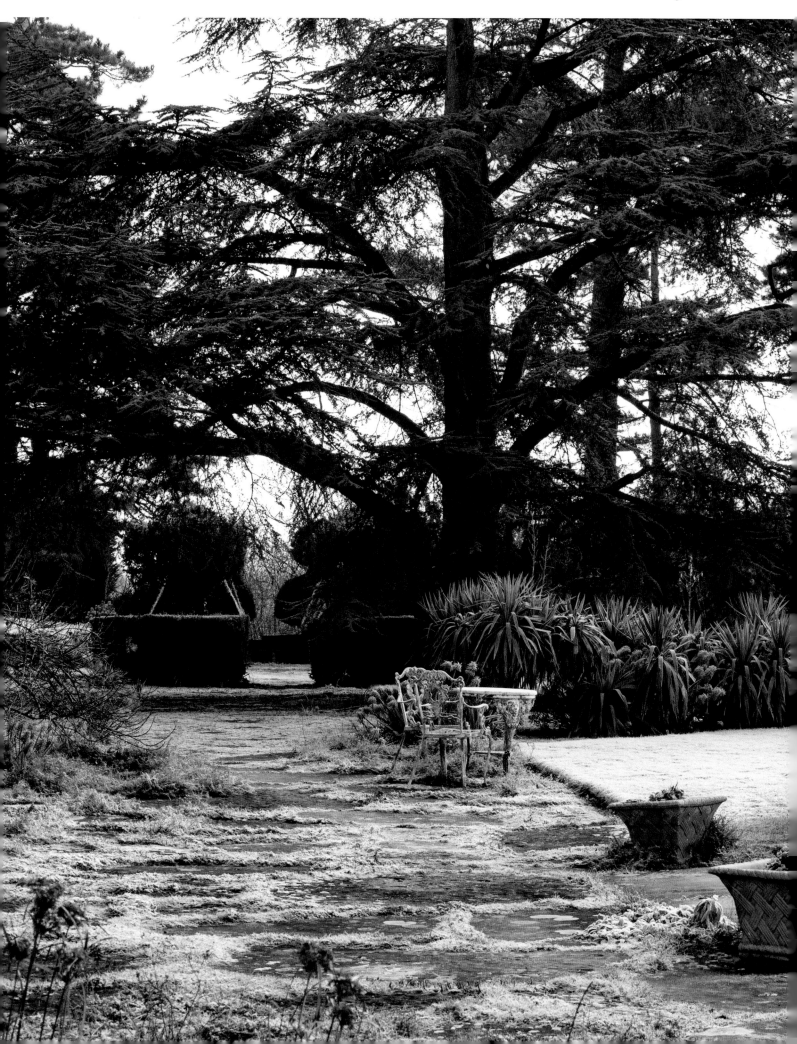

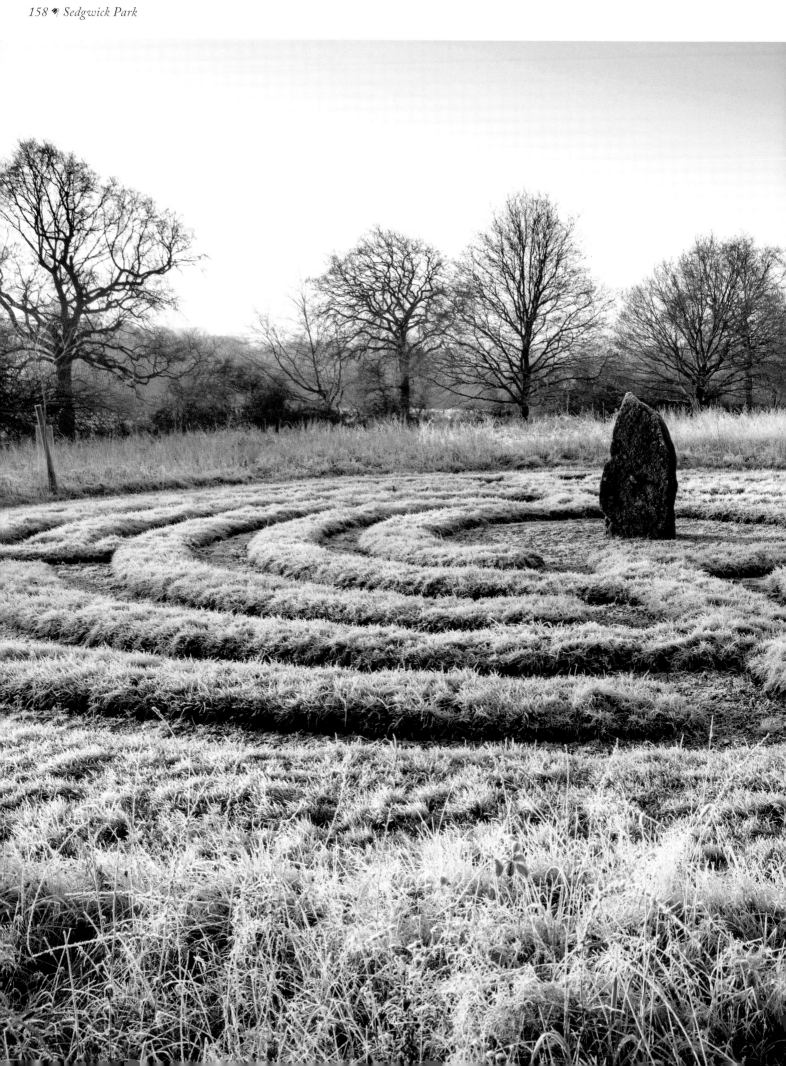

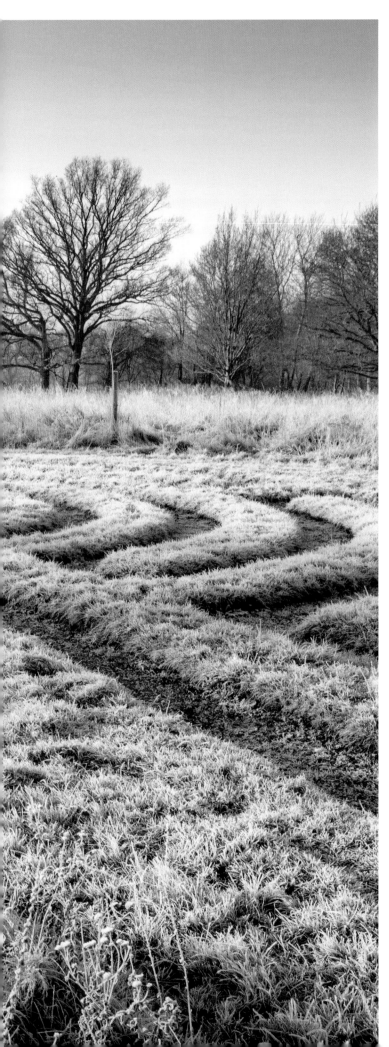

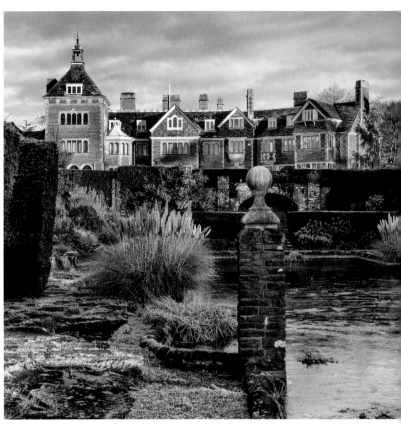

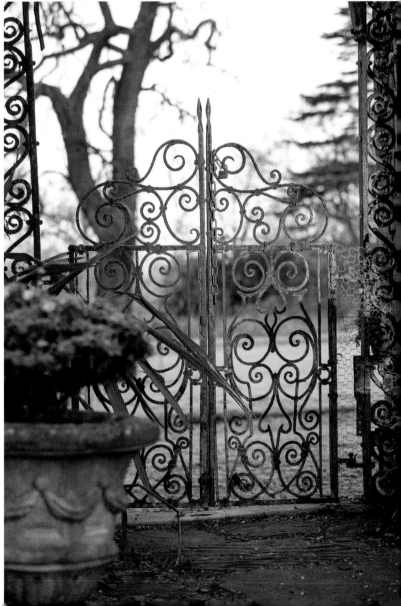

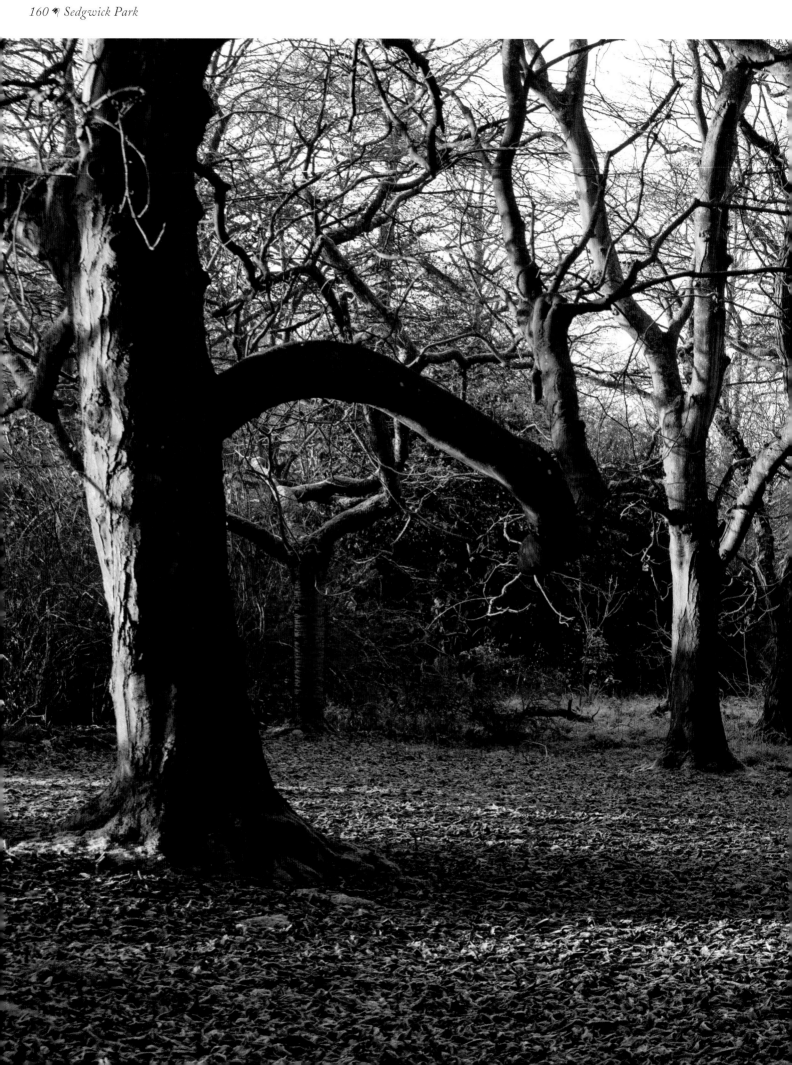

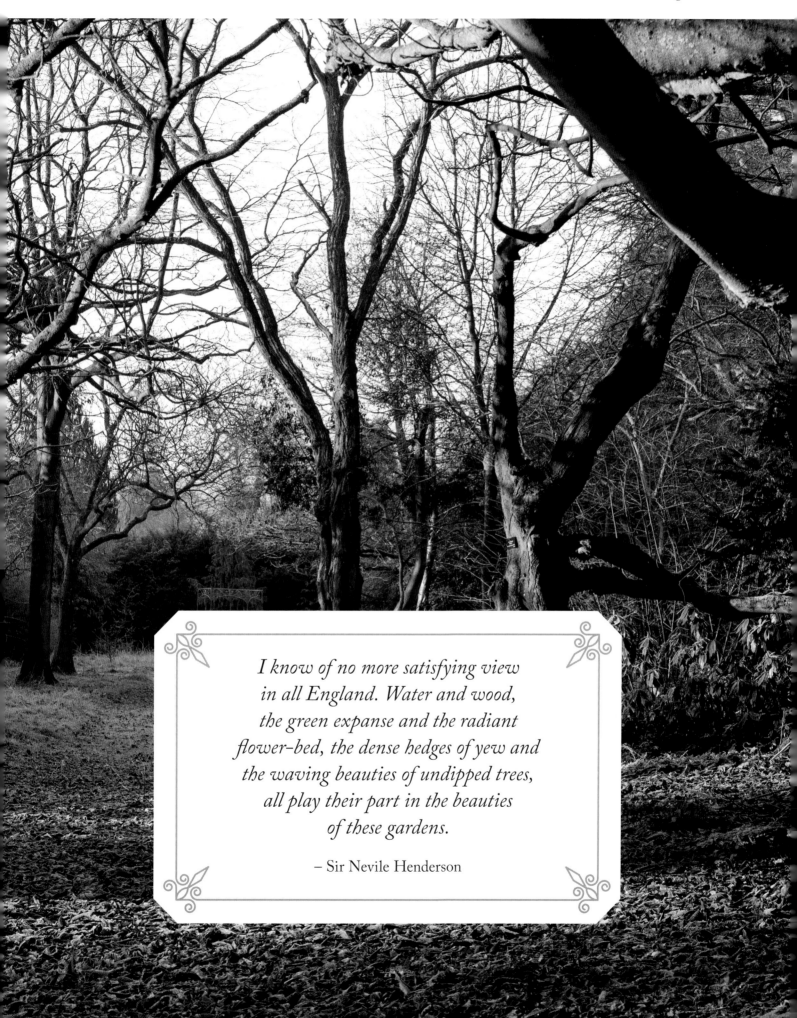

*I know of no more satisfying view
in all England. Water and wood,
the green expanse and the radiant
flower-bed, the dense hedges of yew and
the waving beauties of undipped trees,
all play their part in the beauties
of these gardens.*

– Sir Nevile Henderson

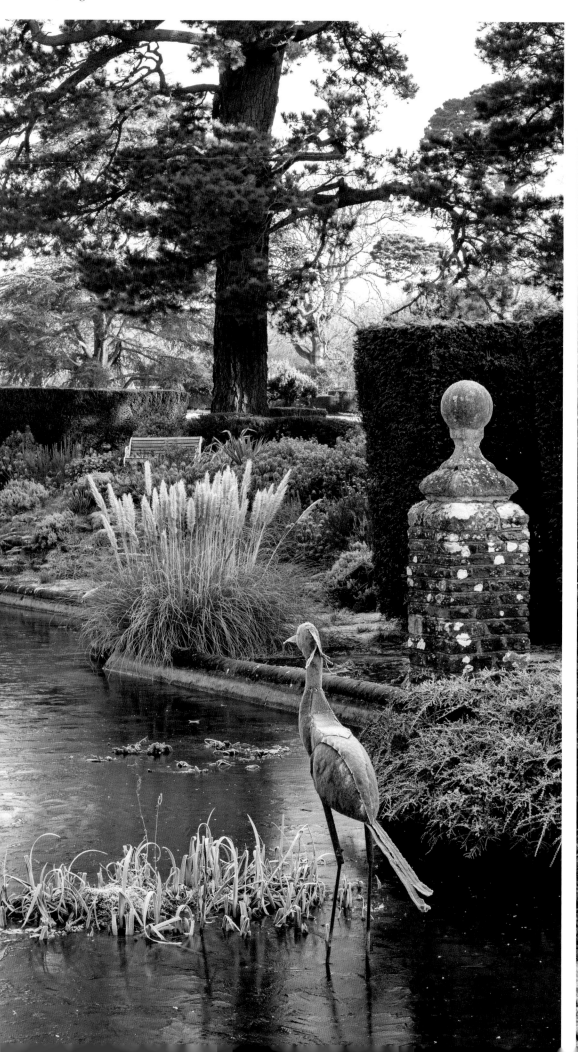

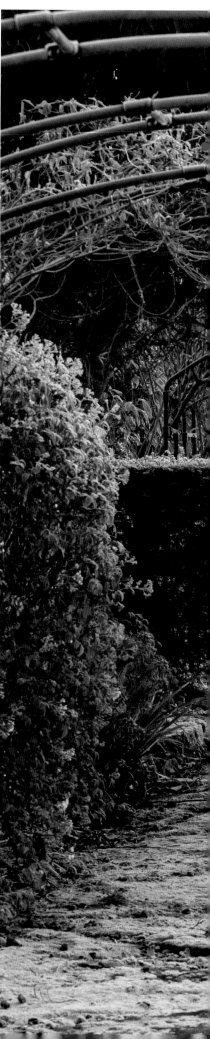

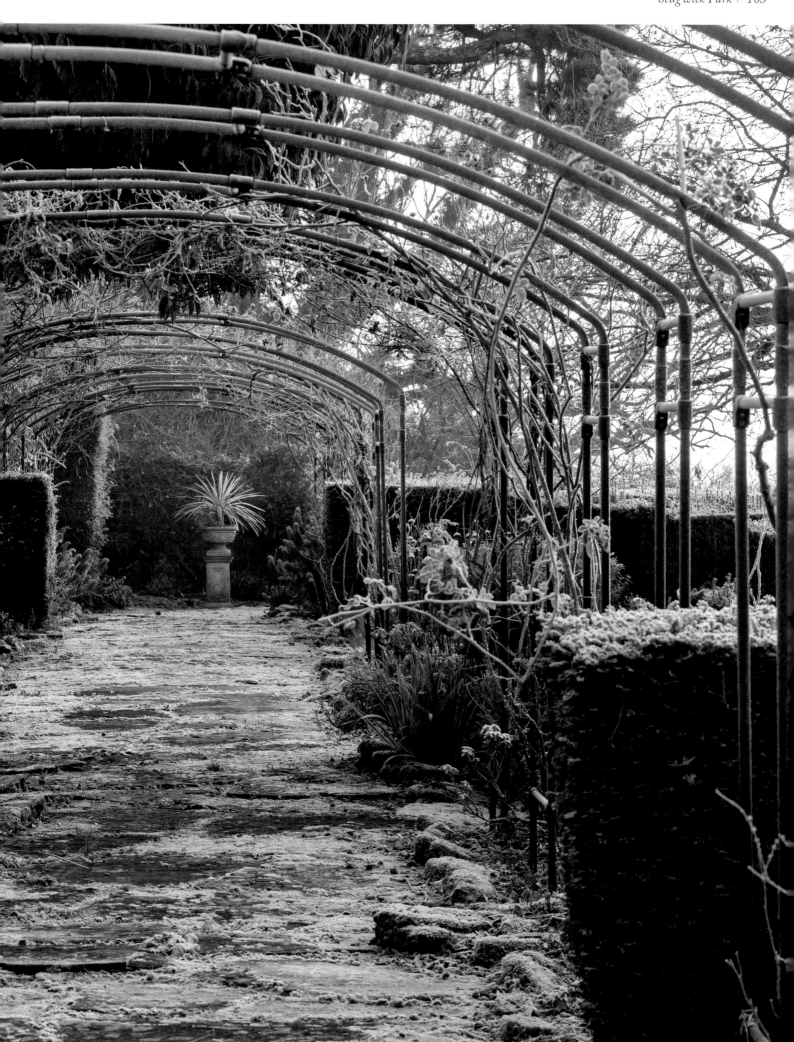

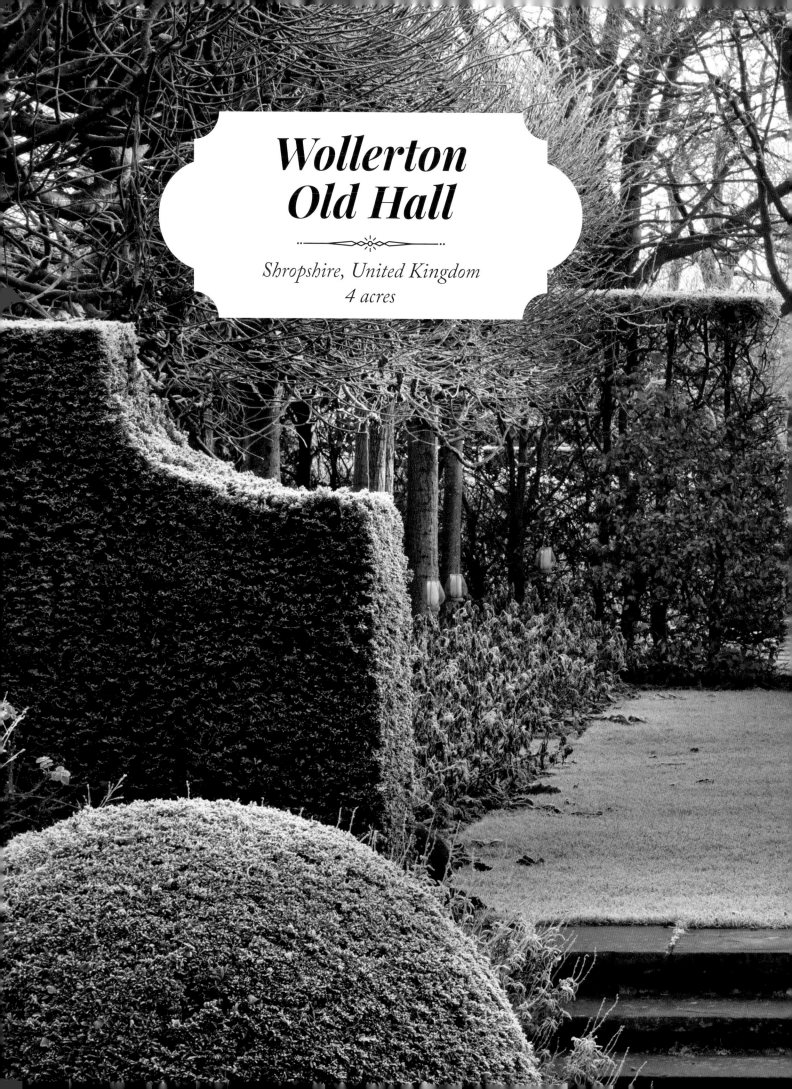

Wollerton Old Hall

Shropshire, United Kingdom
4 acres

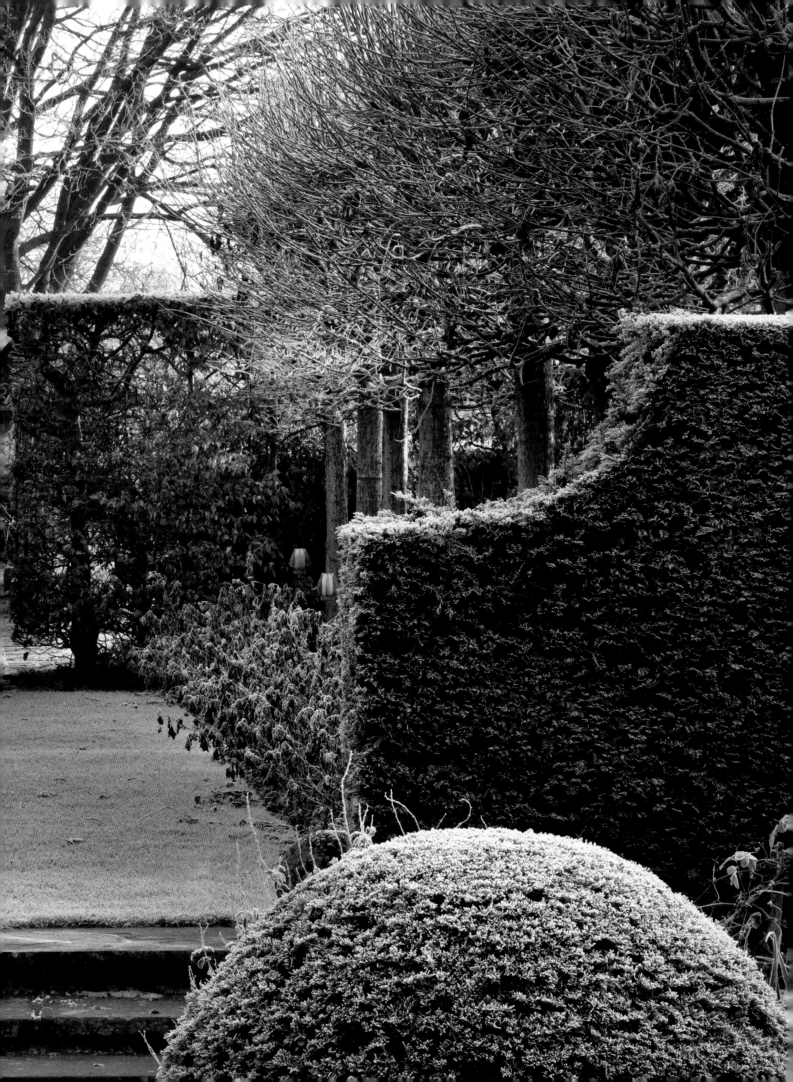

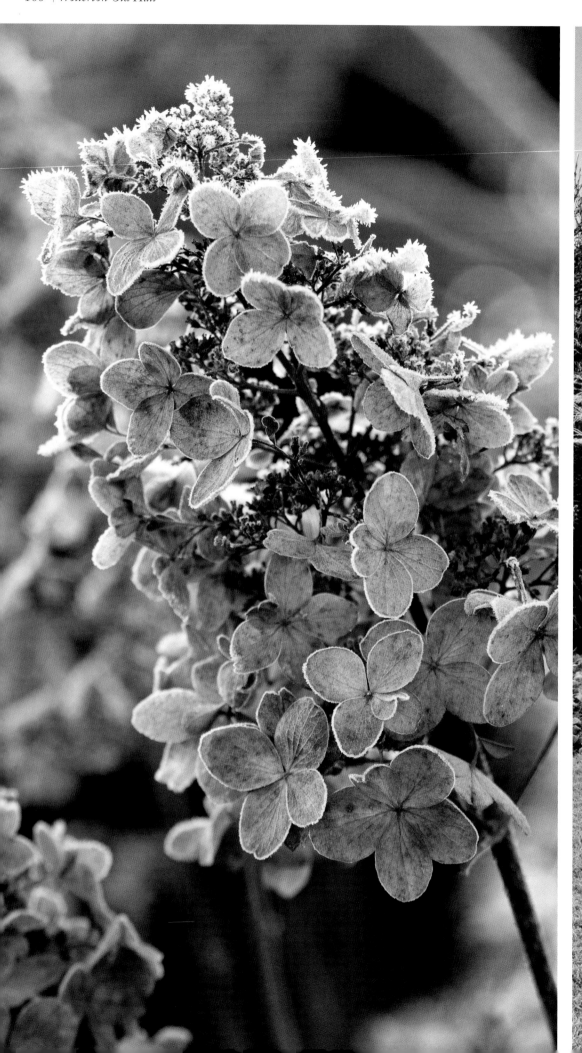

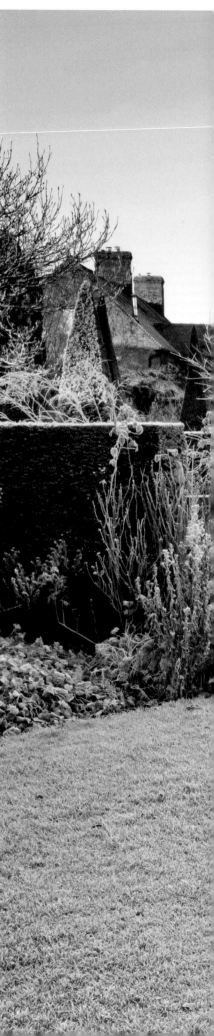

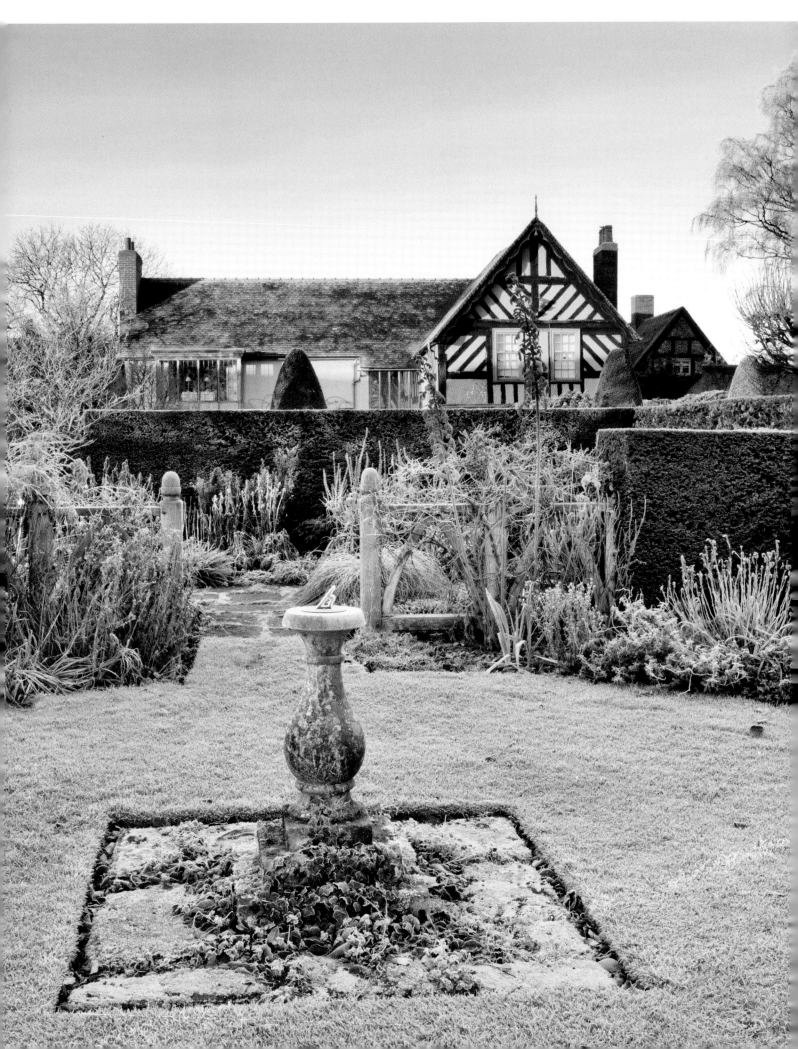

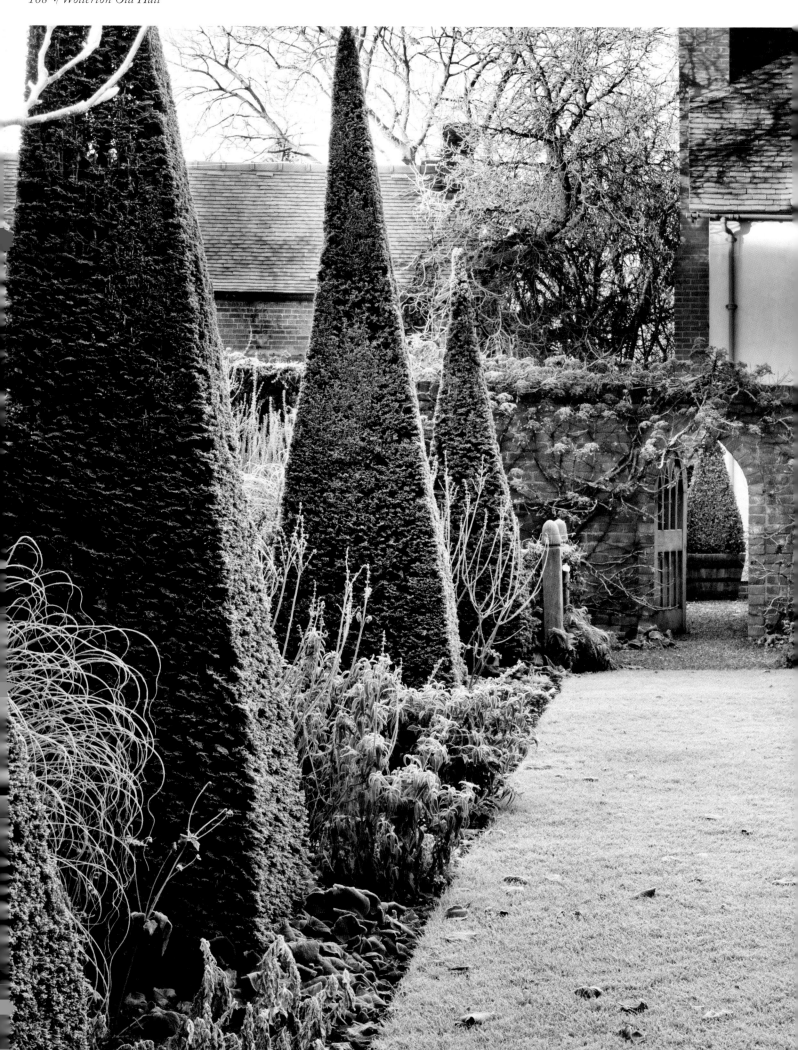

*A few light taps upon the pane
made him turn to the window. It had begun
to snow again. He watched sleepily the flakes,
silver and dark, falling obliquely against
the lamplight. The time had come for him
to set out on his journey westward.
Yes, the newspapers were right: snow was
general all over Ireland. It was falling
on every part of the dark central plain,
on the treeless hills, falling softly upon
the Bog of Allen and, farther westward,
softly falling into the dark mutinous
Shannon waves. It was falling, too,
upon every part of the lonely churchyard
on the hill where Michael Furey lay buried.
It lay thickly drifted on the crooked crosses
and headstones, on the spears of the little gate,
on the barren thorns. His soul swooned slowly
as he heard the snow falling faintly
through the universe and faintly falling,
like the descent of their last end,
upon all the living and the dead.*

– James Joyce, *The Dead* (excerpt)

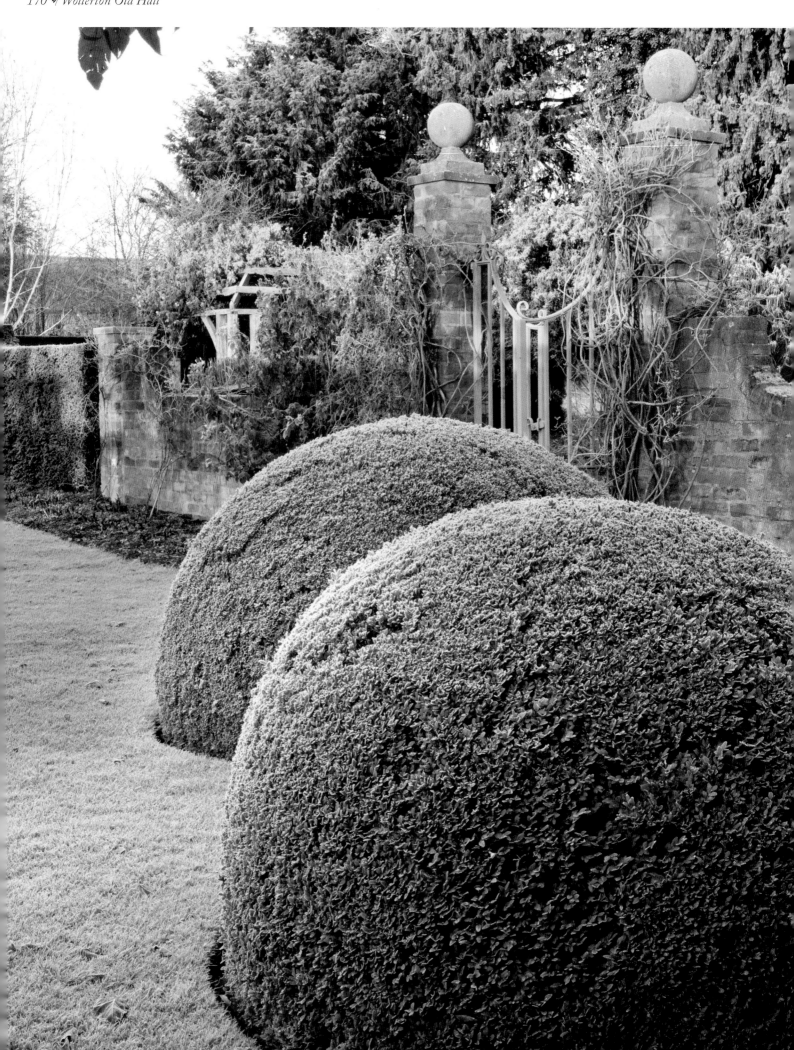

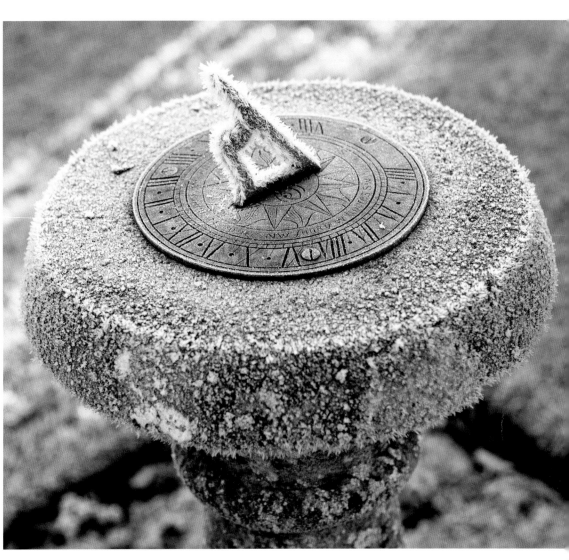

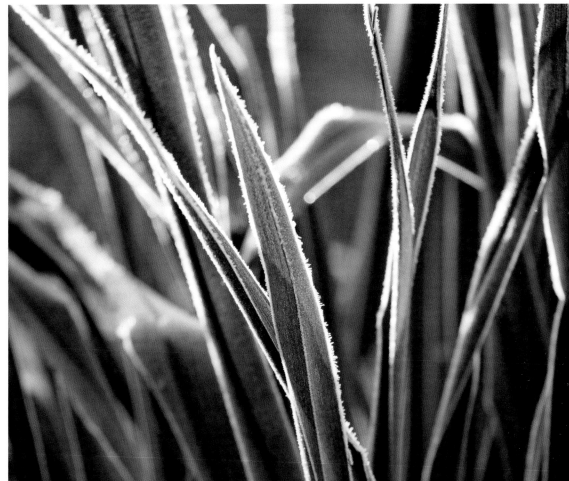

Index

CERNEY HOUSE
Cerney House Gardens
The Garden House
North Cerney
Cirencester
Gloucestershire GL7 7BX
England, United Kingdom
www.cerneygardens.com
gardens@cerneygardens.com
Tel.: +44 (0)1285 831044
Tel.: +44 (0)1285 831300
End of January to end of October,
daily, 10am–4pm
Admission: £5 (adults), £1 (children)
Gift shop

CHÂTEAU DU RIVAU
Le Coudray
37120 Lémeré
France
www.chateaudurivau.com
info@chateaudurivau.com
Tel.: +33 (0)2 47 95 77 47
End of March to April, 10am–6pm,
May to September, 10am–7pm,
October, 10am–6pm
Admission: €10.50 (adults),
€7 (Children 5 to 18 years)
Groups are welcome to visit all year
with reservation
Guided tours (1.5 hours, in English,
German, or Italian) by appointment
Restaurant (open for pre-booked groups
all year round)

CLIVEDEN HOUSE
Cliveden House Gardens
Cliveden Road
Taplow, Maidenhead
Buckinghamshire SL1 8NS
England, United Kingdom
www.nationaltrust.org.uk/cliveden
Tel.: +44 (0)1628 605069
Mid February to December,
daily, 10am–5.30pm
Admission (garden & woodlands only):
£10 (adults), £5 (children)
Opening times and prices alter annually
Cliveden is a National Trust property

LES CONFINES
St. Remy de Provence
France
les-confines.com
info@les-confines.com
Not open for public viewing
For rent as a holiday home
(includes the garden)
Tel.: +44 (0)7771 727483
Tel.: +44 (0)7881 957317

GIARDINO DI NINFA
Doganella di Ninfa
Via Provinciale Ninfina 68
04012 Cisterna di Latina
Latina, Italy
www.fondazionecaetani.org
caetani.giardinodininfa@panservice.it
The Garden of Ninfa is open to the public
on a selection of limited dates each year
Admission: €12
Free for children aged under 11
Groups are welcome by appointment
and garden tours are available
in Italian and English

GRANGE COURT
The Grange
St Peter Port
Guernsey GY1 2Q J, United Kingdom
Open garden once a year
with all proceeds going to charity

HAMPTON COURT
Hampton Court Estate
Hope-Under-Dinmore
Leominster
Herefordshire HR6 0PN
England, United Kingdom
www.hamptoncourt.org.uk
ticketoffice@hamptoncourt.org.uk
events@hamptoncourt.org.uk
Tel.: +44 (0)1568 797777
April to October, daily, 10.30am–5pm
Admission (garden only): £8.50 (adults),
£7.50 (senior citizens),
£4.75 (children 5 to 14 years)
For rent as a wedding and party venue
Café and gift shop

HEVER CASTLE
Hever Castle & Gardens
Hever
Edenbridge
Kent TN8 7NG
England, United Kingdom
www.hevercastle.co.uk
info@hevercastle.co.uk
Tel.: +44 (0)1732 865224
Mid February to March and November,
Wednesday–Sunday, 10.30am–4.30pm,
April to October, daily, 10.30am–6pm,
December (until 4th Sunday before
Christmas), Wednesday–Sunday,
10.30am–6pm, until Christmas Eve, daily,
10.30am–6pm
Admission (garden only):
£13.90 (adults), £12.40 (senior citizens),
£8.80 (children 5 to 15 years)
Free for children aged under 5
Restaurant and gift shop

HOLKER HALL
Holker Estate
Cark-in-Cartmel
Grange-over-Sands
Cumbria LA11 7PL
England, United Kingdom
www.holker.co.uk
info@holker.co.uk
Tel.: +44 (0)15395 58328
End of March to early November,
Wednesday–Sunday and Bank Holiday
Mondays, 10.30am–5pm
On Special Event Days during the year
the Hall and/or Gardens may be closed
to the general public
Admission (garden only): £8
Free for children aged under 16
Restaurant, gift shop and food hall

THE MANOR HOUSE
Kathy Brown's Garden at
The Manor House
Church Road
Stevington
Bedford MK43 7QB
England, United Kingdom

kathybrownsgarden.homestead.com
info@kathybrownsgarden.com
Tel.: +44 (0)1234 822064
End of May to September,
Tuesdays, 1–5pm
Admission: £5
Tours, Tuesdays, 2pm
Larger groups of 15+ are welcome
at other times by appointment

NARBOROUGH HALL
Narborough
Norfolk PE32 1 TE
England, United Kingdom
www.narboroughhallgardens.com
narboroughgardeners@gmail.com
Tel.: +44 (0)1760 338827
May to September,
Wednesday and Sunday, 11am–4pm
Admission: £4,
Free for children aged under 12
Garden: groups welcome by appointment
and garden tours are available
Gardens for rent as a wedding venue
Restaurant

PASHLEY MANOR GARDENS
Ticehurst
Near Wadhurst
East Sussex TN5 7HE
England, United Kingdom
www.pashleymanorgardens.com
info@pashleymanorgardens.com
Tel.: +44 (0)1580 200888
April to September,
Tuesday–Saturday,
Bank Holiday Mondays,
and Special Event Days, 11am–5pm
Admission: £10 (adults),
£5 (children aged under 16),
Groups 15+: £9.50 per person
Free for children aged under 6
Tulip Festival (end of April to
early May): £10.50
Café and gift shop

PETTIFERS
Lower Wardington
Banbury
Oxfordshire OX17 1RU
England, United Kingdom
www.pettifers.com
pettifersgarden@aol.com
The garden is open to visitors
by appointment

SEDGWICK PARK
Sedgwick Park House
Sedgwick Park
Horsham
West Sussex RH13 6QQ
England, United Kingdom
www.sedgwickpark.com
info@sedgwickpark.co.uk
Tel.: +44 (0)1403 734930
The garden at Sedgwick Park is open
on single days throughout the year in aid
of the National Gardens Scheme
www.ngs.org.uk
Guided tours of the garden and ground
floor of the house for small private groups
by appointment (May to October)

TRESCO ABBEY
Tresco Abbey Garden
Tresco
Isles of Scilly TR24 0QQ
United Kingdom
www.tresco.co.uk
Tel.: +44 (0)1720 424108
Open all year round, daily, 10am–4pm
Visitor centre open from
March to October
Admission: £12
Free for children aged up to 15
Café and gift shop

ULTING WICK
Crouchman's Farm Road
Ulting
Maldon
Essex CM9 6QX
England, United Kingdom
www.ultingwickgarden.co.uk
philippa.burrough@btinternet.com

Tel.: +44 (0)1245 380216
The garden at Ulting Wick is open
on single days throughout the year in aid
of the National Gardens Scheme
www.ngs.org.uk
Visitors also welcome by appointment,
April to September in groups of 15+
Admission £5, children free

WATERPERRY GARDENS
Nr. Wheatley
Oxfordshire OX33 1JZ
England, United Kingdom
www.waterperrygardens.co.uk
office@waterperrygardens.co.uk
Tel.: +44 (0)1844 339254
April to October, daily, 10am–5.30pm,
November to March, daily, 10am–5pm
Admission: £7.20 (adults)
Free for children aged up to 16
Plant centre, gallery, gift barn and tea shop

WHATLEY MANOR
Whatley Manor Hotel & Spa
Easton Grey, Malmesbury
Wiltshire SN16 0RB
England, United Kingdom
www.whatleymanor.com
Tel.: +44 (0)1666 822888 (Hotel)
For guests of the Whatley Manor Hotel
& Spa only
For rent as a wedding and
private party venue

WOLLERTON OLD HALL
Wollerton Old Hall Garden
Wollerton
Market Drayton, Shropshire TF9 3NA
England, United Kingdom
wollertonoldhallgarden.com
info@wollertonoldhallgarden.com
Tel.: +44 (0)1630 685760
April to August, Fridays, Sundays
and on Bank Holidays, 12–5pm
September, Fridays only
Admission: £7 (adults),
£1 (children 4 to 15 years)
Groups 25+: £6 per person

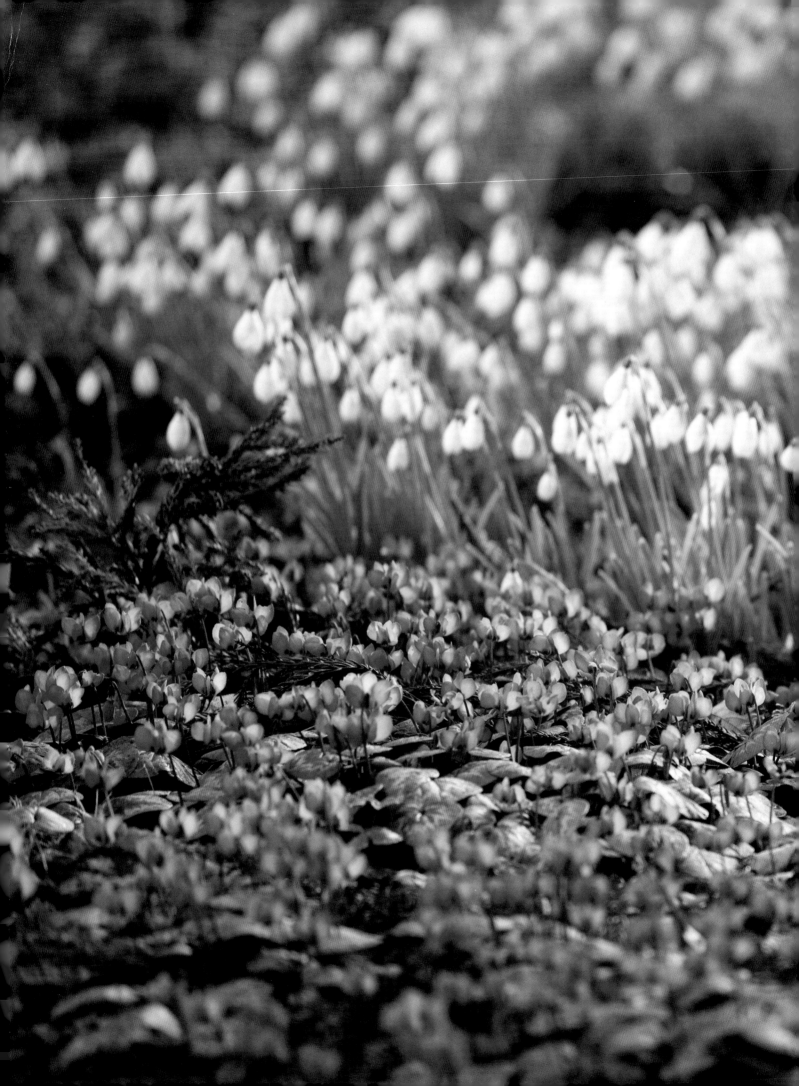

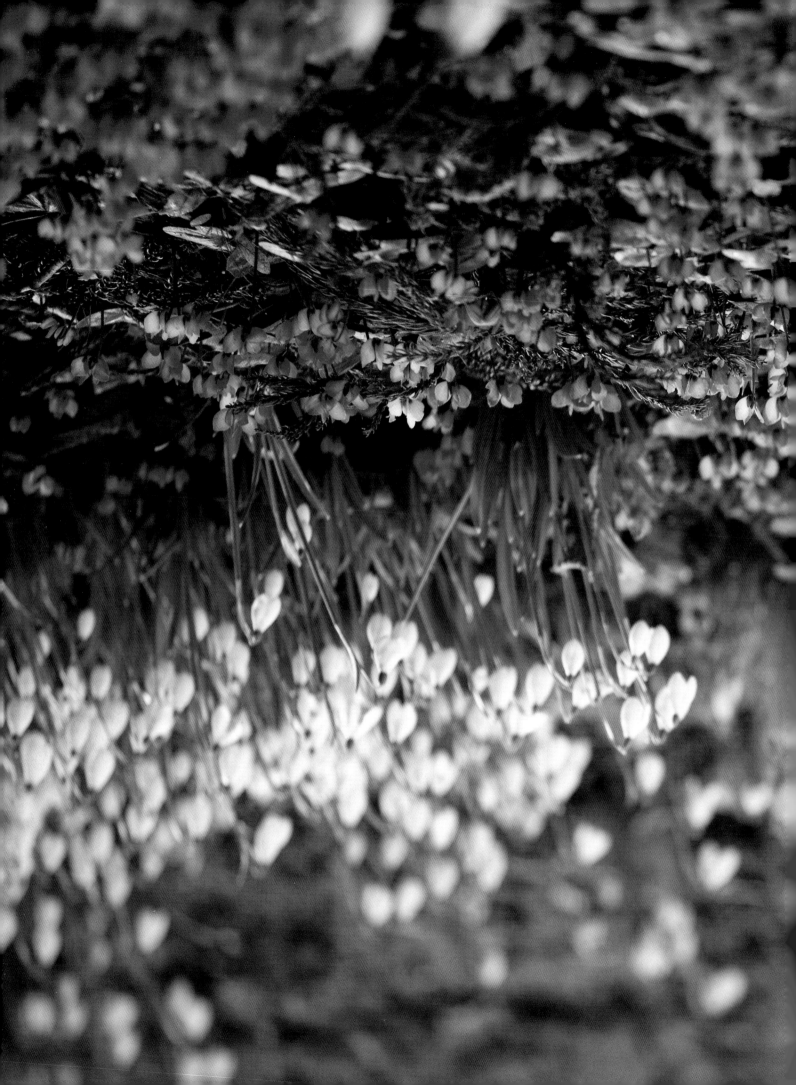

Literary Sources & Imprint

Carroll, Lewis. *Through the Looking-Glass, and what Alice found there.* New York: Macmillan & Co., 1875.

Davenport, Emma Anne G. *Grandmamma.* Hatchard and Co., 187 Piccadilly, 1868.

Dickinson, Emily. *Poems by Emily Dickinson.* Boston: Roberts Brothers, 1893.

Fitzgerald, F. Scott. *Tender is the Night.* University of Adelaide: ebooks@Adelaide

The Gardeners' Chronicle. A weekly illustrated Journal of Horticultural and allied Subjects. Vol. 4. July to December 1875.
London: 41, Wellington Street, Covent Garden, W.C., 1875: 810.

Gower, Lord Ronald. *My Reminiscences.* 3rd Ed. New York: Charles Scribner's Sons, 1884.

Henderson, Sir Nevile. *Water under the Bridges.* Hodder & Stoughton Limited, 1945.

Jones, Jun., Joseph. *Hereford, Cathedral and City. A Handbook for Visitors and Residents.*
Hereford: Joseph Jones & Son, Broad Street, 1858: 140.

Hodgson Burnett, Frances. *The Secret Garden.* Leipzig: Bernhard Tauchnitz, 1912.

Joyce, James. *Dubliners.* The Albatross, 1932.

Keats, John. *The Poetical Works of John Keats.* 2nd Ed. London: William Smith, 113, Fleet Street, 1841.

Milton, John. *Paradise Lost.* London: Whittaker, Treacher, & Co., Ave Maria Lane, 1832.

Moore, Thomas. *The Poetical Works of Thomas Moore, collected by himself. Vol. 5.*
London: Longman, Orme, Brown, Green, & Longmans, Paternoster Row, 1841.

Myrtle, Harriet. *The Water Lily.* London: Thomas Bosworth, 215, Regent Street, 1854.

The Pocket Magazine of Classic and Polite Literature, Vol. 1. London: James Robins & Co., Ivy Lane, Paternoster Row, 1831: 129.

Rossetti, Christina. *The Prince's Progress, and other Poems.* London: Macmillan and Co., 1866.

Sturm, Christoph Christian. *Reflections on the Works of God and of his Providence throughout all Nature, Vol. I.*
Trans. by a Lady. London: printed for J. Walker, Paternoster Row, and J. Harris, St Pauls Church Yard, 1809.

Willard Parsons, Eliza Dwight. *Poems on various Subjects.* Troy: Printed by F. Adancourt, 1826.

© 2016 teNeues Media GmbH & Co. KG, Kempen
Photographs © 2016 Clive Nichols.
All rights reserved.

Ornaments & icons designed by Freepik

Editorial management
 by Nadine Weinhold
Design & layout by Sophie Franke
Proofreading by Artes Translations,
 Dr Suzanne Kirkbright
Production by Alwine Krebber
Color separation & proofing
 by David Burghardt

Published by teNeues Publishing Group
teNeues Media GmbH & Co. KG
Am Selder 37, 47906 Kempen, Germany
Phone: +49 (0)2152 916 0
Fax: +49 (0)2152 916 111
e-mail: books@teneues.com

Press department: Andrea Rehn
Phone: +49 (0)2152 916 202
e-mail: arehn@teneues.com

teNeues Publishing Company
7 West 18th Street, New York,
NY 10011, USA
Phone: +1 212 627 9090
Fax: +1 212 627 9511

teNeues Publishing UK Ltd.
12 Ferndene Road,
London SE24 0AQ, UK
Phone: +44 (0)20 3542 8997

teNeues France S.A.R.L.
39, rue des Billets,
18250 Henrichemont, France
Phone: +33 (0)2 48 26 93 48
Fax: +33 (0)1 70 72 34 82

www.teneues.com

ISBN: 978-3-8327-3332-2

Library of Congress Control Number:
2015958054

Printed in the Czech Republic

Bibliographic information published by the Deutsche Nationalbibliothek. The Deutsche Nationalbibliothek lists this publication in the Deutsche Nationalbibliografie; detailed bibliographic data are available on the Internet at http://dnb.d-nb.de.